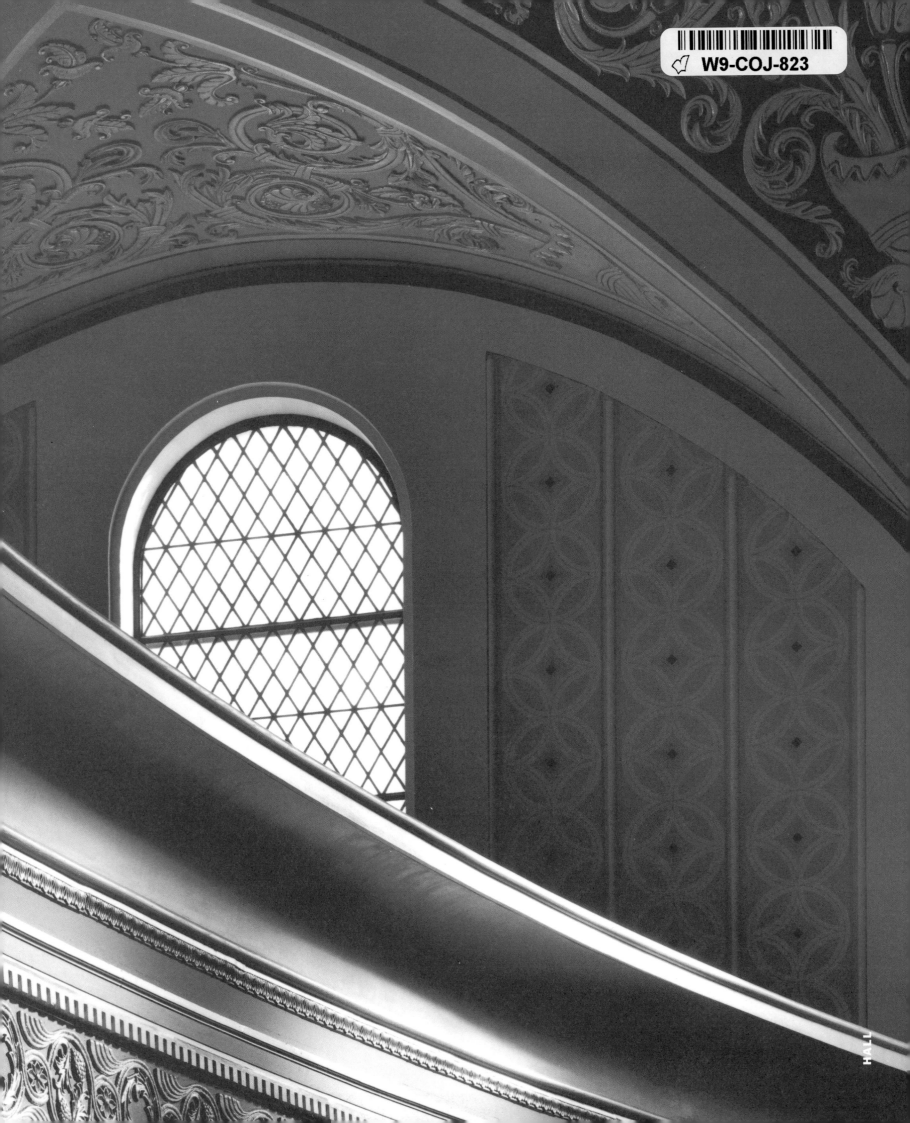

HALL

BUILDING IMAGES

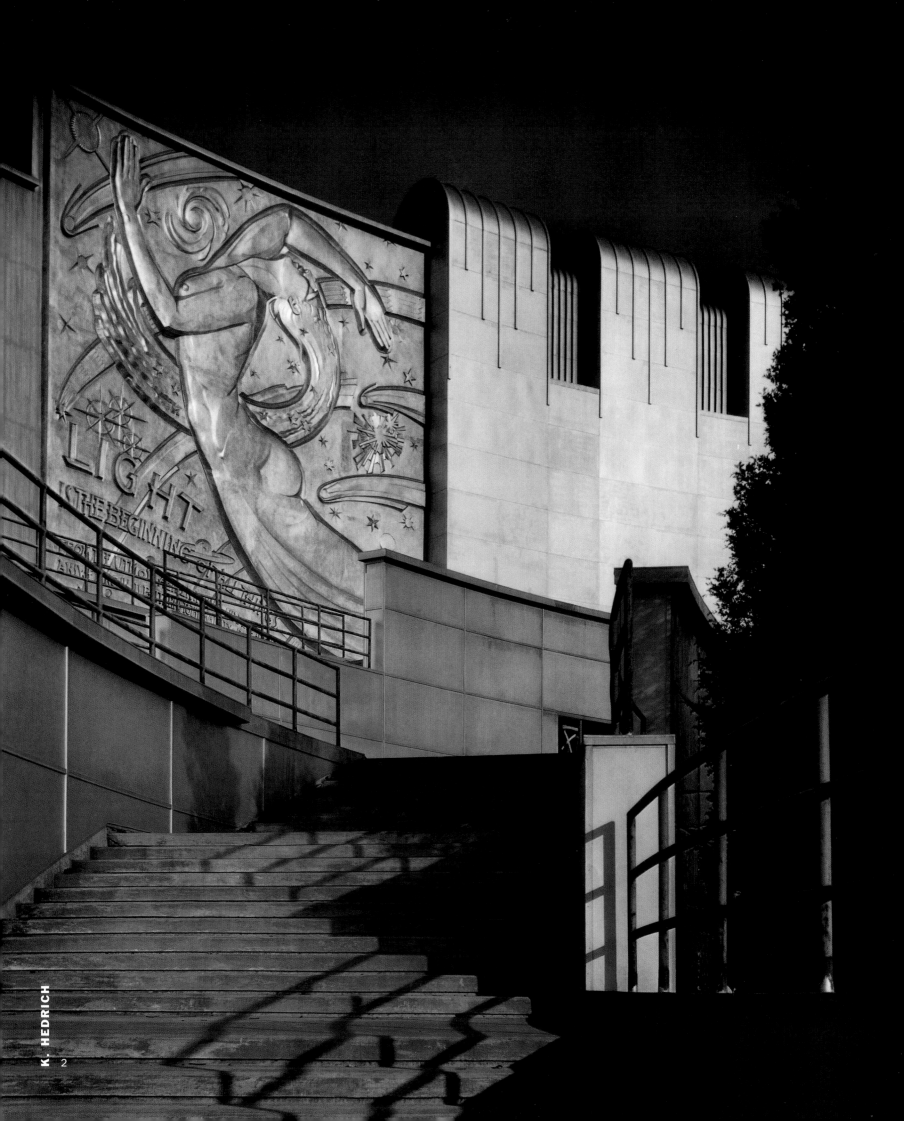

2

BUILDING IMAGES:
SEVENTY YEARS OF PHOTOGRAPHY AT
HEDRICH BLESSING

ESSAY BY TONY HISS

INTRODUCTION BY TIMOTHY SAMUELSON

PRODUCED IN COLLABORATION WITH
THE CHICAGO HISTORICAL SOCIETY

CHRONICLE BOOKS
SAN FRANCISCO

Introduction © 2000 by Chicago Historical Society
Essay © 2000 by Tony Hiss

Photographs 1929–1979
© Hedrich Blessing Collection
Chicago Historical Society 2000

Photographs 1980–2000 © 2000 Hedrich Blessing

Library of Congress
Cataloging-in-Publication
Data available.

ISBN 0-8118-2657-0

Printed in Hong Kong.

Designed by Lowell Williams
and Julie Hoyt, Pentagram

Book Packaging by Learning Arts Publications,
New Mexico

*Building Images: Seventy Years of Photography at
Hedrich Blessing* is published to coincide with the
exhibition of the same name at the Chicago
Historical Society.

Distributed in Canada
by Raincoast Books
9050 Shaughnessy Street
Vancouver, British Columbia V6P 6E5

10 9 8 7 6 5 4 3 2 1

Chronicle Books LLC
85 Second Street
San Francisco, California 94105

www.chroniclebooks.com

Cover **BILL ENGDAHL**
(Front) 1964
Everett Dirksen
Federal Building
Chicago, Illinois
Associated Architects:
A. Epstein & Sons, Inc.;
Mies van der Rohe;
C. F. Murphy Associates;
Schmidt, Garden & Erikson

Cover **NICK MERRICK**
(Back) 1994
Northern Navajo
Medical Center
Shiprock, New Mexico
Architect: Anderson
DeBartolo Pan

Endsheet **STEVE HALL**
(Front) 1991
St. Louis Historical Society
Library and Archive
St. Louis, Missouri
Architect: Murphy, Downey,
Wofford, and Richmond

Endsheet **HUBE HENRY**
(Back) 1948
Power House
Sherwin Williams Plant
Chicago, Illinois

For Ken, Ed, and Bill, who started it all, and especially for Jack, who passed the torch.

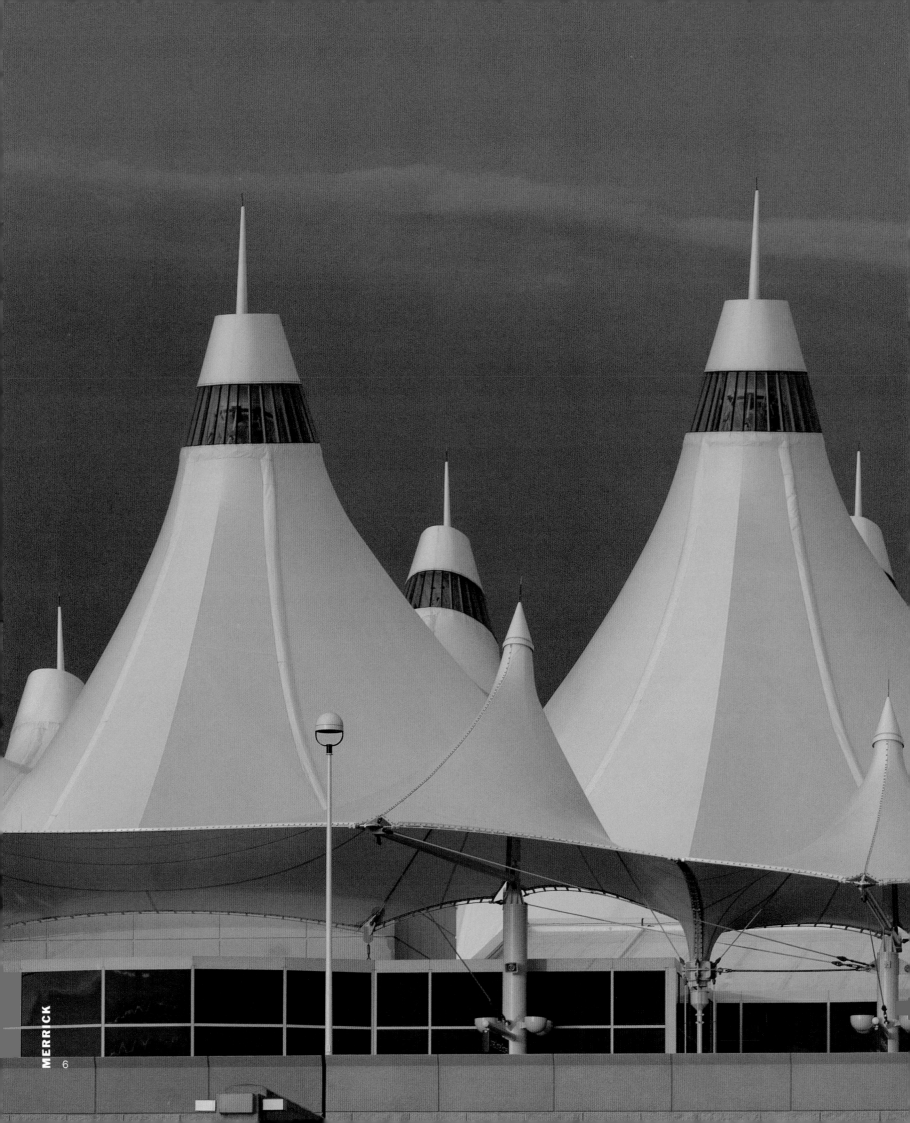

Acknowledgments

Hedrich Blessing is indeed a very fortunate photographic studio. We have been able to blend art and commerce successfully for over seventy years because of the hard work, dedication, and friendship of many people. While the photographers receive the credit for the work of Hedrich Blessing, we have always had, and are very appreciative of, a dedicated support staff of production and office people who keep the studio operating smoothly. Wayland Choy, our longtime head of production, and Alan Parr, our master printer, deserve special recognition for their contributions.

Each photographer at Hedrich Blessing works with an assistant as a team in the creation of the photographs. Literally hundreds of assistants have worked at the studio over the past seventy years. While too numerous to name individually, to all of you we give our thanks.

The photographs, of course, would not have been possible without the support of our clients. We at Hedrich Blessing have had the good fortune to be able to count among our clients many of the best American architects, interior designers, graphic designers, and related professionals and manufacturers. We are indebted to these very creative and demanding professionals who continually push us to be better. The friendships and long professional relationships that we have with many of our clients are personally rewarding and professionally invaluable.

Lowell Williams of Pentagram Design is one of those long-standing clients and friends of Hedrich Blessing. His knowledge of the studio and our work made him the ideal person to design this book. I was more than pleased when he agreed both to design the book and to tackle the arduous task of final editing of the photographs. From the thousands of photographs that we had identified for possible inclusion, Lowell spent many days piecing together the visual and metaphorical connections that produced the final form and flow of this book. My admiration goes both to Lowell and his assistant Julie Hoyt for the beauty that they have wrought.

This book has been a collaborative effort of many people whose work has been terrifically managed and organized by Ron Schultz of Learning Arts Publications. Ron has acted as my guide through the long process of bringing this book into print. Thank you.

One of the true discoveries for me in putting this book together was Tony Hiss. In our many conversations, I found a sensitive, sophisticated man whose artistic process I could admire and respect. His compelling essay has provided new perspectives on the work of Hedrich Blessing.

My thanks go to Timothy Samuelson for his insightful introduction and his stewardship of the Hedrich Blessing archive. This book and the exhibition that it accompanies could not have been produced without the efforts of the Chicago Historical Society. The photographs in *Building Images: Seventy Years of Photography at Hedrich Blessing*, dated from 1929 to 1979, are part of more than 300,000 images that make up the Hedrich Blessing Photographic Collection, owned and preserved by the Chicago Historical Society.

Alan Rapp, editor, and Michael Carrabeta, design director of Chronicle Books, have my gratitude for their support and efforts on behalf of this project. We would not have this beautiful book without them.

The patience, good humor, and perseverance of my partners Jim Hedrich, Jon Miller, Steve Hall, and of all the photographers at Hedrich Blessing must be noted. The demands that this project put on their already busy schedules were not easy to manage. Of special note is Mike Houlahan, our managing partner. Mike coordinated the efforts of our staff, compiled the notes on the photographs, and served as my sounding board for ideas as the book evolved.

The life of an architectural photographer is one of grueling hours, working around the schedules of building occupants, chasing an elusive quality of light—often in strange towns away from our families and friends. I know that I speak for all of the photographers when I say that we could not succeed without the love, understanding, and support of those we care most about: our families. It is to them that we truly owe all our thanks.

Nick Merrick
Senior Partner and Photographer
Hedrich Blessing

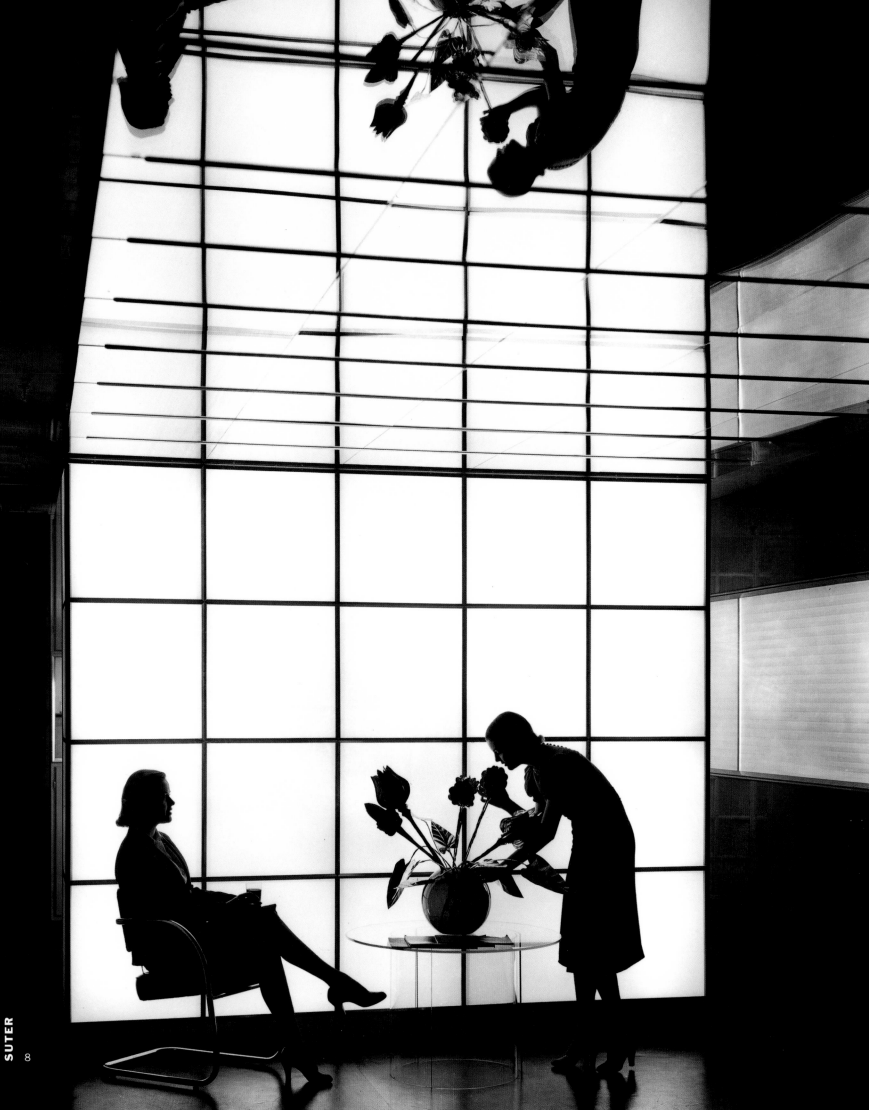

Contents

Photographers	On Camera
Ken Hedrich	1929 – 1971
Bill Hedrich	1931 – 1988
Giovanni Suter	1938 – 1972
Hube Henry	1945 – 1964
Bill Engdahl	1948 – 1985
Bob Harr	1952 –
Jim Hedrich	1966 –
Bob Porth	1968 – 1988
Bob Shimer	1969 –
Nick Merrick	1977 –
Jon Miller	1979 –
Sandi Hedrich	1981 – 1988
Scott McDonald	1983 –
Marco Lorenzetti	1985 – 1998
Steve Hall	1985 –
Chris Barrett	1991 –
Craig Dugan	1993 –
Justin Maconochie	1993 –
G. Todd Roberts	1994 –

Managing Partners	Tenure
Ed Hedrich	1931 – 1976
Jack Hedrich	1953 – 1993
Mike Houlahan	1986 –

Introduction

Timothy Samuelson

Being an architectural photographer in Chicago has never been an easy task.

Books and periodicals on architectural history repeatedly tell the story of how Chicago's pantheon of great architects have shaped the course of modern architecture, but little recognition has been given to the role of the city's architectural photographers as the messengers that spread their ideas far and wide. In all probability, the architects could not have done it without them.

In a city known for architectural innovation, Chicago's architectural photographers have had to be equally creative in recording it. Merely depicting isolated images of facades and rooms has never been enough. It takes a special kind of photographer to make the skyscrapers soar, to make spaces flow, and to convey the emotional intensity that is the soul of all great buildings.

Everyone knows that the best way to understand a building is to actually experience it. Since it is not always possible to see a building firsthand, the difficult and problematic art of photography is often the only alternative.

Firsthand experience is especially critical for interpreting modern architecture, with its subtle nuances of space, form, and light. For photographers, modernist buildings are especially challenging, requiring them to break conventional rules of photography and to develop new ones. Open space instead of rooms, great expanses of reflective glass, crisp geometric precision, ever-expanding height, and countless other factors challenged the skill and sensitivity of the photographers that sought to capture the new architecture on film. Otherwise, in the hands of conventional photographers, the studied simplicity of great buildings can become merely simple.

Over the years, Chicago's architects have relied on a handful of talented photographers to offer the power of their buildings to the public. The work of these photographers, as published in books and magazines, often became the basis upon which the architects and their buildings were studied, judged, and in some cases immortalized.

Fortunately, Chicago nurtured a number of talented photographers who were up to the task. J. W. Taylor could be considered the father of Chicago architectural photography. Starting out as the proprietor of a drafting and architectural supply firm, Taylor initially offered architectural photography as a small sideline in the early 1880s. His earliest works were clumsy, cramped images, as he struggled to portray large downtown buildings while handicapped by limited equipment and the tight vantage points afforded by the crowded city streets.

By the end of the same decade, Taylor had evolved a skilled command of Chicago's architecture. He learned how to make the early skyscrapers soar straight and true. In 1890, he documented the majestic Auditorium Building inside and out, including its cavernous theater, which he illuminated with multiple remote flashes. He built up a growing library of architectural images, which he offered for sale to the public in mounted folios, or made available for publication in architectural journals, exposing Chicago's architecture to a wider audience.

In the 1890s, Chicago photographer Ralph Cleveland was responsible for many of the views that have become classic images of the work of architect Louis H. Sullivan. The son of noted landscape architect H. W. S. Cleveland, he showed great sensitivity in conveying Sullivan's unity of striking geometric forms and romantic emotional power. After Cleveland closed his studio at the end of the nineteenth century, Henry Fuermann assumed the mantle as the photographer of choice for Chicago's progressive architects. His studio captured the distinctive character of the jewel box Midwestern banks that occupied Sullivan's later career. Most of the familiar historical images of Frank Lloyd Wright's early Prairie Houses with their dramatic horizontal lines and open, flowing interiors were immortalized by Fuermann's skill and instinctive sensitivity.

Although the creative momentum fueled by Sullivan, Wright, and other progressive architects earlier in the new century had diminished by the 1930s, the decade coincided with the beginning of a new chapter in Chicago's architectural story line. Establishing a firm of specialists in architectural photography at the dawn of the Great Depression was a daunting challenge; since 1929, the firm of Hedrich Blessing proved to be in the right business at the right time, becoming the city's new messenger of modern architecture and achieving an international reputation that extends beyond its regional association with the city. Chicago is proud to claim the firm as its own, and can be credited as a pivotal participant in its success.

From its inception, Hedrich Blessing was immersed in the innovative modernism of Chicago's architectural community. Ken Hedrich's abstract approach of "Don't make photographs, think them" appealed to a new generation of progressive architects that

emerged in the period. A fortuitous early event for the firm was earning the confidence of architect John Wellborn Root, Jr., a principal in the firm of Holabird & Root, whose work included soaring, streamlined skyscrapers like the Chicago Board of Trade, the Palmolive Building, and countless other progressive structures in Chicago and elsewhere. Hedrich Blessing's success in capturing the drama of these buildings soon led to other commissions, including their appointment as the official photographers for the prestigious journal *Architectural Forum*.

Another key achievement that showcased Hedrich Blessing's abilities were the images created for Chicago's A Century of Progress International Exposition held in 1933–34. Although they were not the official photographers of the fair, their photographs, more than any others, became the defining images of the event.

In the succeeding years, Hedrich Blessing earned the confidence of many of the city's leading progressive architects, gracefully documenting the work of Mies van der Rohe; Keck and Keck; Skidmore, Owings & Merrill; and many others. Hedrich Blessing's clientele, however, was not just limited to the work of the well-known modernist firms. Their skill and sensitivity made the firm's services much in demand from a broad range of architects and designers, as well as from popular and professional publications. As a result, the firm became the premier chronicler of the diverse trends of architecture and design throughout the mid-to-late twentieth century.

By the late 1980s, Hedrich Blessing's vast archive of photographic materials was increasingly in demand as a resource for people studying architecture and design during the nearly six decades the firm had been in business. Recognizing their responsibilities as caretakers of invaluable and irreplaceable historical material, Hedrich Blessing initiated efforts in 1989 to place their archives in a public institution where the photographs could be documented, archivally stored, and made available to the public. Although the collection was valued at $3.2 million, and still brought in considerable revenue from reprint and publication orders, the firm decided that preservation and public accessibility should take precedence over financial gain from the material.

Institutions from across the country expressed strong interest in the collection, but Hedrich Blessing made it clear that they preferred the material remain in Chicago. The strongest contender was the Chicago Historical Society, the city's oldest cultural institution, dating from 1856. The institution already had experience in developing and maintaining a photographic archive, and had recently completed a state-of-the-art photographic storage and cataloguing facility. Further, the Society established the C. F. Murphy Architectural Study Center, a major research facility devoted to Chicago architecture.

Securing the Hedrich Blessing archive for the Chicago Historical Society soon became a matter of strong civic support and pride. Funds for its acquisition and processing were raised from many sources, with special support from Chicago's architectural, real estate, and construction communities. In May 1991, the Chicago Historical Society formally announced its acquisition of the Hedrich Blessing collection of prints, negatives, and transparencies, dating from the firm's establishment in 1929 through 1970. The collection was later expanded with the firm's donation of materials dating through the 1970s.

The Chicago Historical Society's commitment to the Hedrich Blessing collection did not end with the acquisition of the material. It was, in fact, just the beginning. The museum undertook one of the most ambitious cataloguing projects in its history, entering information on the over 150,000 prints and negatives of the original donation into a highly detailed, computerized database that allows access to the collection from a broad range of subject areas.

The Hedrich Blessing collection remains one of the Chicago Historical Society's most prized and heavily used photographic archives. Architectural historians continue to draw upon it as a rich resource documenting the evolution of modern architecture. The collection is much more than familiar images of well-known buildings by the masters of modern architecture. Hedrich Blessing's photographers documented a wide range of styles and building types created by the famous as well as the obscure, providing a diverse mosaic of the evolving urban environment. Interest and information is also drawn from the resources of the firm's nonarchitectural commercial work. The collection is as versatile in its potential uses as it is diverse in its content.

As the firm of Hedrich Blessing enters the twenty-first century, it continues to set the standard for excellence in photography. As in the movie *It's a Wonderful Life*, imagine how the history of twentieth-century architecture might have turned out had Hedrich Blessing never existed. Assuredly, it would have been very different.

On the same note, it is comforting to know that the messengers are still on the job.

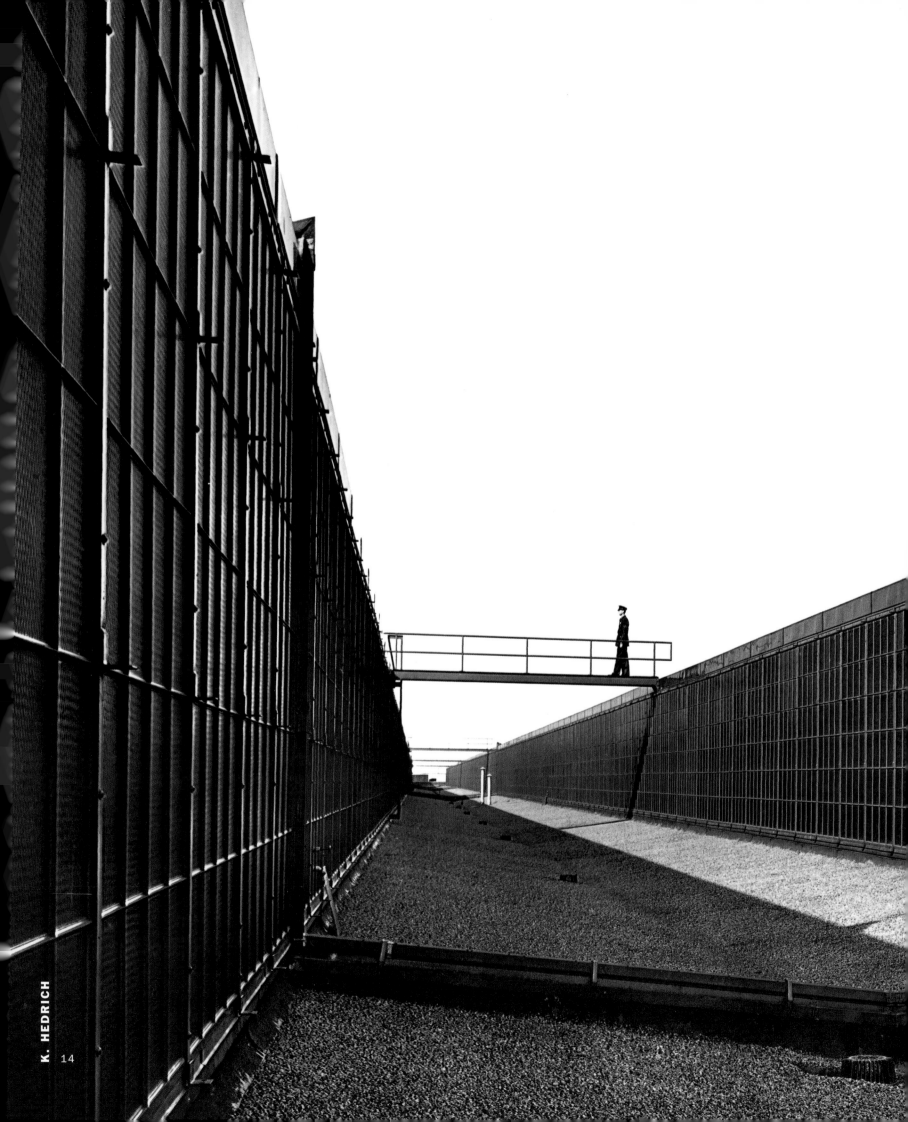

14

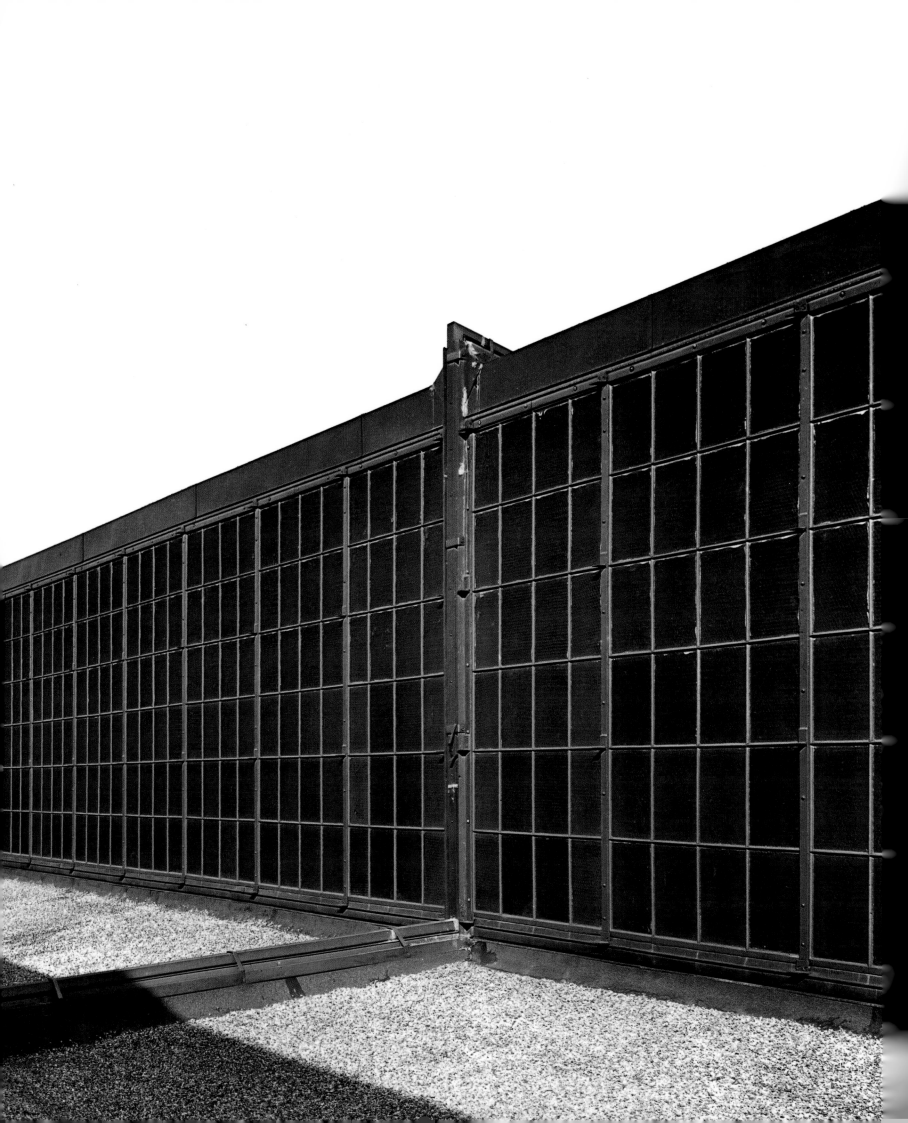

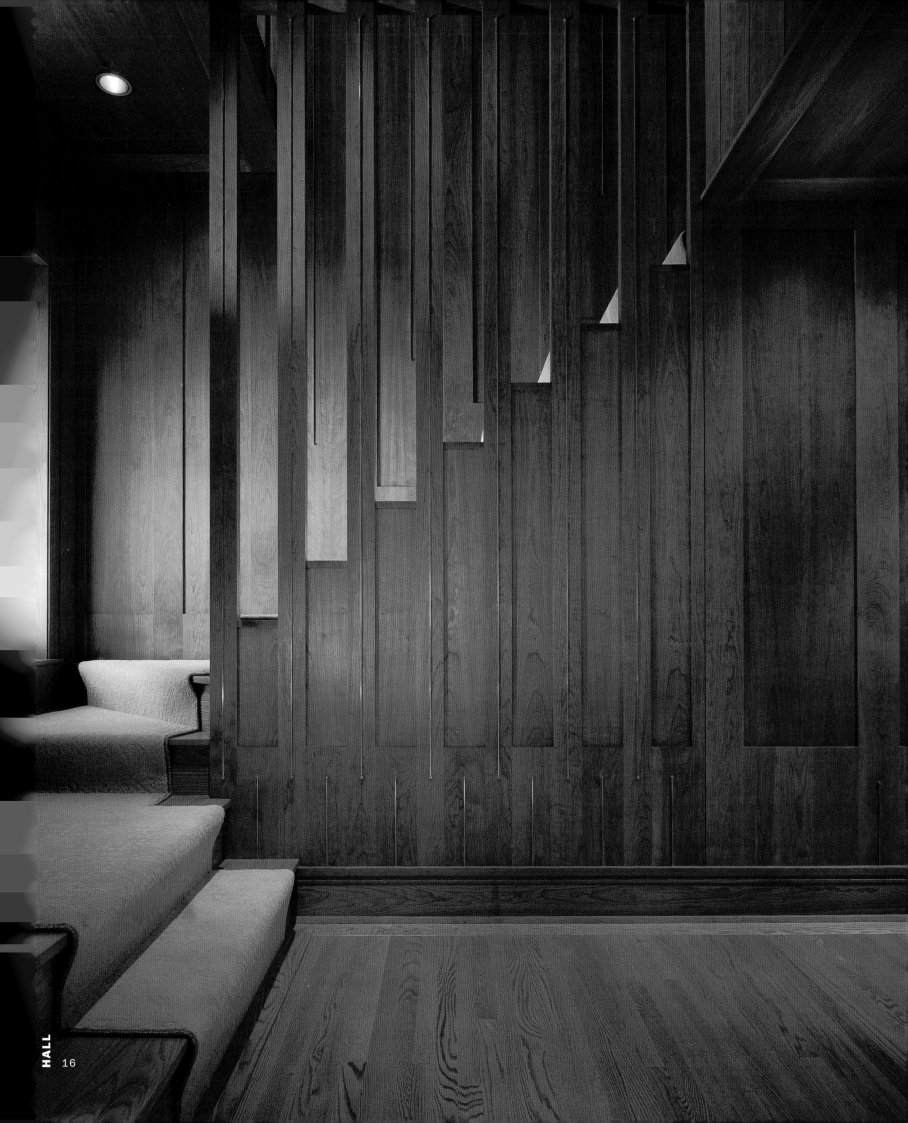

Seventy Years on the Higher Plane

Tony Hiss

In late 1999—at very much the same time that people at Hedrich Blessing Photographers, in Chicago, were beginning to select the exceptional and eye-opening images that are the true text of this book celebrating their first seventy years as architectural photographers— North American archaeologists were meeting in Santa Fe, New Mexico, to acknowledge that they had been blinded by theory for the past half century. Their long-held, abruptly abandoned assumption—called Clovis, for short—had maintained that the first human beings ever to arrive in the New World had been groups of hunters who had crossed a late Ice Age land bridge from Siberia to Alaska; chipped stone spear points left behind by this group, which are 11,500 years old, were first unearthed near Clovis, New Mexico.

But now it's clear, after several new discoveries, including the uncovering of a child's footprint in Monte Verde, in Chile, along with bits of stone, bone, wood, and fragments of hide-covered huts—incontrovertible evidence all at least 12,500 years old—that it's time to look again. In the sudden new freedom to see things afresh, numerous new "pre-Clovis" theories are rapidly being brought into the light of day; they propose multiple migrations to the Americas over many thousands of years, some from Siberia by land, some from Siberia by boat, and perhaps still others from Europe and even Australia. This was "the last time in history when people occupied an entirely new land," the *New York Times* has written, "with little more than their own ingenuity and an eye on far horizons."

"My God, this is an exciting time to be involved in research in the peopling of America," one archaeologist told the *Times*. Another archaeologist has been re-excavating a promising site in South Carolina—the first time around, he had stopped looking when he'd reached the Clovis level, after finding Clovis-era artifacts there just as expected. But now he's finding probable pre-Clovis traces directly beneath the spot he'd previously been digging in and had left behind. Why had he never dug deeper before? "You don't look for what you don't believe in," he told a reporter.

My God, this is an exciting time to be involved. You don't look for what you don't believe in. Here are two phrases that can illuminate our understanding of an earlier twentieth-century story—also a before-and-after tale; this one a Chicago-based story—about how and when and why blinders can be abruptly dropped by strong-minded professionals, and also about what happens next. The shift, instead of being from Clovis to pre-Clovis, moves from pre-Hedrich to Hedrich and thereafter. In this story, Ken Hedrich, a twenty-one-year-old photographer who opened his own commercial photography studio in downtown Chicago at the end of 1929, after a brief-enough apprenticeship shortened by the great stock market crash, listened not to the findings of his fellow photographers, but to the evidence of his own senses and his own inner promptings. In that new state he opened his eyes to the city and the world that was changing around him.

The hundreds of images Ken Hedrich made almost immediately; the tens of thousands more images he and his brother, Bill Hedrich (now eighty-six), and the small group he gathered around him during the next generation came to make; and the tens of thousands more images that have been made since then by an evolving and still small, tightly knit group of family members and outsiders clearly have changed the nature of architectural photography, redefining it as a business and enriching it as an art form. (The work in this book is drawn from more than half a million images exposed since 1929 by—amazingly—only nineteen Hedrich Blessing photographers.)

Writing in the early 1970s and thinking back to 1930, the New York architectural photographer Joseph W. Molitor (in his comprehensive textbook for students and fellow professionals, *Architectural Photography*) was still marveling: "The impact this young firm had on the profession over the next forty years is, without a doubt, one of the greatest in the history of all photography." Molitor found it impossible to see clearly ahead to the *what* or the *when* of another such transformation in the business: "There has not been any dramatic change in the style of architectural photography since 1930 and Ken Hedrich," Molitor wrote. Although, surely, "someday," he speculated, "another Hedrich will come along and view architecture entirely differently than any of us do today." At which point, he said, a golden age would be superseded by a diamond age.

Chicago's Century of Progress International Exposition of 1933 and 1934 became the first large-scale demonstration project for Ken Hedrich's perceptions, interpretations, energy, and enthusiasm. Chicago—rightly—has never been shy about celebrating its own remarkableness. At the first Chicago World's Fair, the city had rejoiced in its unprecedented growth and strength (despite the fire, it was the first metropolitan area in human history to anticipate late-twentieth-century population surges and accelerate from being a small settlement to a city that was home to a million people—among them an extraordinary colony of modern architects—in little more than half a century).

The Columbian Exposition of 1893, whose gleaming white, dreaming-of-Rome, colonnaded temples gave rise to a generation of national efforts to build the City Beautiful, fostered a heroic, only partly successful campaign to create an unprecedented and spacious civic precinct that echoed the Roman Forum at the heart of every industrial American city. The 1933–34 Century of Progress International Exposition, near Lake Michigan on the Near South side of the city, was a showcase instead for the kind of brand-new but already prospering, angular, exuberant, sleekly pared-down, Buck Rogers or Emerald City buildings that by then had, here and there, begun popping up within older American skylines. (Writing about Hedrich Blessing's 1930s' subjects in 1984, Robert A. Sobieszek, Director of Photographic Collections at George Eastman House, called this style of architecture European Art Deco, Depression Modern, and Streamline Modern.)

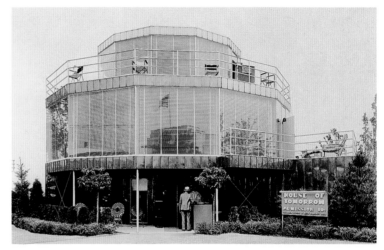

House of Tomorrow, Century of Progress
Photo: Kaufman & Fabry

An unknown photographer, an employee of Kaufman & Fabry, a Chicago architectural photography firm of repute for many years that had been named official photographers of the 1933 World's Fair, made the image shown here of the Century of Progress International Exposition's House of Tomorrow (designed by two young Chicago hotshots, architects and brothers George Fred Keck and William Keck). Working within the established traditions of what after the fact came to be called "documentary photography," this photographer set up his eight-by-ten-inch view camera at a point where he could take in as much of the building as possible, and exposed his image, a good, honest, workmanlike, interesting picture—a pre-Hedrich picture, as we would now say. The documentary assumption about such images was that, since they faithfully recorded—and each in its rightful place—every brick, rivet, windowpane, or doorknob of any given building's facade, they formed a complete visual record or dossier or abstract; an impartial,

archival summing up of a structure's meaning and function that hereafter posterity could retrieve, should it have a need to, like a fifty-year-old tax return. A memory aid. A point of reference. What was so different about Ken Hedrich's photographs of buildings from the very capable pictures that his contemporaries were taking?

A few words here about the underlying nature of photography: It's not that we have discovered in the years since this picture was taken that photographs can lie or distort, or that photographs are only subjective and partial—we had all those things figured out already. Instead, we've been finding, or working our way back to, something far more substantial, valuable, magical.

When it comes to photography, there were two genies inside the bottle. In the first hundred years after the invention of the camera, it seemed to many people to be one more of those dazzling new nineteenth- and twentieth-century machines, like a washing machine, say, or the telegraph or the telephone, gizmos that took on what had previously been human work, such as laundry or shouting to make our voices heard at distance (or writing letters for the same reason); the new machines, we thought, both did the jobs and the chores better, and got them done automatically and without complaint. (By the way, Louis-Jacques-Mandé Daguerre announced his magnificent invention to the world in the summer of 1839, which makes practical photography a hundred and sixty years old; since

Hedrich Blessing has just turned seventy, that means it has been part of the photographic world for well over two-fifths of that world's existence.)

This was the first genie of the camera: point and shoot, and there you were. Without your having to do anything more about it—except you or someone else taking care of developing the film and making the print—the riches of visual experience got reassembled on a piece of paper, right in front of your very eyes, it seemed. Then they were yours to keep, or make a few copies to hand around, or make more copies and sell. Traditional painting, as John Szarkowski, then curator of photography for the Museum of Modern Art, New York, pointed out a quarter of a century ago in *Looking at Photographs*, an immensely thoughtful book, "was slow, difficult, rare, and expensive, and was therefore only used to record things of great importance, such as religious sacrifices, kings and condottieri, ancient myths, and the rich." Photography, which was "quick, easy, ubiquitous, and cheap," could be used by almost anyone to "record everything." Which just about sums up the Industrial Age's concept of the purpose and function of genies—they brought into the lives of everyone (or at least into middle-class lives) resources, abilities, and amusements that formerly had been restricted to kings, priests, and the specially favored.

It even turned out that the first genie of the camera was far cleverer than anyone had suspected. It wasn't just faster at assembling masses of visual details than

painters could ever be (the lens is quicker than the hand), it was also rapidly undermining any pretensions to having mastered a complete and thoroughgoing understanding of the visual world. Eadweard Muybridge's early photographs from the 1880s, which showed in sequence how humans and animals actually move through space from moment to moment, brought forward, as Szarkowski noted, "many thousands of individual optical facts, almost all of which looked unfamiliar." This compelling new visual evidence made it painfully obvious that a trained painter, who in the nineteenth century had been taught ten or twelve perspectives for displaying a head or a hand, hadn't learned enough at all.

Because—and we now had incontrovertible photographic proof of it—all the time and every day the world presents us with and begs us to take in, cherish, benefit from, and revel in an almost infinite range of perspectives and circumstances, artists "never really painted what they saw," art historian E. H. Gombrich wrote, summing up the prephotographic situation. "They painted rather what they had learned to paint." We thought at first that the camera showed us *everything*.

We then quickly saw that it left something out— information, or feelings, or both. By its very nature, it had to omit many things. It made a two-dimensional representation of a three-dimensional world; worse, it made a *one-eyed*, two-dimensional representation of a three-dimensional world we get to see the full three dimensions of because we've been gifted with binocular vision, and so have always had depth perception at our command. Even more reductively, a photograph shows us only an instant from life: it's a two-dimensional slice of a four-dimensional universe that, moment after moment, ceaselessly unfolds and evolves.

Prodded by Muybridge and others, we gradually began to catch up with the idea that we needed to rethink and resee, and vastly expand our notion of what *everything* means, and how much it has in it, when we talk about being able to *see everything*. Our conventional assumptions about reality and our long-ingrained habits of looking, sometimes mixed with carelessness or laziness, had led us to acknowledge only a fraction of what actually meets our eyes. *You don't look for what you don't believe in.*

Perhaps it was inevitable that photography has taken such a long time to get used to, since as an interface with visual reality the camera is truly an odd device. Rather than serving as the mechanical equivalent of an eye, it's much closer to being the opposite of normal vision. People see between blinks; a camera sees only during a usually short flicker of sight and is blind or asleep the rest of the time.

The second genie of the camera—the one that's taken us longest to come to terms with—is based on the insight that when we look at a photograph we're actually in a way looking at more than everything. While our eyes are seeing the buildings or objects or the life or people in any photograph, our mind is also directly

gazing at the workings of another mind: the focus, the noticing, the attention, the choices (conscious and unconscious), the aspirations and intentions, the accomplishments, and the degree of understanding present within the man or woman who framed the photograph in front of us. We can't see whole minds, of course, but we can know some of what and who that photographer once was, at least during a single moment, now already some time back—a day or a week, a decade or a lifetime ago—when an image in front of one camera mattered enough to that one mind and set of eyes so that the shutter got pressed.

What makes it possible to see so penetratingly when looking at a photograph? *The Nature of Photographs*, a recent book by the contemporary American photographer Stephen Shore, greatly helps disentangle the matter. After a lifetime of careful noticing, Shore has found that even when we think we're only glancing casually at an ordinary snapshot, our minds are involved in a complex process of sampling and evaluating each of four fundamental choices that go into the taking of every photograph: choosing where to stand (finding a vantage point); choosing what to include and what to leave out (framing the picture); choosing when to take the picture (selecting just one moment, a time of day, or an arrangement of lighting conditions from among all possible times and conditions); and choosing whether to bring the foreground or the background into focus (a picture's so-called plane of focus).

Sometimes photographers make these choices slowly and deliberately; at other times they occur in the instant and are seemingly beyond the reach of conscious awareness—just as the viewer's attention may be offhand and momentary, or absorbed and contemplative. In both cases, noticed or not, minds are at work. "Focus," Shore suggests, "is the bridge." It is, first of all, a bridge within a picture "between the mental and the depictive levels: focus of the lens, focus of the eye, focus of the attention, focus of the mind."

Focus crafts a far longer bridge, as well. Whenever we, as viewers, take the time to notice what's happening within ourselves as our eyes and minds roam across a photograph, in such a moment of private and quiet concentration we unerringly come into contact with the attention and focus of the mind that formed the photograph.

In other words, photography, strangely, is as much like telepathy, or at least a small slice of it, as it is like telegraphy. Every exposure made is in this sense a double exposure, because, if we let it, it can show us an inside as well as an outside. A telephone extends the reach of our physical abilities by carrying our voices and our ears out to faraway places, but it doesn't teach us to listen better or to speak more wisely. It amplifies us, rather than changes us. A camera can refine our perceptions so that we get more out of ordinary looking.

Francis Whitaker, a renowned American artist/blacksmith who in the mid-twentieth century, at forges

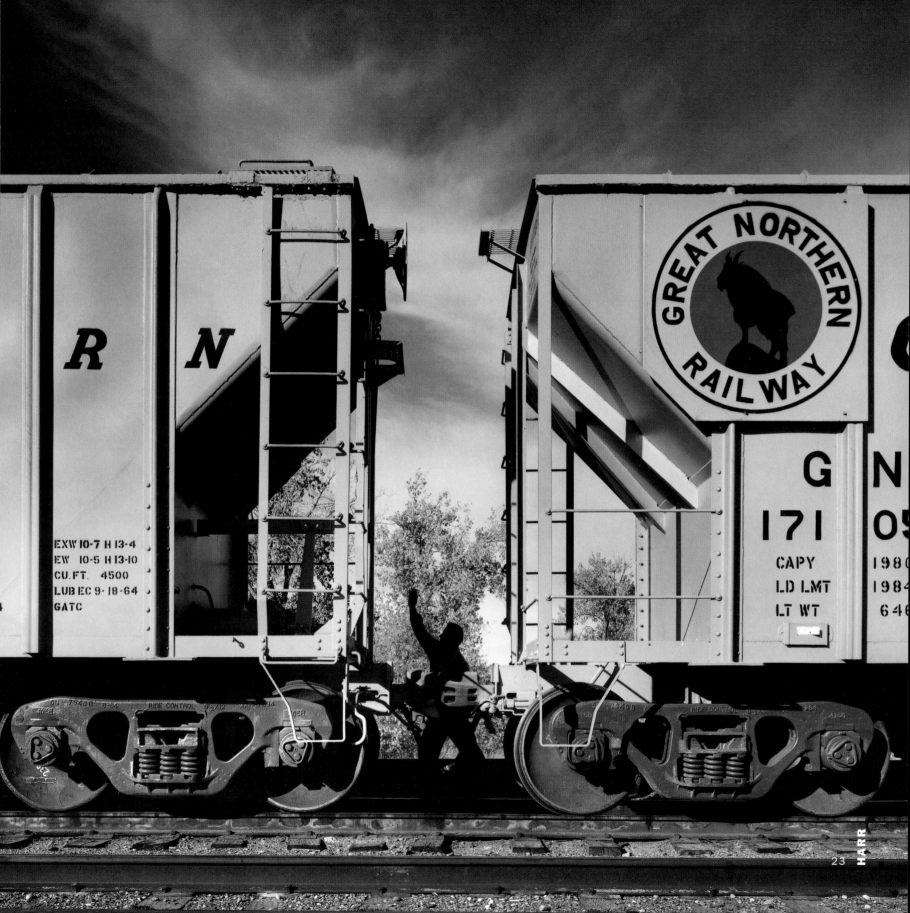

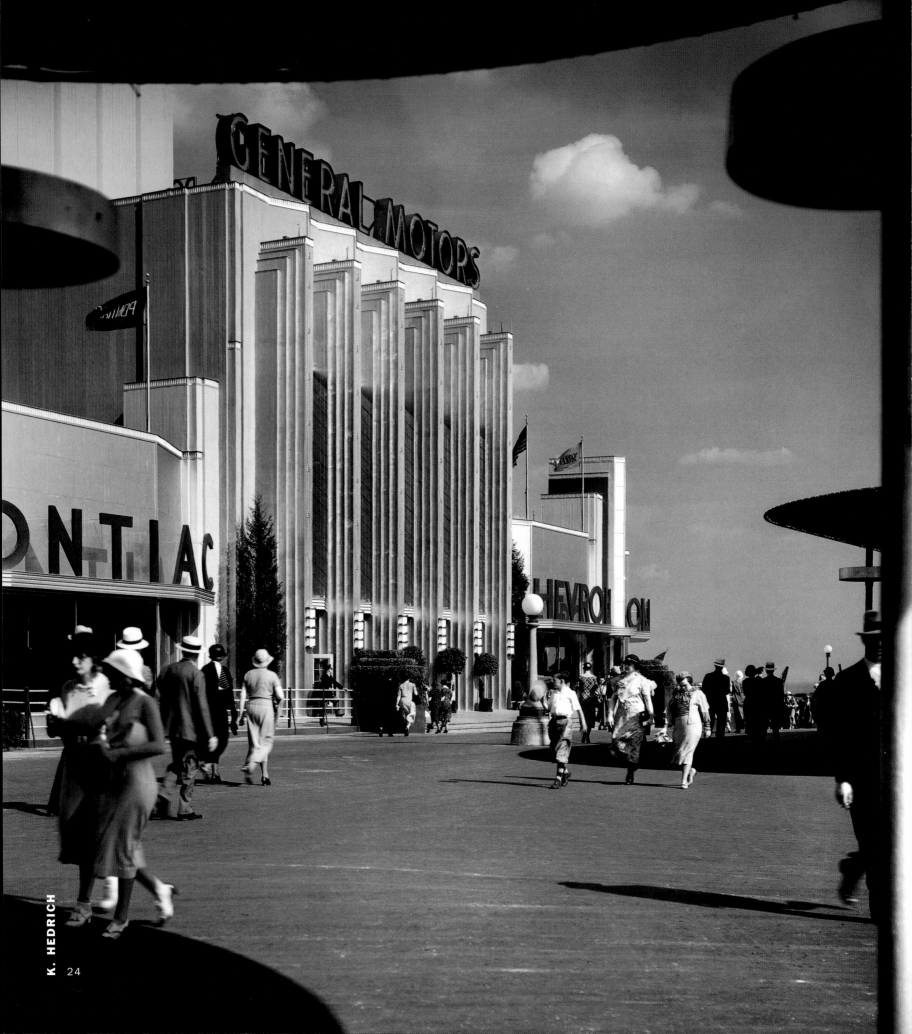

24

in Carmel, California, and in Aspen, Colorado, almost single-handedly kept alive the techniques of handmade decorative ironwork, used to tell his students that hand-eye coordination, which they thought they were aiming at, was a waste of their time and energy. It was hand-eye-*mind* coordination that would lead them beyond apprenticeship to mastery—and that, as they progressed, would help them create work that people would want to live with and keep close at hand, to look at again and again. Because that way mind can speak to mind.

All of which brings us straight to the core of Kenneth Arthur Hedrich's genius as an architectural photographer. While still in his early twenties, and with little formal training at his command, he learned how to make two minds visible within the same picture: the mind of the photographer and the mind of the architect whose building he was photographing. The photographer became a relay point, a beacon, a revealer of an architect's innermost purposes; the "design intent" is what Nick Merrick, one contemporary Hedrich Blessing photographer, calls it. For Jon Miller, another current Hedrich Blessing photographer, it's the "Big Idea."

This means both a real-life building as it has been brought to completion, and the spark that gave rise to it: that first crystallization of thought and form and feeling that sprang into the architect's mind back when it was time to start thinking about what might be built and how it could be shaped.

Or, to use the words of the citation that accompanied the Fine Arts Medal, a gold medal that the American Institute of Architects presented to Ken Hedrich in 1959 (forty years later, the certificate still hangs in the reception area of the Hedrich Blessing offices just north of the Loop): "Instead of recording a mere image, you have etched in film the elements of architectural personality. With your sympathetic interpretation, you have achieved the higher plane of active collaboration with the architect."

Take another look at the anonymous Kaufman & Fabry photographer's 1933 shot of the House of Tomorrow, and then look at Ken Hedrich's image from the same year of the same building. (The Hedrich picture, while exceptional, is not one of the highly dramatic Century of Progress photographs he made, like his nighttime shots of the Chrysler Building pavilion, that people at the time got most excited about. But this picture suits our purposes better, because it shows how, once having found the higher plane, that was where he took his stand; it was his vantage point, and it defined his approach to any exposure made thereafter.)

There are many ways in which these two 1933 photographs seem to be almost the same picture: both of them are conscientious and yet slightly informal portraits that painstakingly show as many facets of this odd, ten-sided structure as possible, while at the same time almost casually incorporating several fair-goers who are either lounging or standing around,

House of Tomorrow, Century of Progress
Photo: Ken Hedrich

It's the work of a man whose job quite clearly, as Bill Hedrich remembers in his 1994 "Oral History of William C. Hedrich," part of the Chicago Architects Oral History Project, was to "stand up in front of every exhibit and take a picture." Which meant one shot for the reassembled Fort Chicago (the only buildings anywhere near the Loop in 1830) and one shot of the House of Tomorrow—with the same attention to each. So it's not a picture of a house; it's a picture of an attraction, an exhibit, a curiosity, a pastime. A *ride*. Something that could be disassembled overnight, and indeed is already fading into the hazy, too bright sky.

"We didn't do any of that," Bill Hedrich goes on to say. Ken Hedrich, using the same elements, made a picture of a real house. No signs, no ticket booths; you're asked to come to terms with the structure itself. The windows are largely opaque, but you get glimpses into some of them, and even out the other side. You can begin to think, as when looking into the windows of any real house, about the partly hidden, partly transparent lives that are already unfolding within. This is subtle, skillful work and gets us right to the truly innovative part of the picture; it shows us how closely attuned Hedrich had become to the Big Idea here. He knew how this structure had been designed, he saw what the Kecks had been thinking about it.

To photograph the House of Tomorrow and also to show the context within which it had been conceived, Hedrich's assignment had to include showing "tomorrow"

and certainly not doing much of anything. There are also lots of chairs and other pieces of patio furniture scattered about quite idly. Both pictures are firmly grounded in a less-than-imposing real-world setting of newly planted and still rather scraggly shrubs and trees.

The Hedrich picture is immediately far more eye-catching than the Kaufman & Fabry picture; Ken Hedrich has searched for and found a moment when the facade of the house, darkened by shadow, clearly stands apart from, and announces its presence to, the Lake Michigan sun and sky. But that's not the essential difference between the two photographs. The Kaufman & Fabry image is locked—or, in terms of any Hedrichian potential, mired—within the real-time context of the fair itself. The "ADMISSION 10¢" sign is the most crisply defined detail in the picture; two windows catch reflections of the pavilions just behind the camera.

with the same faithfulness it shows "house." He had to find a way to photograph tomorrow itself—a tomorrow that happens already to have a house in it, and probably many more houses, as well. That's where the Keck brothers had been—not in a "what if" place, like an amusement park ride, but out on a planet with gravity, materials, needs, ideas, and no structures at all to begin with. Then you almost had to work backward to the present to build something for the World's Fair: What did those people have back then that we could use up here in tomorrow to assemble a house for our time? Oh, yes, venetian blinds, steel staircases and railings, etc., etc. And so the building came into being.

But how do you photograph tomorrow? Ken Hedrich, who lived as firmly in the present as anyone on staff at Kaufman & Fabry, prowled around the House of Tomorrow until he found a single spot—around in back, almost exactly, as it happened, opposite the place where the Kaufman & Fabry man had stood—where the world had been wiped clean of today and its shortcomings, and showed only those things that have always been there for Chicagoans and always will be (or near enough to always for any tomorrows we can hope to live into): bright sun, huge lake, endless sky.

Since it's a real house in a could-soon-be-real tomorrow, the four people in the picture become not lounging fair-goers, and not extraneous extras whom Hedrich couldn't shoo away at the moment when the sun was right. They're inhabitants of tomorrow, proof of its existence, comfortable in its reality. As they gaze down on us (they're up on elevated decks, but Hedrich has also managed to make the house look as though it has been sited to command the top of some small eminence), they're also looking back to us. Looking up toward them, like small children gazing in wonder at a teenager, we're invited to think about who and what we ourselves might become.

That's why the picture still works, long after the particular tomorrow that the Kecks had projected themselves into has been debunked, superseded, largely forgotten.

There's also so much hope in the picture, and such respect for each assignment—a young man's enthusiastic welcome for the next steps in architecture and the verve of the chance takers, probably the only aspects that Ken Hedrich himself would have felt comfortable talking about. Paul Strand, in 1917, said that an honest photographer's work was rooted in "a real respect for the thing in front of him," and some sixty-five years later, Strand amplified that famous remark by telling an interviewer that he had always tried to express that respect by "much looking and simple being there" before photographing whatever region or country his travels had taken him to.

That would have made sense to Ken Hedrich, whose assessment of his own talents was sturdy, down-to-earth, succinct, and misleadingly prosaic. His youngest brother, Jack Hedrich, says that "Ken's esthetic was always covered in axle grease." Ken Hedrich was such an excellent businessman that in his own mind he was always able to explain his own actions simply as sound business decisions. His son, Jim Hedrich, himself now a Hedrich Blessing photographer, says that his father's best friends were Chicago CEOs who told him—accurately, probably—that he could have been one himself. He owned five blue suits and sixteen white shirts, and that's what he wore when he took pictures; on evenings and weekends he played cutthroat bridge and cutthroat pinochle with his brothers or went duck hunting with them. (Jack Hedrich, who in 1993 retired as the firm's nonphotographer managing partner, took on that role after the death, in 1976, of a fourth Hedrich brother, Ed. Ed had taken over from Henry Blessing, who moved to California in 1931 when the firm was still so young and poor that it seemed a crime to change the name, because that would require printing up new stationery.)

So Ken Hedrich, by his own definition, wasn't a mind-reader; he was a salesman who was clever enough and energetic enough to have figured out that if you talked to an architect, especially a young man trying his hand at the latest thing, you could find out what the man liked best about his own work, and then you just went out and spotted it and shot it and made a presentation print of it. If it took you three hours and never-before-needed technical ingenuity to get the one shot the client was thinking about—well, that just guaranteed repeat business.

It was also true that the Hedrichs, extraordinarily, had found a way to beat the Depression. Bill Hedrich, in his oral history, can still feel the hope and excitement that moved him sixty years before: "The fair kept us busy in the middle of the Depression. In the middle of the Depression, 1933–1934, we were busy night and day. What a blessing that was!" When his interviewer asks if the fair had been of true value, "because in the middle of the Depression here is this big splash when many people were having a hard time," Bill Hedrich's response is emphatic and still appreciative: "But look what it did. Look at the architecture it created. Look at the jobs it created. Look at the things when we were all grasping for a straw. The light at the end of the tunnel. I mean, it was wonderful."

Photography, early in the nineteenth century, opened its eye on the world just before that world began to change beyond all recognition, moving from a population of less than one billion to a population (at the moment) of six billion on its way to ten billion before it will probably start to level off. Architectural photography as a discipline is only a minute fragment of the world of photography, and Hedrich Blessing photographers are an even smaller subset, a niche within a niche. Most of their commissioned work records a special,

passing moment in the life of a building, those hushed few days when the contractors have moved out and the new tenants have yet to move in. It's like a wedding portrait, or a commencement picture—a building just before it begins to play its part as a shelter, a second skin for people.

It's also like a nature photograph—to find a moment that expresses a Big Idea, you have to wait around not so much for a shy animal to show itself, but for something much huger, "for further earth rotation to take place," as a New York architectural photographer put it.

Because of the nature of post-Hedrich architectural photographs, what a wealth of information we now have about the world we're trying so hard to make and not lose. Just at the moment we need all the help we can get.

My God, this is an exciting time to be involved. This explains the carefulness, the craftsmanship, and perhaps also the formality and the endless technical inventiveness with film and lights and lenses that have characterized the work of successive Hedrich Blessing photographers over the last seventy years. It can explain why work for the bold young Chicago architects of the 1930s—like the Keck brothers and John Wellborn Root, Jr.—led to work with the internationally known masters of twentieth-century American architecture: Frank Lloyd Wright, starting in the 1930s, Eliel Saarinen in the 1940s, and Mies van der Rohe and Skidmore, Owings & Merrill in the 1950s; and to the interior architects who, in the 1970s, broke away from established architectural firms and set up their own greatly successful companies. And to all the other sub-specialties that Hedrich Blessing photographers made their own over the years: product photography, industrial photography, editorial photography for magazines. Clients such as Meredith (publishers of *Better Homes & Gardens* and many other magazines) and USG (formerly U.S. Gypsum), have been firmly loyal, staying with Hedrich Blessing for more than sixty-five years.

It explains the *outwardness* of Hedrich Blessing, but doesn't explain the hidden coherence of Hedrich Blessing, day to day, generation to generation—coherence best exemplified by "the sharing," as Hedrich Blessing photographers refer to it, and by "the transition," Jack Hedrich's term. Hedrich Blessing, uniquely within the world of architectural photography, where every practitioner either goes his or her own way, or has some kind of loose contractual arrangement with a booker, has evolved as a modern, freestanding, self-training guild: every Hedrich Blessing photographer who goes "on camera," as the firm calls it, has completed an apprenticeship to two or more Hedrich Blessing photographers who themselves learned the business as assistants.

Between assignments comes the sharing: grouped around two large light tables, the "on camera" photographers lay out their latest work, critique each other,

exchange techniques, pass on hints. "It's by far our biggest asset," says Bob Harr, originally a Ken Hedrich assistant, who's been on camera for forty-two years. "We're in competition with the world, but never with each other. It maintains a standard of quality." "Everybody is delighted to share what they know with everyone else," says Jim Hedrich.

The transition is perhaps even more remarkable: without losing its own design intent, or Big Idea, Hedrich Blessing in its most recent quarter century has managed to move from being exclusively a family-owned business to being a partnership of professionals only one of whom is a Hedrich—Jim Hedrich. Outwardly, at least, they are united only by the renewed interchange of the sharing and shared memories of their own apprenticeships (hauling around up to a thousand pounds of cameras, lights, and lenses for a Hedrich Blessing photographer already on camera).

Inwardly? Look at the glorious, supple, subtle, caring, and at times infinitely attentive images in this book to see the connectedness that has held nineteen different photographers together for the last seventy years. Focus is the bridge. Mind is speaking to mind. You can look for what you believe in.

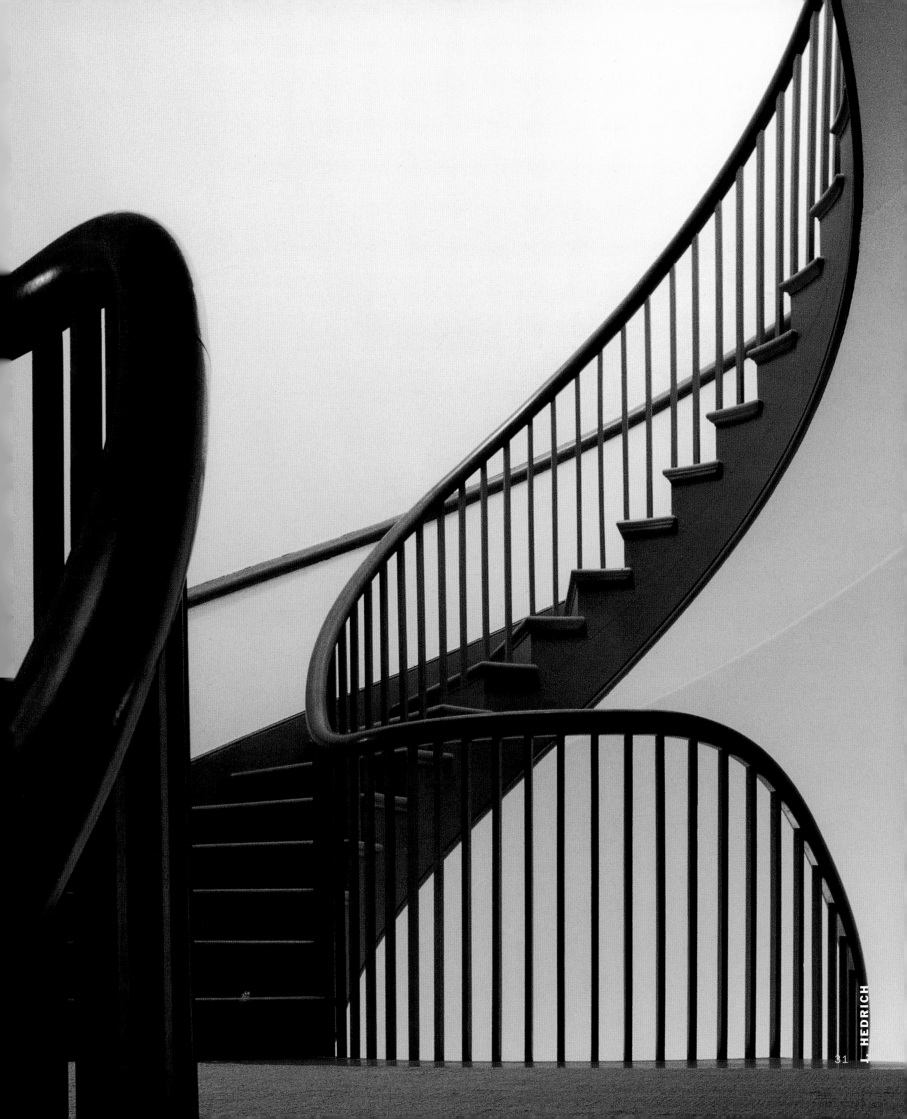

J. HEDRICH

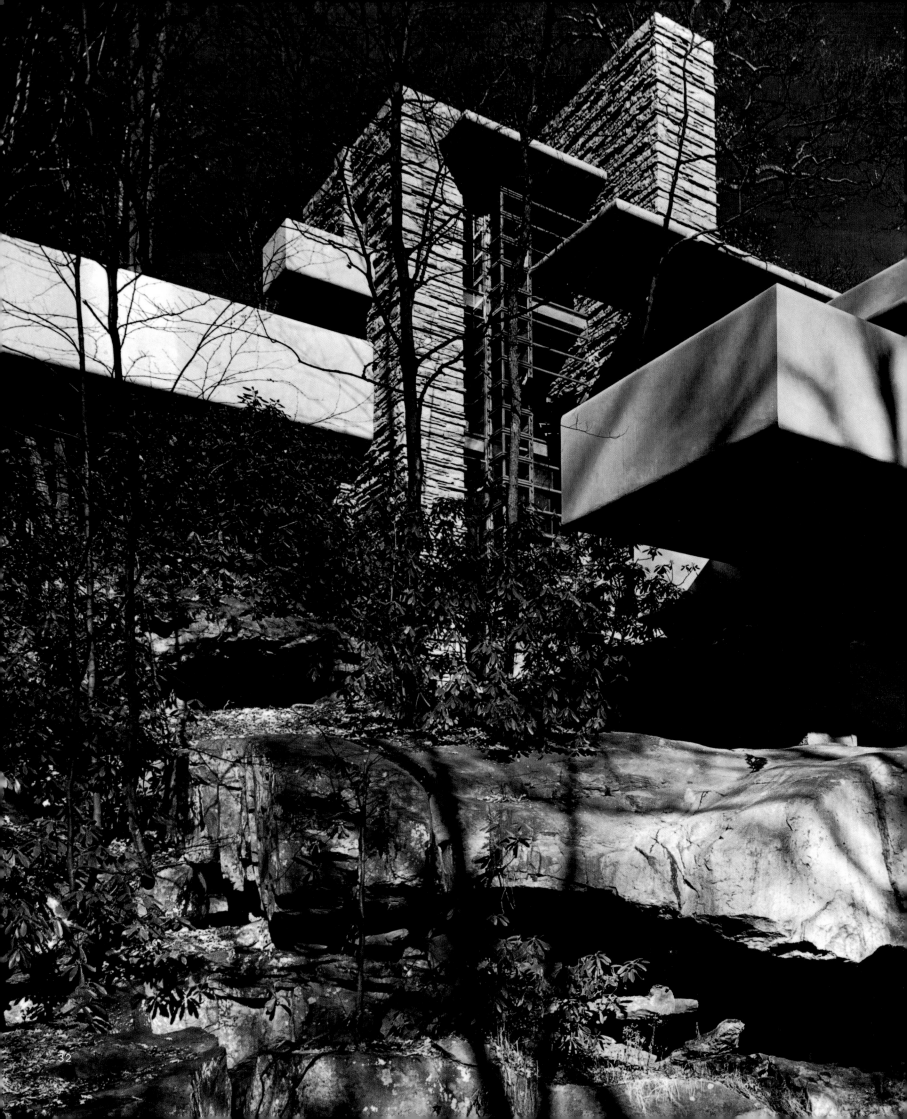

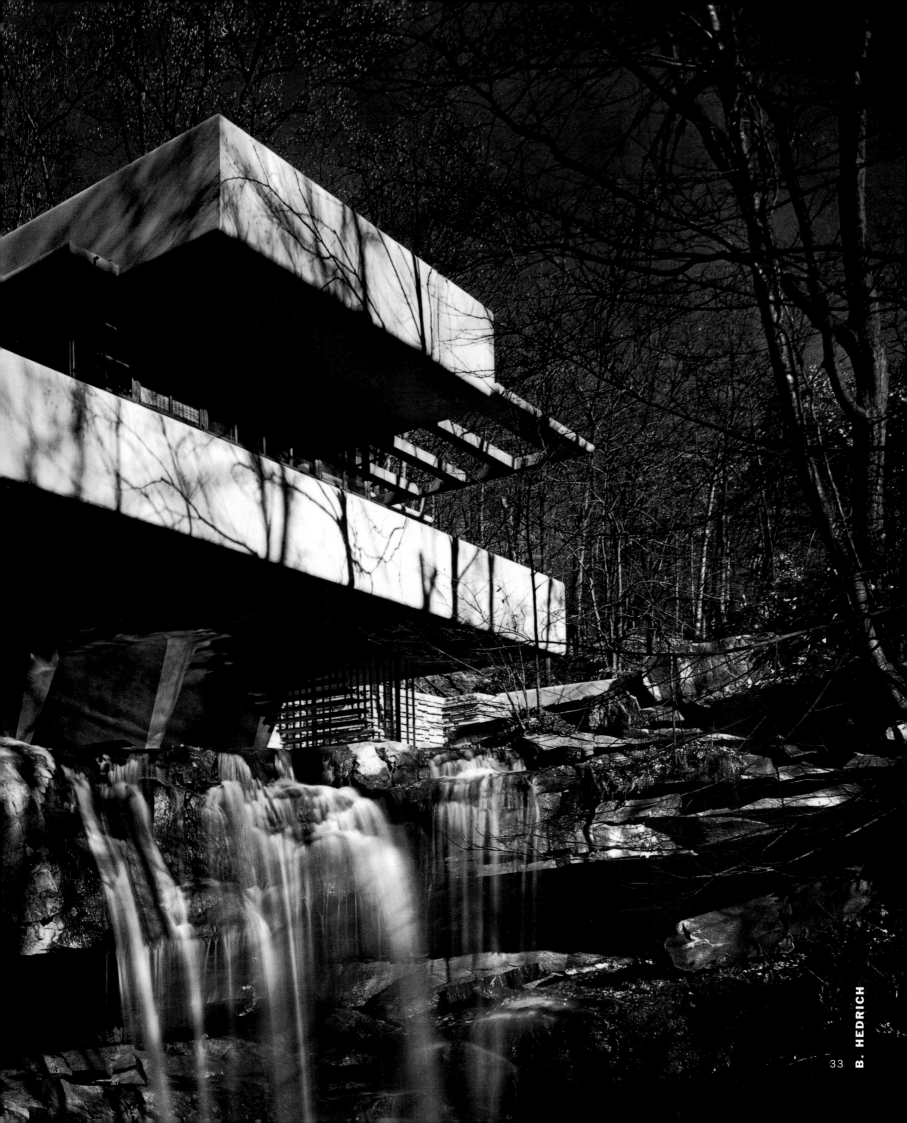

33

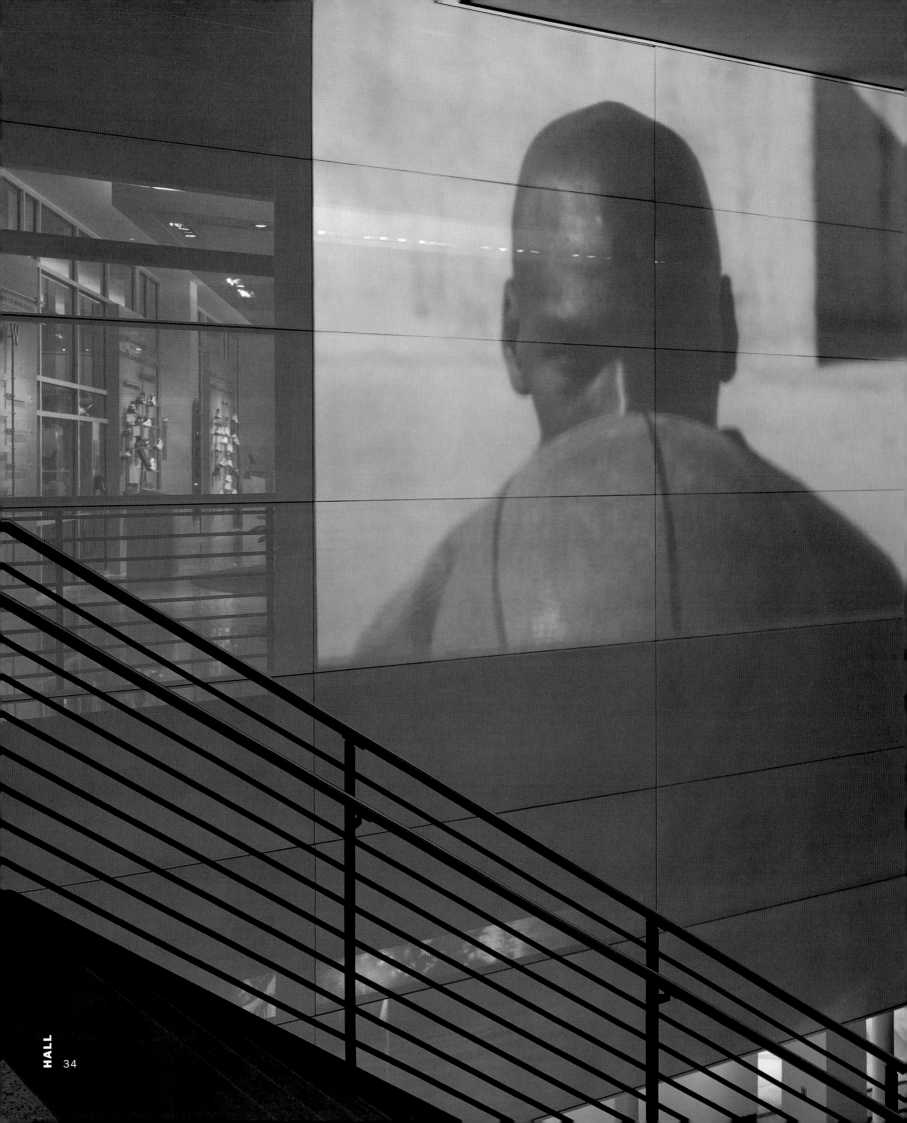

16 **STEVE HALL**
1990
Private Residence
Chicago, Illinois
Architect: Quinn and
Searl Architects

23 **BOB HARR**
1965
Great Northern Train Yard
Great Falls, Montana

24 **KEN HEDRICH**
1933
General Motors Building
A Century of Progress
International Exposition
Chicago, Illinois
Architect: Albert Kahn

31 **JIM HEDRICH**
1971
Shakertown
Pleasant Hill, Kentucky

32–33 **BILL HEDRICH**
1937
Edgar Kaufmann House
("Fallingwater")
Bear Run, Pennsylvania
Architect: Frank Lloyd Wright

The shoot was difficult because of the nature of the structure, which rises from a waterfall in cantilevered steelbeam-supported terraces. The building is about three stories high, and the best place to take the photograph was from the middle of the very cold stream. So we went into town and bought some waders.

When Frank Lloyd Wright saw the image, he initially critiqued it as rather "acrobatic." But it was later to become his favorite perspective on the Kaufman residence. Indeed, this picture is reputed to have given the residence the name "Fallingwater."

34 **STEVE HALL**
1999
Niketown
Miami, Florida
Architect: Nike Design Group

41 **BILL ENGDAHL**
1964
Everett Dirksen
Federal Building
Chicago, Illinois
Associated Architects:
A. Epstein & Sons, Inc.;
Mies van der Rohe;
C. F. Murphy Associates;
Schmidt, Garden & Erikson

42 **KEN HEDRICH**
1930
Board of Trade Building
Chicago, Illinois
Architect: Holabird & Root

The commission to photograph the newly completed Chicago Board of Trade building in 1930 was the first major architectural photographic assignment performed by Hedrich Blessing. John Wellborn Root, principal of Holabird & Root, was influential in steering Ken Hedrich toward the practice of architectural photography.

43 KEN HEDRICH

1932

The Field Building

Chicago, Illinois

Architect: Holabird & Root

Completed in the depth of the Great Depression, the Field Building was the last major high-rise building to be built in Chicago before World War II. Not until the Prudential Building was built in 1953 was there another period of significant "skyscraper" architecture in Chicago.

44 BOB SHIMER

1996

Ackerman McQueen

Advertising

Dallas, Texas

Architect: Rand Elliott

45 SCOTT MCDONALD

1985

College of DuPage

Glen Ellyn, Illinois

Architects: Wight & Co.

46–47 BOB HARR

1983

Large Upright

Internal/External Form

Three 1st National Plaza

Chicago, Illinois

Sculptor: Henry Moore

48–49 NICK MERRICK

1986

McCormick Place Annex

Chicago, Illinois

Architect: Skidmore,

Owings & Merrill

Design Architect: Bruce Graham

The Annex is a separate building in the convention complex, south of the Chicago Loop. It is one of Bruce Graham's last projects to be built in Chicago, and in his typical fashion, it is a unique design and engineering solution. To create large freespan spaces for the convention hall, the roof structure is suspended from cables hung from large pylons. I realized that the visual story of the building was to be told up on the roof. My assistant and I lugged our camera gear up stairs and through a roof hatch, and I was surprised to see the Chicago skyline three miles away, spread out before me. Bruce Graham's masterpiece, the Sears Tower, was in direct relationship with the tapered skyscraper-like pylons.

50 **KEN HEDRICH**
1942
Curtiss-Wright Plant
Buffalo, New York
Architect: Albert Kahn

*Wartime security measures
prohibited Ken Hedrich from
making photographs that
revealed details of U.S. fighter
planes. The result of that
proscription was this powerful
silhouetted composition.*

51 **NICK MERRICK**
1993
O'Hare International Terminal
Chicago, Illinois
Architect: Perkins & Will
Design Architect: Ralph Johnson

52 **MARCO LORENZETTI**
1996
Zorn Residence
Chicago, Illinois
Architect: Krueck and Sexton

53 **MARCO LORENZETTI**
1993
Stainless Steel Apartment,
860 North Lake Shore Drive
Chicago, Illinois
Architect: Krueck and Sexton
Building Architect:
Mies van der Rohe, 1950

54 **KEN HEDRICH**
1930
Lobby, A. O. Smith Building
Milwaukee, Wisconsin
Architect: Holabird & Root

55 **KEN HEDRICH**
1942
Statler Hotel
Washington D.C.
Architect: Holabird & Root

56 **STEVE HALL**
1997
Attic Club, LaSalle National
Bank Building
Chicago, Illinois
Architect: David Adler, 1934
Renovation Architect: VOA
Architects, 1997

*My father worked in the LaSalle
National Bank Building
(formerly the Field Building) for
over twenty-five years, so the Attic
Club held for me friendly ghosts.
This shot is a conscious tribute
to several stairwells photographed
by the founding photographers at
Hedrich Blessing.*

57 **KEN HEDRICH**
1942
Morton May Residence
Ladue, Missouri
Architect: Samuel Marx

Photo: Engdahl

*We drove out to Plano, Illinois
on a day late in the fall of 1985
to shoot the famous glass and
steel house on the Fox River,
which I had seen in my mentor,
Bill Hedrich's, photographs.
Arthur Drexler, the Curator of
the Mies Archive at the Museum
of Modern Art, wanted pictures
of the house for a show that the
museum was assembling in New
York on the master architect's
life of work. The actual reason
they wanted the house re-
photographed had to do with the
way the curtains were arranged
in the original photographs. In
some views, the curtains masked
the view through the corners of
the house. It was Jack Hedrich
who pointed out to Mr. Drexler
that Mies, himself, was present
at the original photography
session, and suggested that this
must have been the way Mies
wanted the house rendered. But
Drexler was not as concerned with
the history of the matter as he
was with capturing on film that
transparent effect that is so much
about Modernist architecture.*

68 **BILL HEDRICH**
1959
Air Force Academy
Colorado Springs, Colorado
Architect: Skidmore,
Owings & Merrill
Design Architect: Walter Netsch

69 **BILL HEDRICH**
1958
McGregor Hall
Conference Center,
Wayne State University
Detroit, Michigan
Architect: Minoru Yamasaki

70–71 **SCOTT MCDONALD**
1986
Clark Memorial Fountain,
Notre Dame University
South Bend, Indiana
Architect: John Burgee with
Philip Johnson

72 **KEN HEDRICH**
1933
St. Paul County Courthouse
St. Paul, Minnesota
Architect: Holabird & Root

73 **KEN HEDRICH**
1930
A.O. Smith Building
Milwaukee, Wisconsin
Architect: Holabird & Root

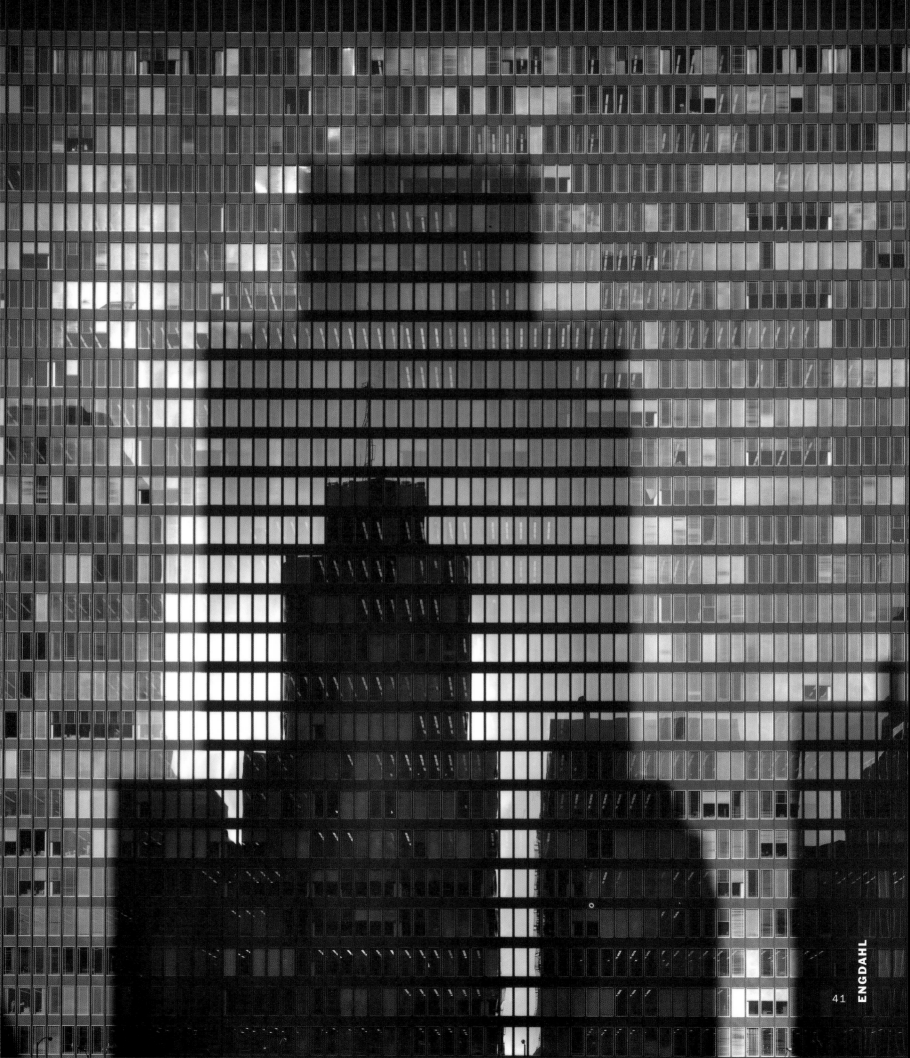

ENGDAHL

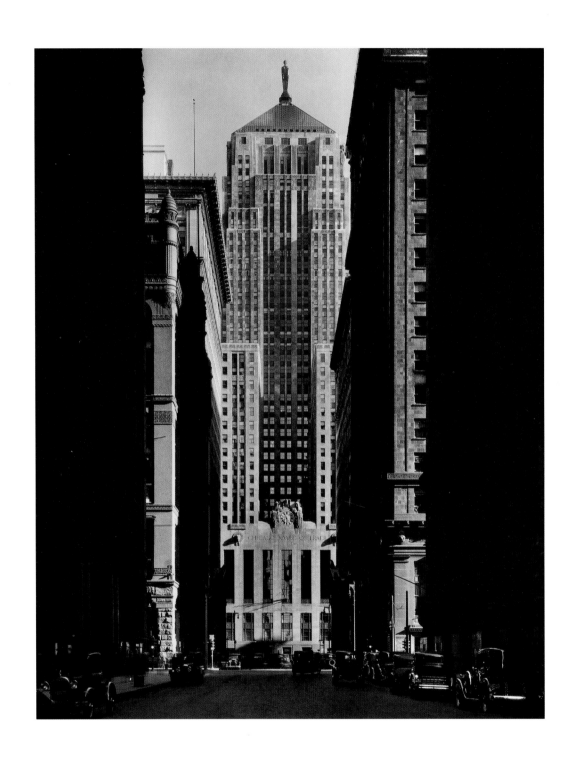

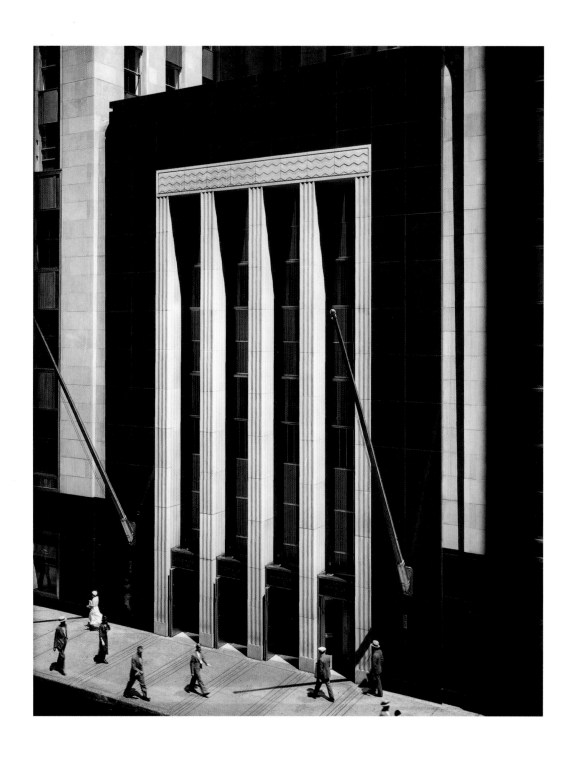

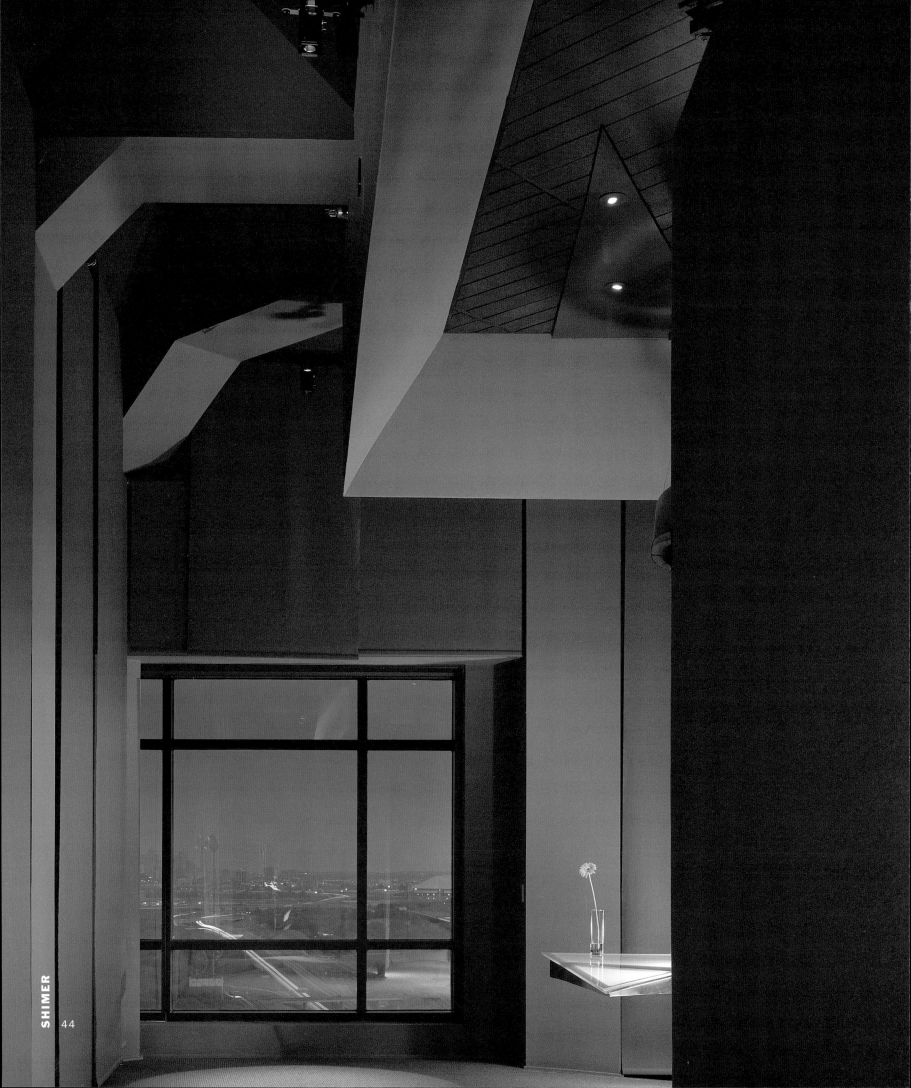

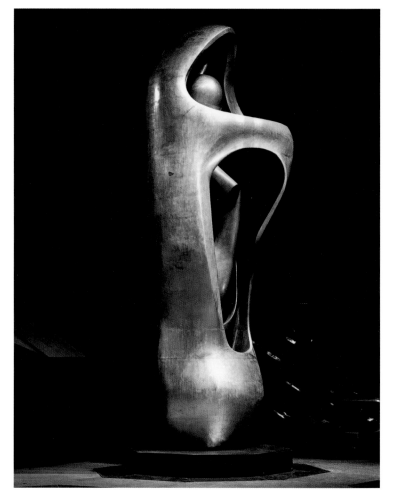

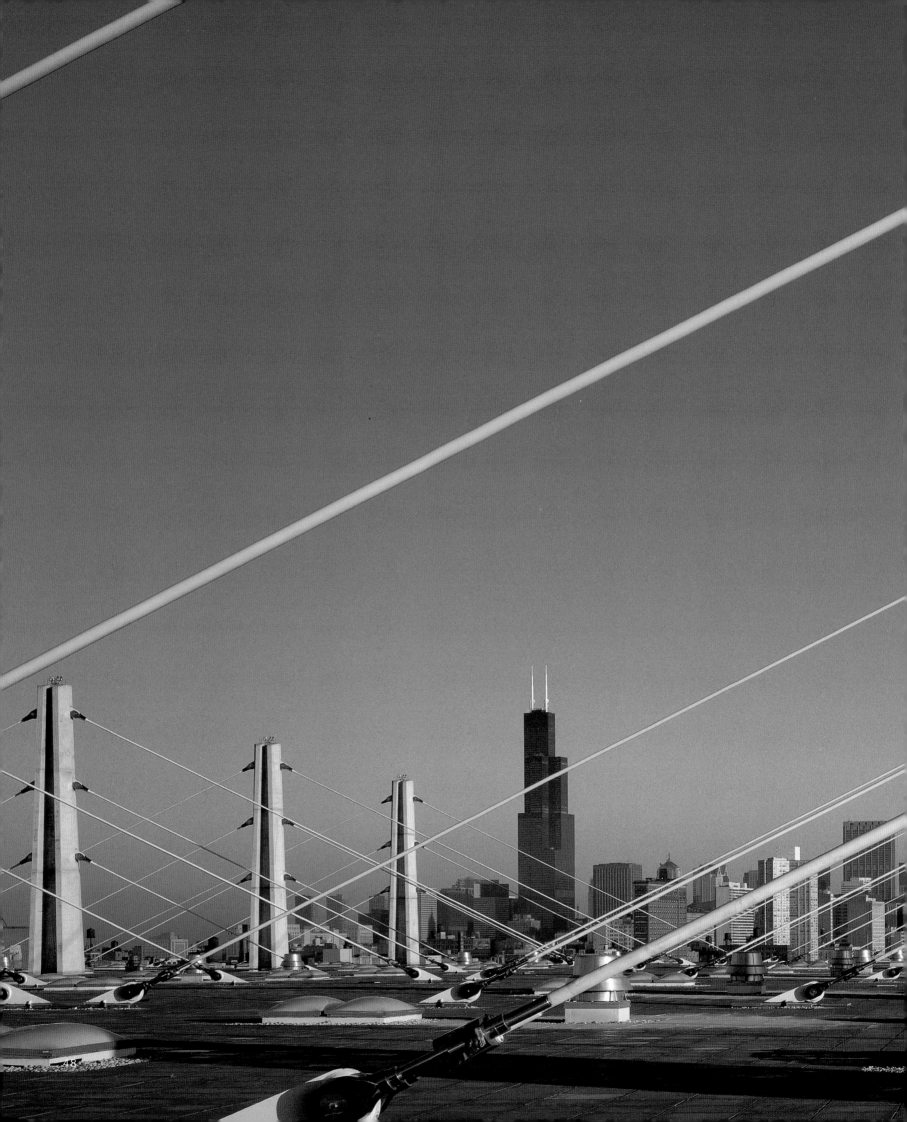

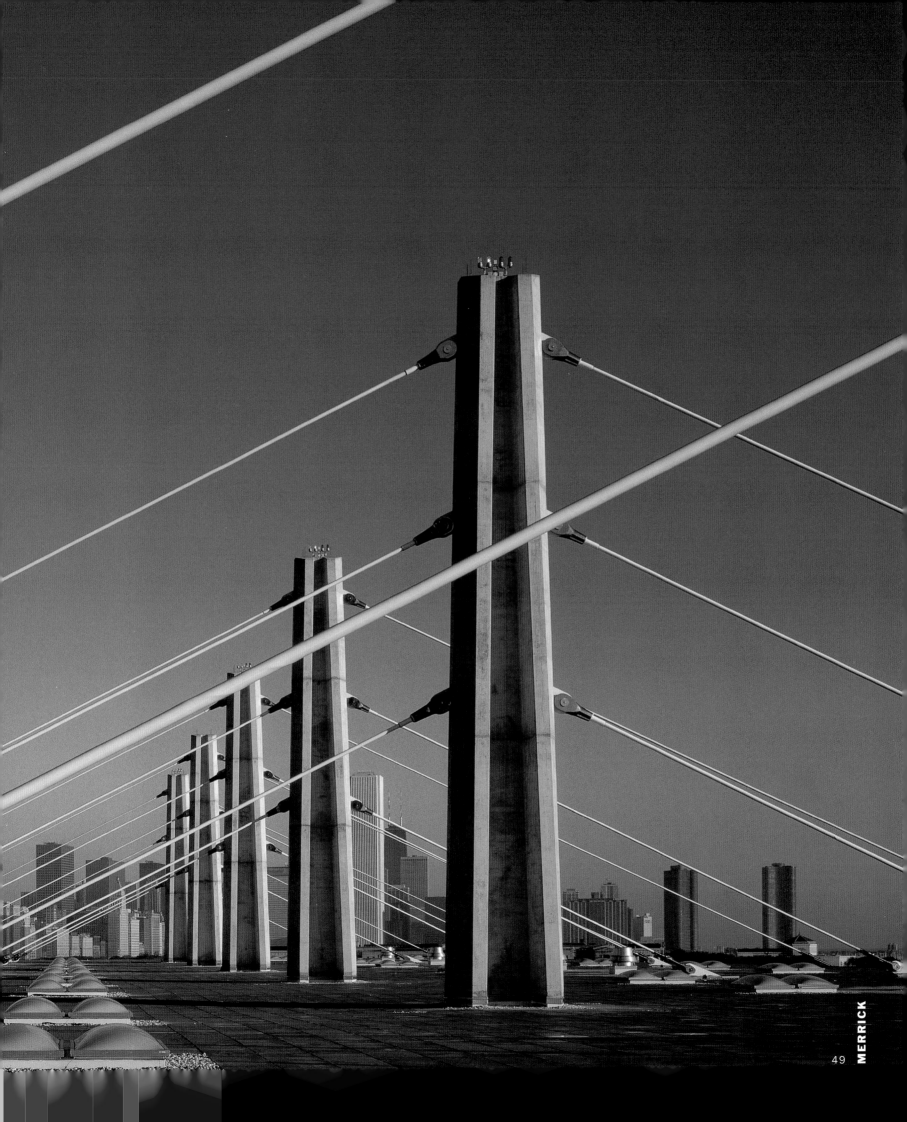

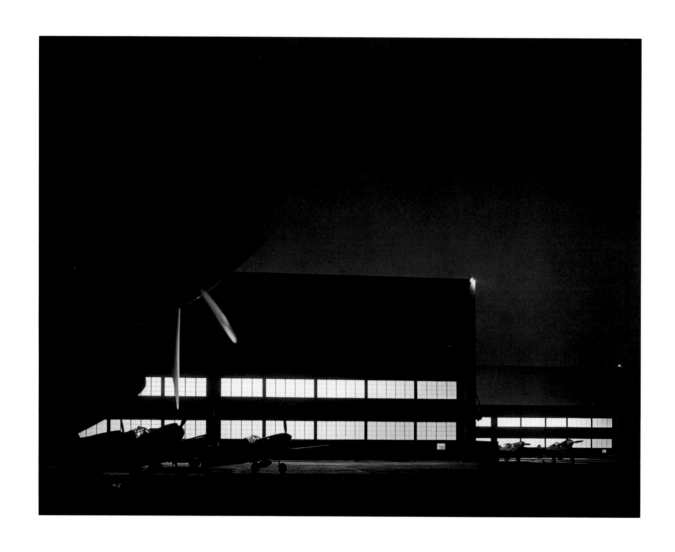

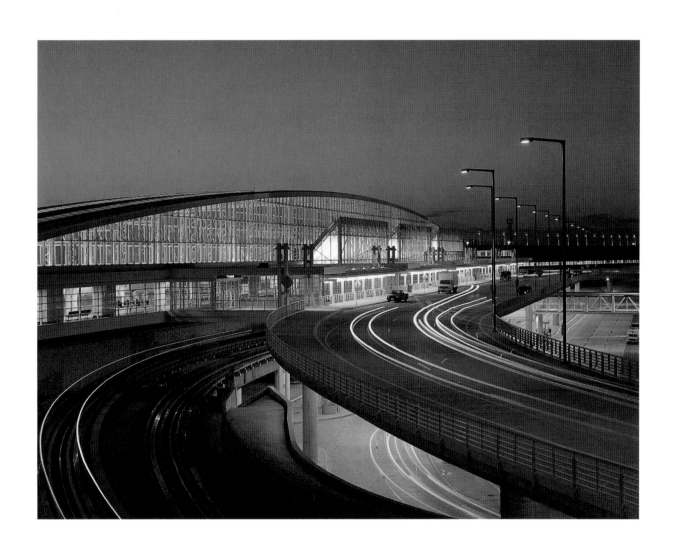

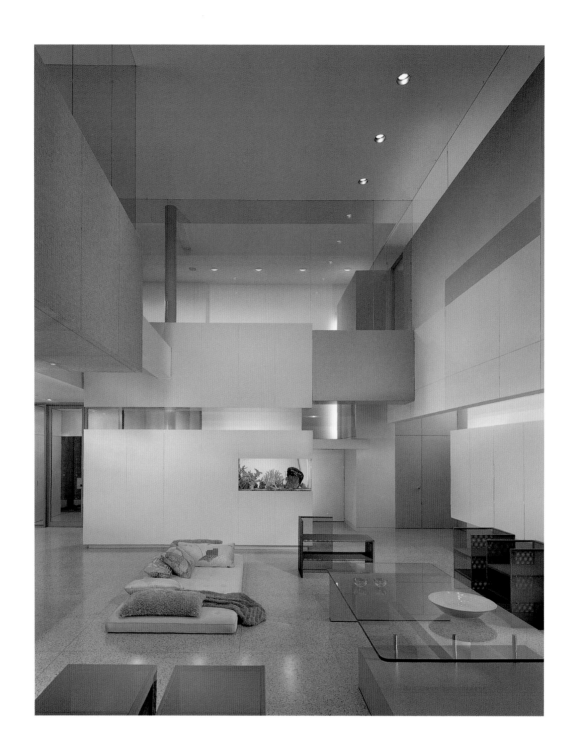

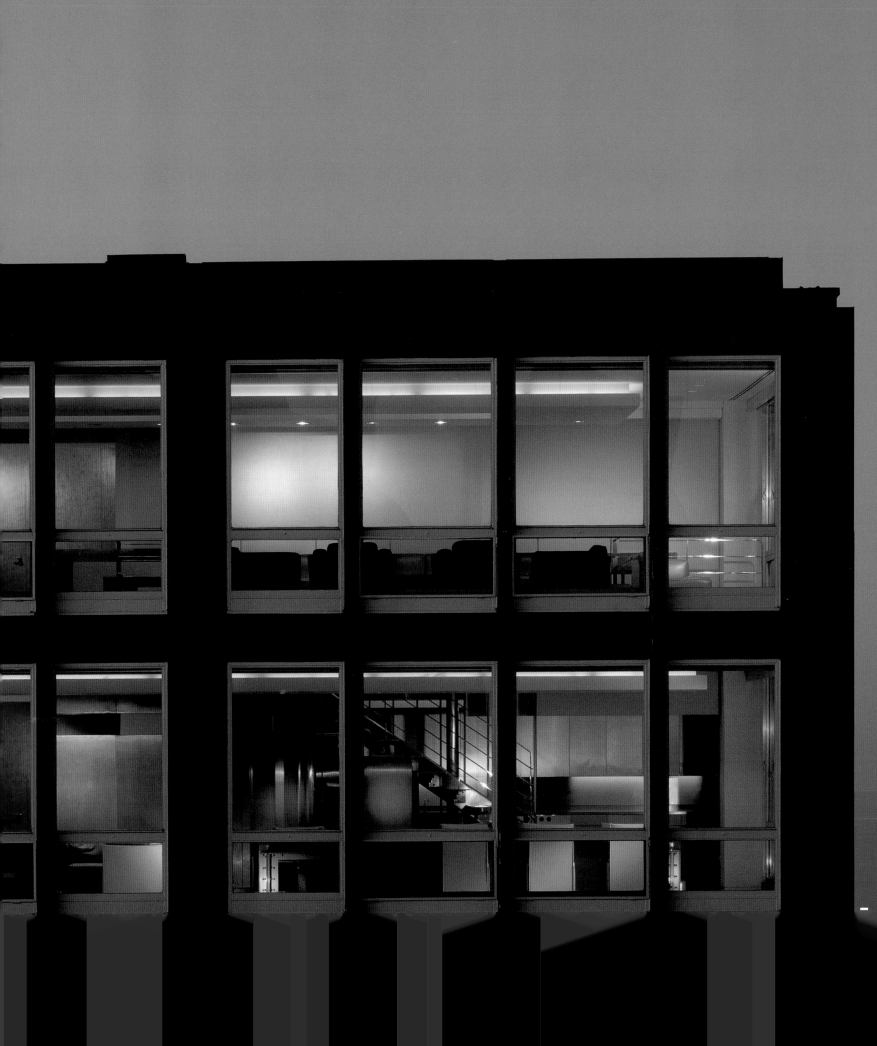

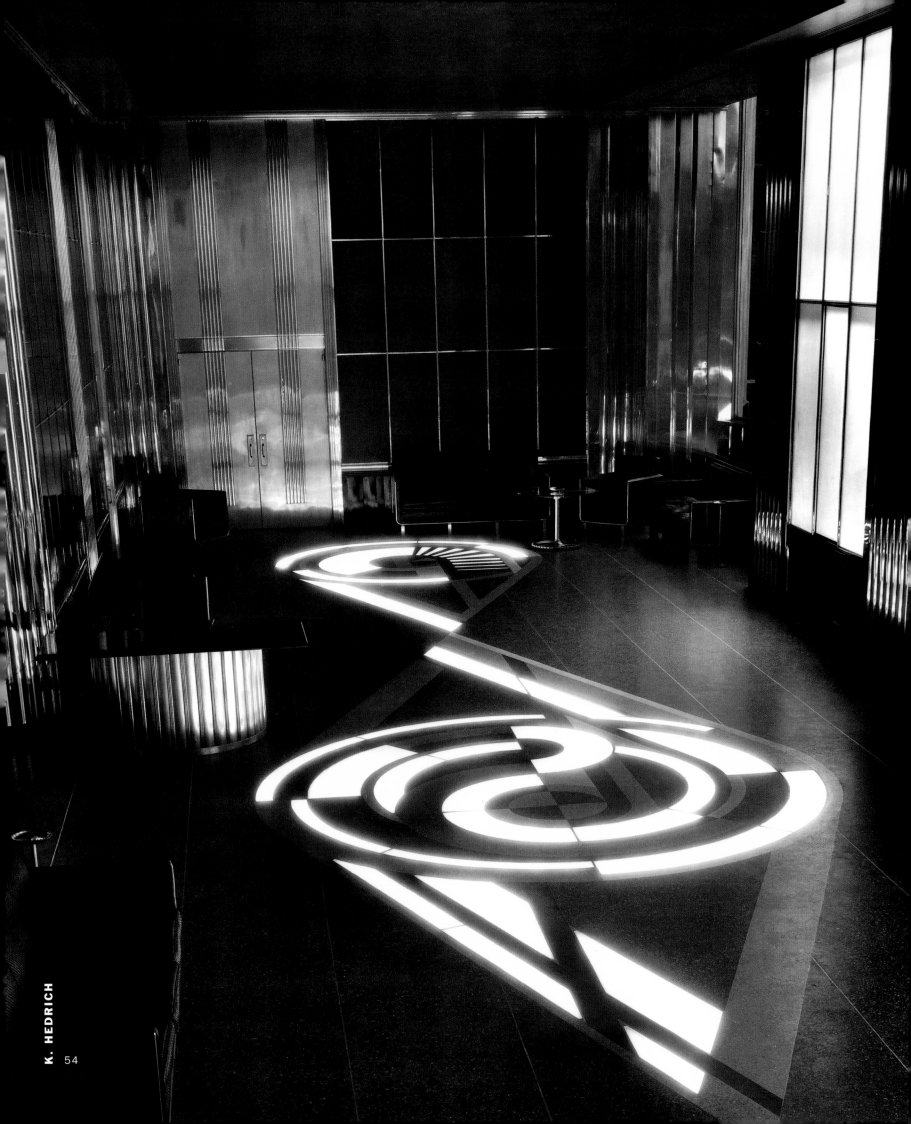

54

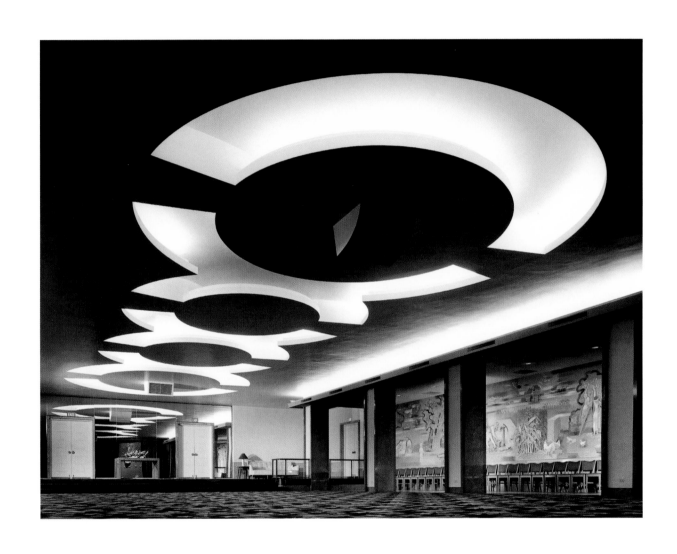

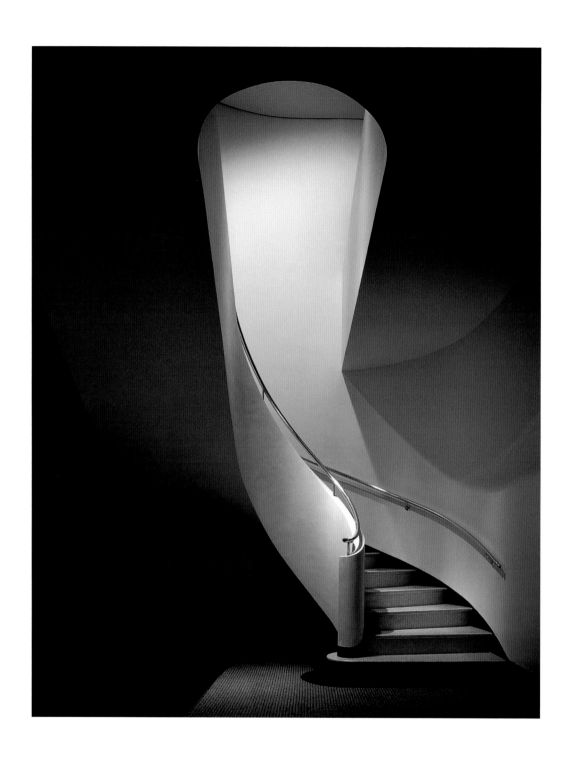

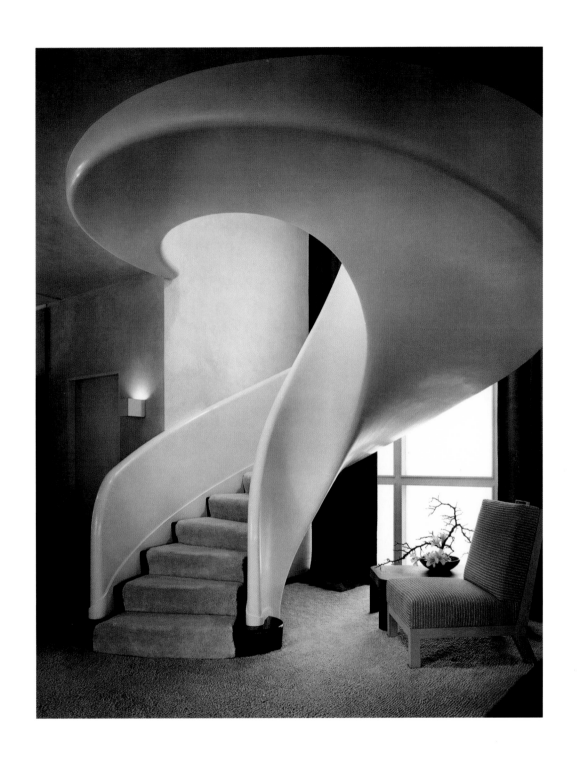

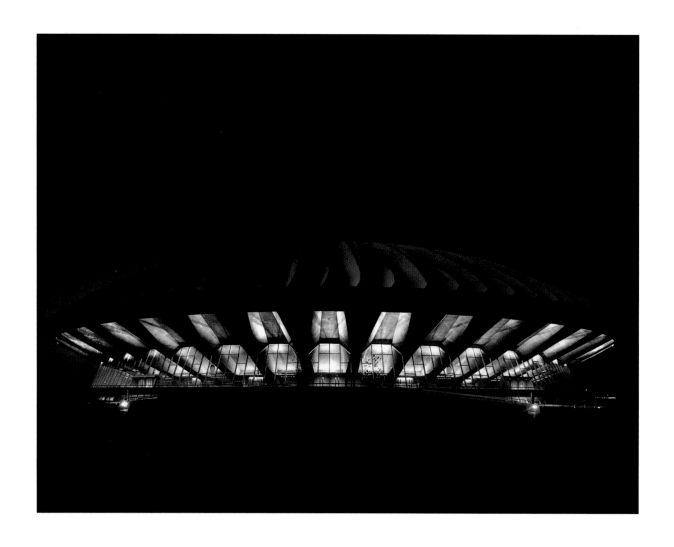

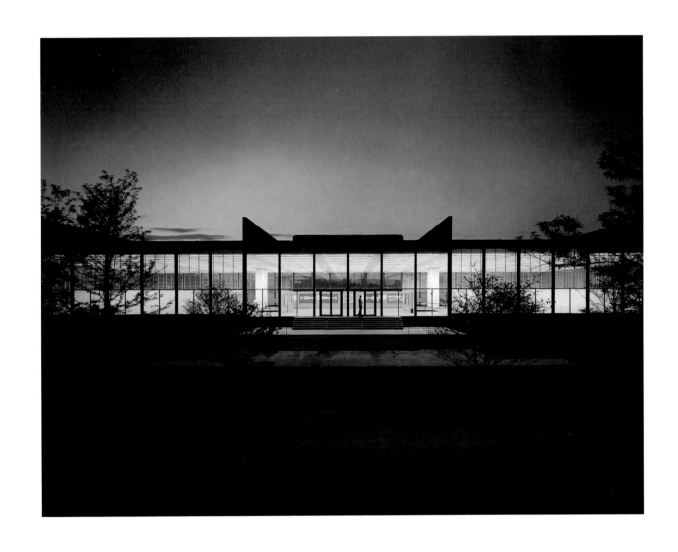

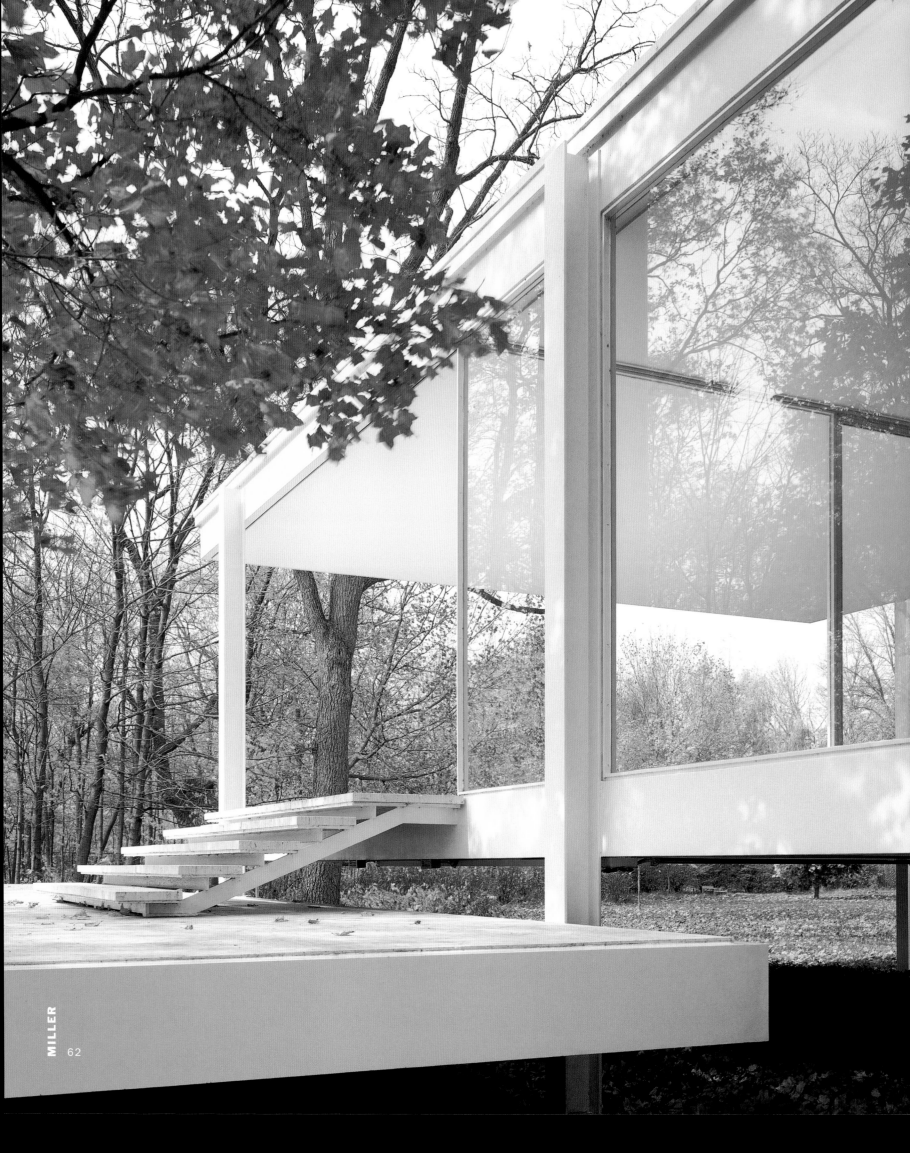

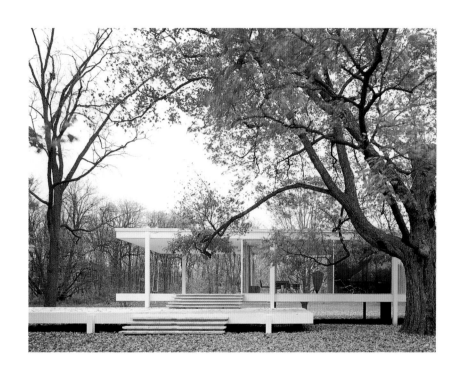

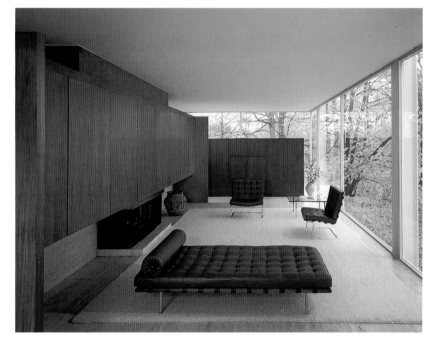

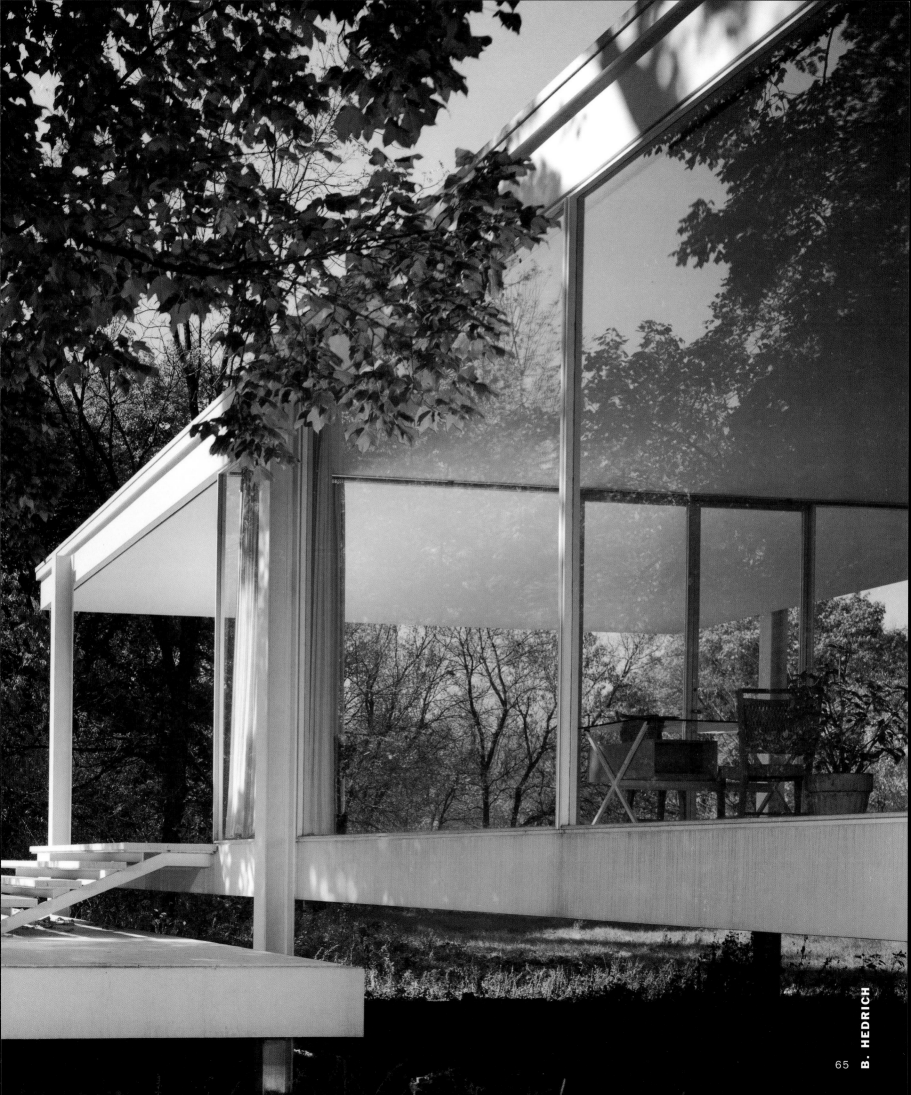

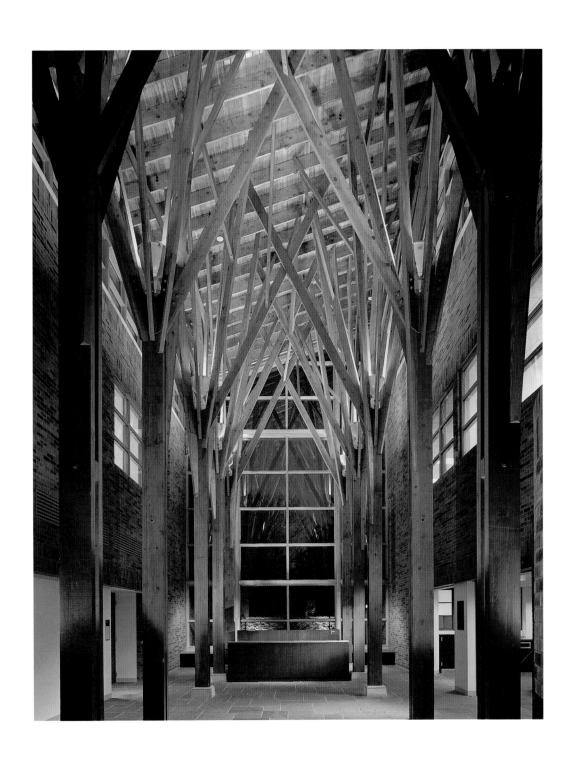

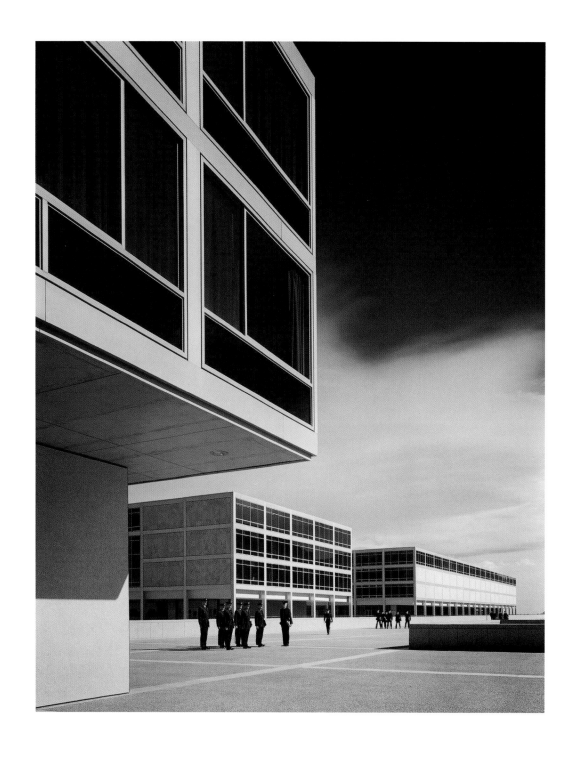

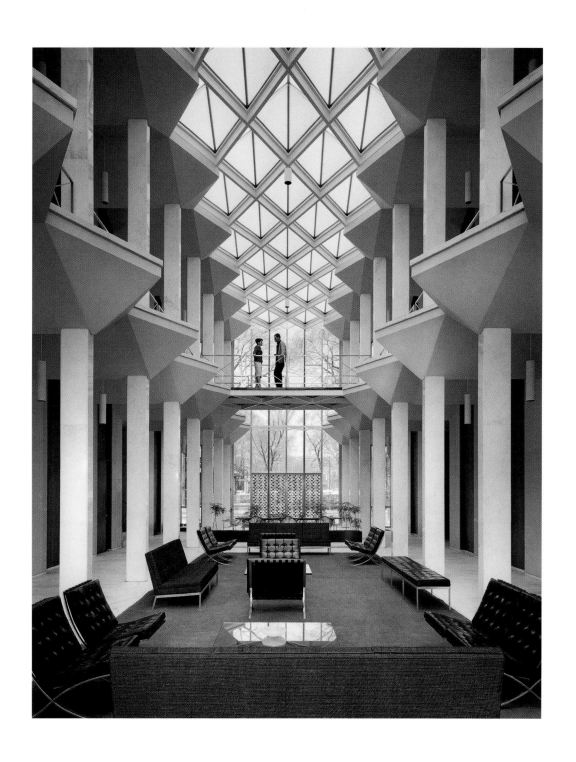

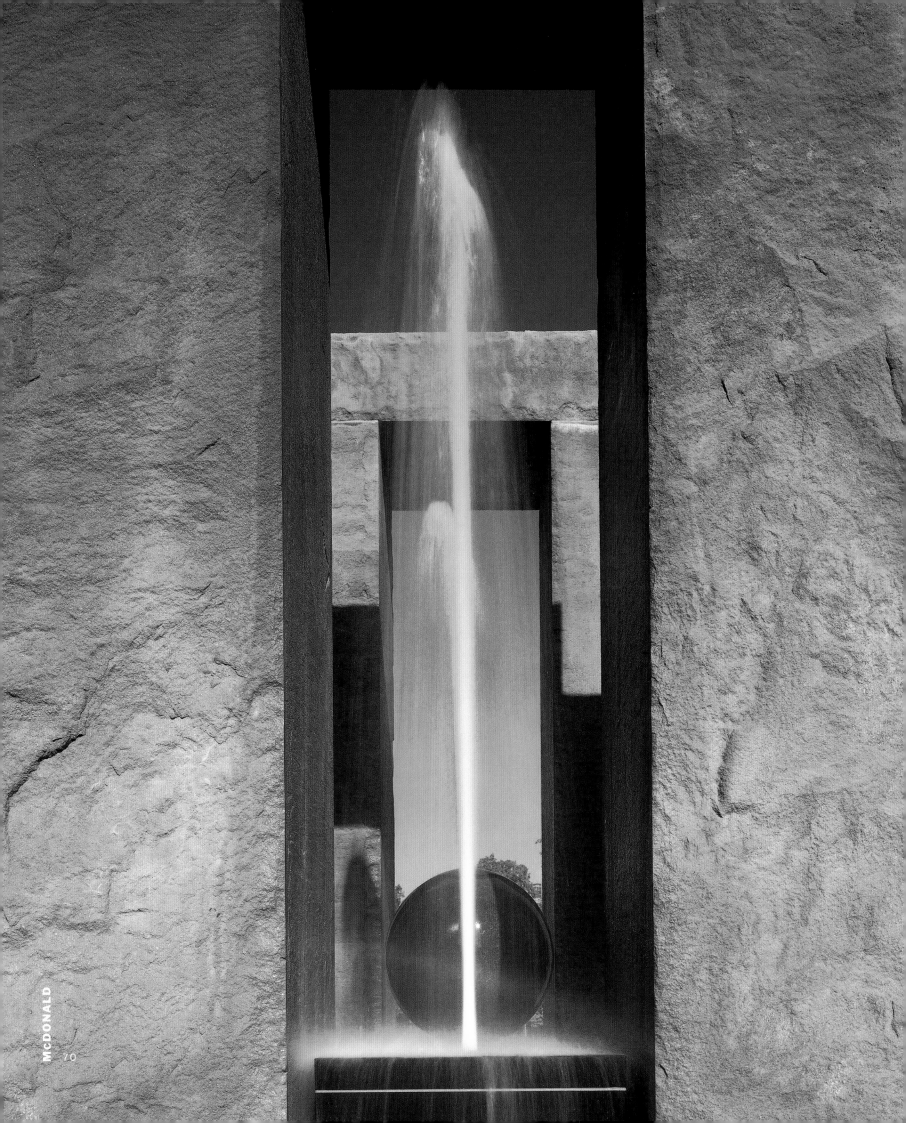

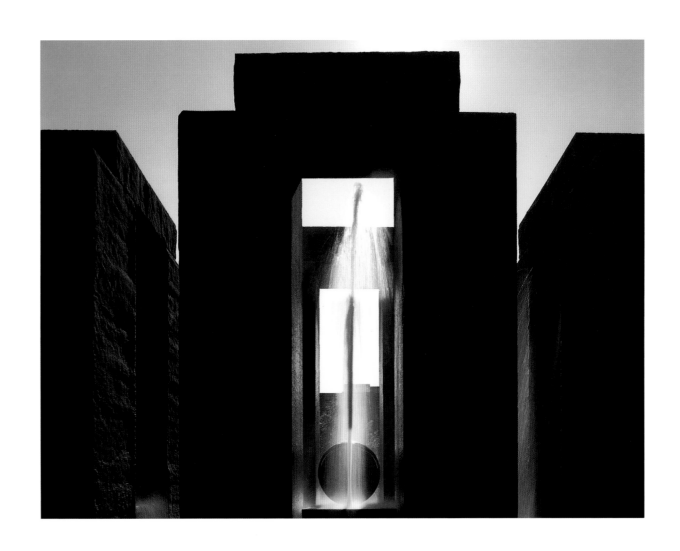

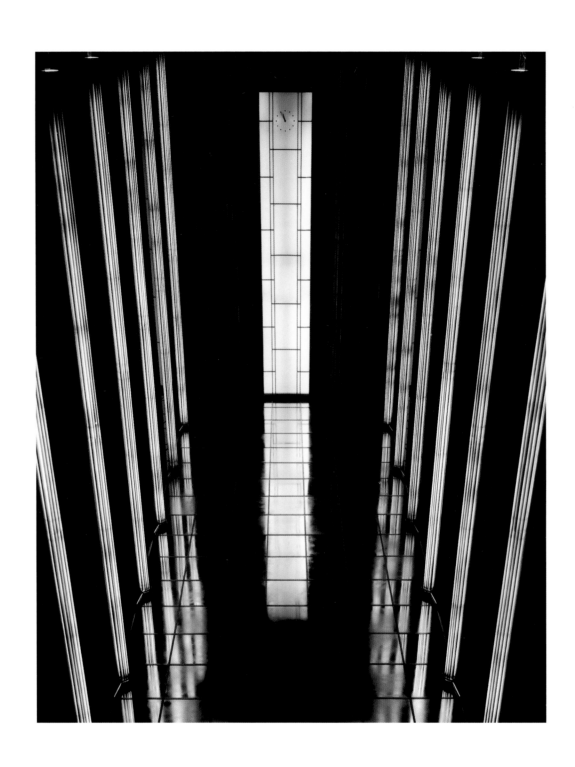

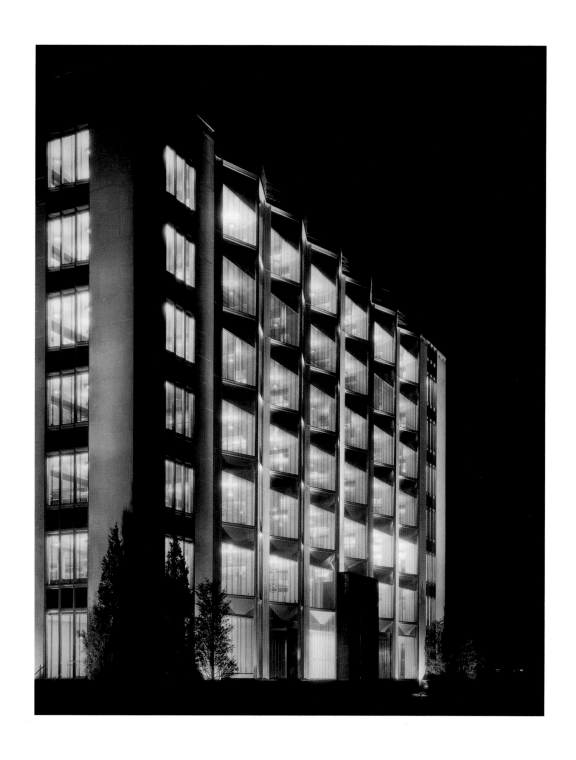

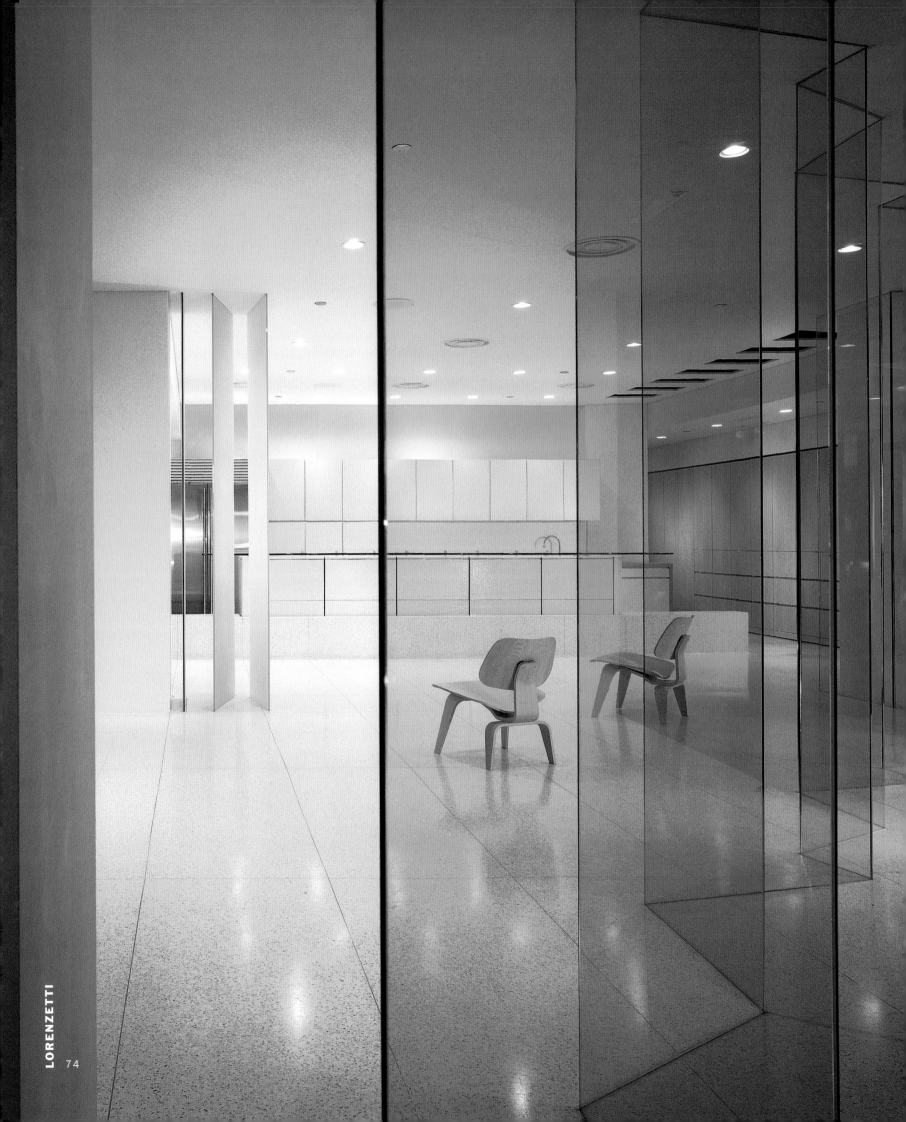

74 **MARCO LORENZETTI**
1998
Herman Miller Showroom
Chicago, Illinois
Architect: Krueck and Sexton

It was a great experience to work with Ron Krueck. His vision was unique, and he loved the pictures. He understood that the space would be remembered by the images we made together. They had to be like seamless satin; mysterious and color sensitive. His pictures were always incredibly laborious, and he was involved in every minute detail in every frame. These were his pictures, and his adoration for the images inspired the shoot.

79 **JIM HEDRICH**
1973
Banco di Roma
Chicago, Illinois
Architect: Skidmore,
Owings & Merrill
Interior Designer:
Bob Kleinschmidt

Bob Kleinschmidt and Don Powell were among the very first architects in the country to specialize in interior architecture.

They established the interiors department at Skidmore, Owings & Merrill before moving on to a long and successful career partnership. Hedrich Blessing learned and benefited greatly from working with Bob in these early days. He helped cultivate our insight into spatial forms and respect for nuances of color, fabric and materials, as well as meticulous attention to detail that informs great interior architecture—and the photographs thereof.

80 **SCOTT MCDONALD**
1993
Private Residence
Cancun, Mexico
Architect: Gomez, Vazquez,
Aldana & Associates

81 **STEVE HALL**
1996
Chicago State University
Chicago, Illinois
Building Architect: Harry
Weese Associates
Interior Architect: Eva Maddox
& Associates

82 **STEVE HALL**
1996
Halftime: 75 Years of
Chicago Architecture
Arts Club of Chicago
Chicago, Illinois
Designer: Stanley Tigerman

Architecture Magazine commissioned these photographs. It was an inspiration simply to photograph inside this elegant minimal space designed by Mies van der Rohe. The gentleman in the photograph was poised viewing the show as I composed the image. His presence and demeanor made me feel as if Mies himself was there.

83 **JIM HEDRICH**
1982
Boston Museum of Fine Art
Boston, Massachusetts
Architect: I. M. Pei

84 NICK MERRICK

1987

190 S. LaSalle St. Building

Chicago, Illinois

Architects: John Burgee

with Philip Johnson

In conferring with John Burgee preparatory to the shoot, I learned that the building's essence lay in its references to past Chicago buildings, such as the Masonic Temple that once occupied the site. The most artic-ulated and symbolic parts of the building were the rooftop and gables. The Attic Club across the street had windows that opened, and the owners granted me access. The irony of the older Modernist Sears Tower juxtaposed against the new Post-Modernist building was inescapable to me.

85–87 NICK MERRICK

1990

Congress Hall Building

Berlin, Germany

Architect: Hugh Stubbins 1957

Reconstruction: Stubbins

Associates 1988

After World War II, the United States gifted this building to the people of West Berlin. It was originally intended as a peace conference center—an adjunct to the United Nations. One feels the winglike protection of the arch

embracing the auditorium. Its protective, yet soaring quality resonated for me—especially because the Berlin Wall had just been torn down, and there was an uneasy, yet exhilarating atmosphere in the city.

88 BOB HARR

1992

CLA Building, California

Polytechnic State University

San Luis Obispo, California

Architect: Antoine Predock

89 NICK MERRICK

1995

Clark County

Government Center

Las Vegas, Nevada

Architect: Fentress Bradburn

90 BOB SHIMER

1988

Proposed Lake Wells Tower

Chicago, Illinois

Architect: Helmut Jahn

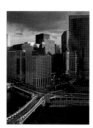

Site

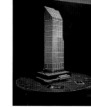

Model

91 BOB HARR

1990

1st Bank Plaza

Minneapolis, Minnesota

Architect: Pei, Cobb,

Freed & Partners

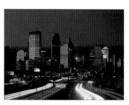

Site

Model

Bob Harr pioneered the art of photocomposition in which an architectural model of a proposed building is introduced photo-graphically into its future site. Made in the heyday of the specu-lative office boom in the late 1980s, such images were the cen-terpiece of elaborate marketing strategies designed to prelease buildings before they were built. Indeed, signing up tenants in advance was often a precondition to obtaining financing for a proj-ect. As a consequence, many of Hedrich Blessing's photocompos-ites, such as the office tower on page 90, feature designs that were never built.

Mies van der Rohe is reportedly the first architect to have requested simple photomontages from Hedrich Blessing. Mies would have model after model made of his prospective buildings, often with refinements so imperceptible that only the master himself could see the details. Photographs were then made and cut-and-pasted into site shots.

In 1977 Bob Harr was commissioned by the Houston-based developer Gerald Hines to create a model-in-site photocomposite that would rival reality. A new process for emulsion stripping of two or more transparencies enabled him to create a composite photograph that set a new standard for photocomposition verisimilitude. In 1980, Bob was introduced to Raphaele, a computer retoucher in Houston who could produce photocompositions digitally—long before PhotoShop. Bob was so skeptical of the process that he had the first assignment emulsion stripped as well—just in case. But Raphaele produced a masterful composite and thereafter collaborated on dozens of assignments with Bob Harr.

92 **MARCO LORENZETTI**
1994
Eliel Saarinen Residence,
Cranbrook Academy
Bloomfield Hills, Michigan
Architect: Eliel Saarinen, 1930

The Saarinen house was my first commission from the then editor of interior design, Stanley Ambercrombie. The space is a jewel; every facet of detail is a glimmering gem. The passion shown in Saarinen's design is both subtle and forceful. Because of him, I loved making those images.

93 **BILL HEDRICH**
1946
Eliel Saarinen Residence,
Cranbrook Academy
Bloomfield Hills, Michigan
Architect: Eliel Saarinen, 1930

94 **SCOTT MCDONALD**
1984
Chicago River, North Branch
Chicago, Illinois

95 **BILL ENGDAHL**
1963
Marina City
Chicago, Illinois
Architect: Bertrand Goldberg

The first time Bill shot Marina City with the bridge up, construction was still going on, and so

the raised structure hid the major part of a very large sign in front of the building. When architect Goldberg saw the shot, he liked the composition that the bridge created with the towers, and asked that we make a shot similar in our final photography of the completed project.

96 **JIM HEDRICH**
1996
Ritz-Carlton Hotel
Cancun, Mexico

97 **JIM HEDRICH**
1998
Ritz-Carlton Hotel
Montreal, Canada

98 **CHRIS BARRETT**
1991
Piazza d'Italia
New Orleans, Louisiana
Architect: Charles Moore

99 **BILL HEDRICH**
1976
Santa Clara Civic Building
San Jose, California
Architect: Caudill, Rowlett, Scott

100 BOB HARR
1991
191 Peachtree Street Towers
Atlanta, Georgia
Architect: John Burgee
with Philip Johnson

101 JON MILLER
1997
Civic Opera Building
Chicago, Illinois
Building Architect: Graham,
Anderson, Probst & White, 1929
Renovation Architect:
Skidmore, Owings & Merrill

102–103 BILL HEDRICH
1969
Lake Point Tower
Chicago, Illinois
Architect: Schipporeit-Heinrich
Associates

104–105 STEVE HALL
1996
Museum of Contemporary Art
Chicago, Illinois
Architect: Josef Paul Kleihues

106 KEN HEDRICH
1933
Desoto Pavilion
A Century of Progress
International Exposition
Chicago, Illinois
Architects: Holabird & Root

107 KEN HEDRICH
1933
Chrysler Building
A Century of Progress
International Exposition
Chicago, Illinois
Architect: Holabird & Root

*Hedrich Blessing was not the
official photographer for the
Century of Progress Exposition,
but John Wellborn Root encour-
aged Ken Hedrich to photograph
pavilions that he had designed
and others as well. The result
was a striking series of images
that captured the dramatic quality
of the "Depression Modern"
pavilions, and established
Hedrich Blessing as a firm with
a bold new approach to architec-
tural photography.*

108 MARCO LORENZETTI
1988
860-880 Lake Shore Drive
Chicago, Illinois
Architect: Mies van der Rohe,
1950

*After assisting for a year and a
half, I was determined to go on
camera. I was told that, to make
a really great architectural image
the subject matter—the building
itself—must be significant. Jon
Miller told me that my first year.
I guess I took it to heart because
soon after, for several dawns, I
trudged out to 860-880 Lake*

*Shore with an eight-by-ten-inch
view camera; an old Deardorff
lent by the studio. These pictures
began a simplified, formal style
that I soon adopted for all my
architectural work.*

109 NICK MERRICK
1982
Tenneco Employee Center
Houston, Texas
Architect: Skidmore,
Owings & Merrill
Design Architect: Richard
Keating

110 GIOVANNI SUTER
1944
Private Residence
Denver, Colorado
Architect: Burnham Hoyt

111 MARCO LORENZETTI
1989
Perkins & Will Offices
Chicago, Illinois
Architect: Perkins & Will
Interior Designer: Neil Frankel

*This picture was made for Neil.
Our relationship over several
years grew into a partnership of
sorts. He understood the power of
photography. We created a style,
emulating Nick's pictures for
Skidmore, Owings & Merrill.
Like the International Style in
architecture, we craved simplicity,
transparency, steel, and glass.*

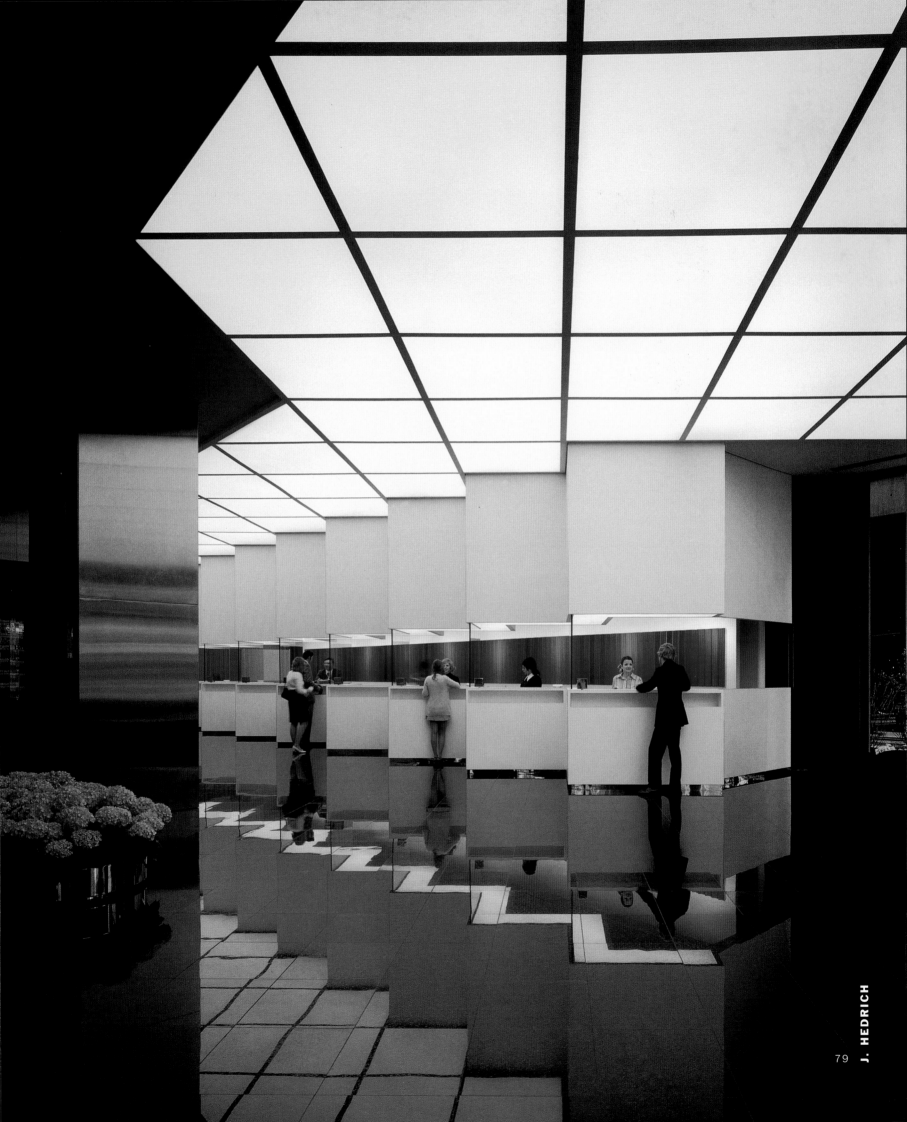

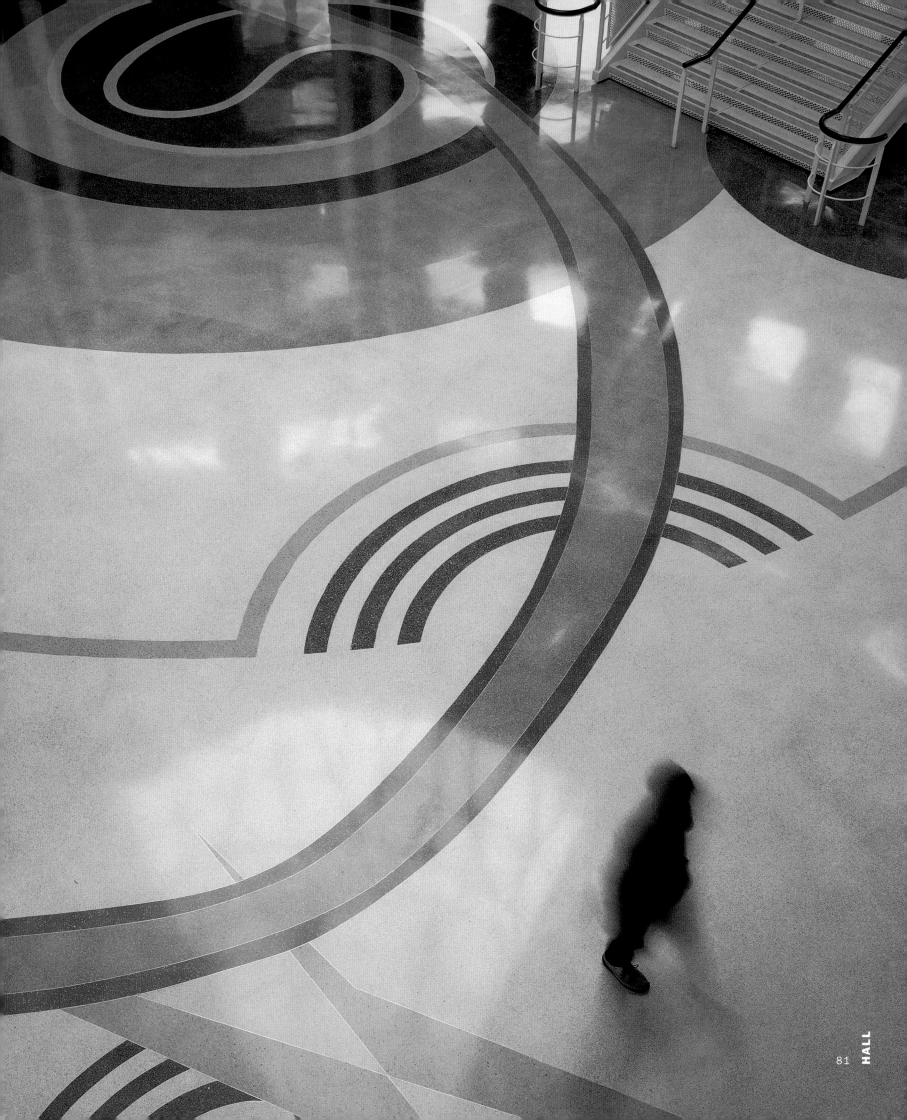

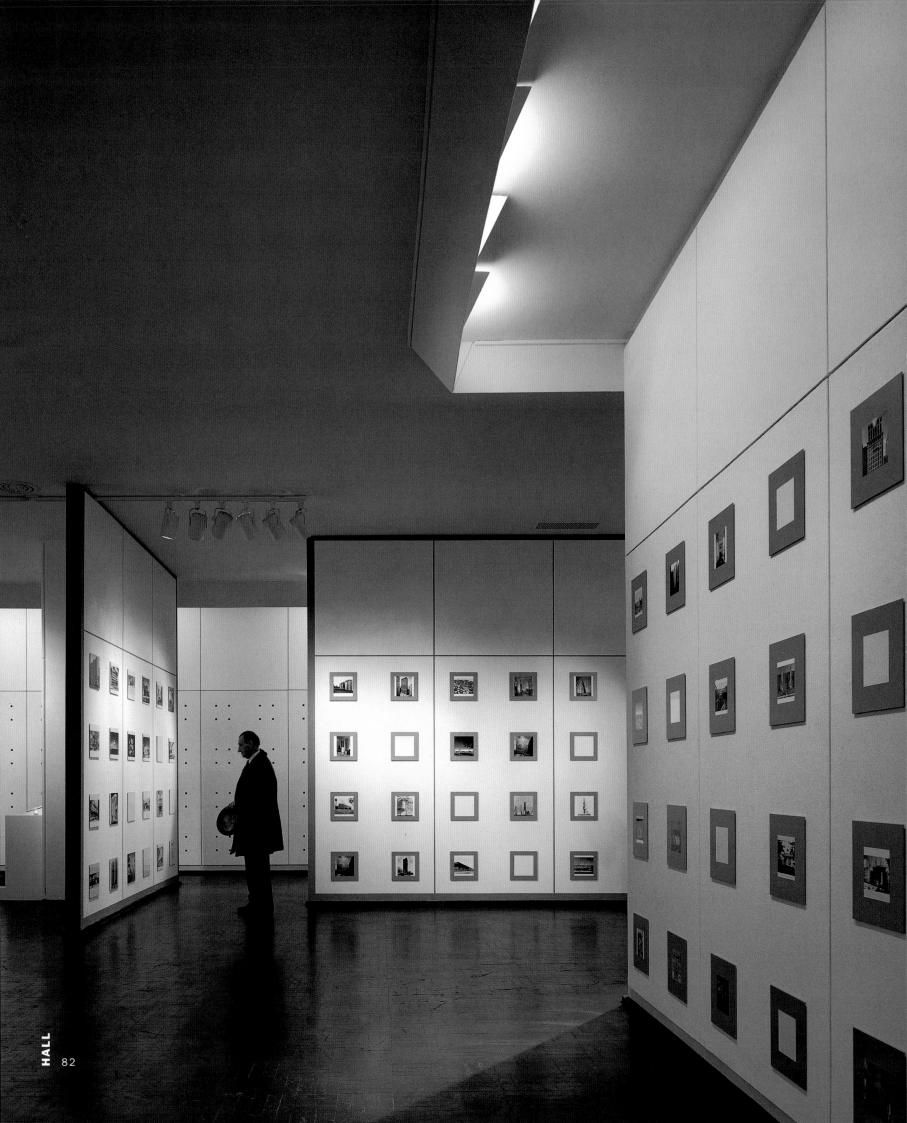

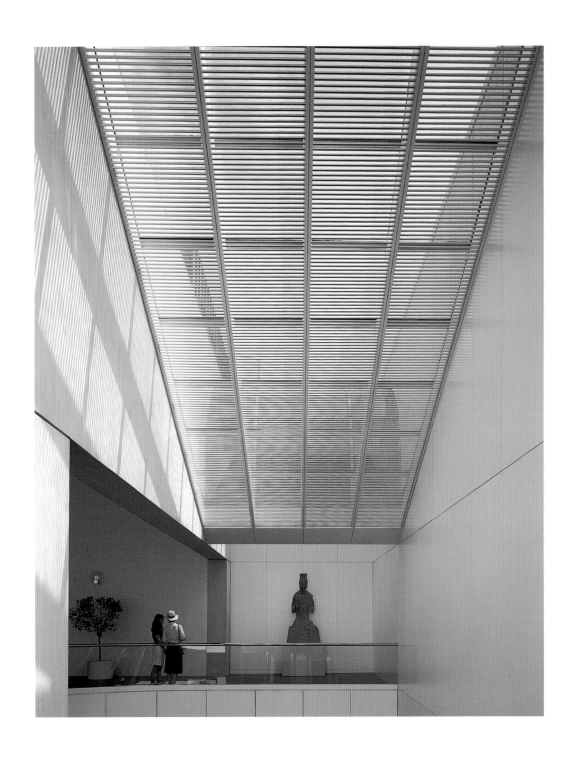

J. HEDRICH

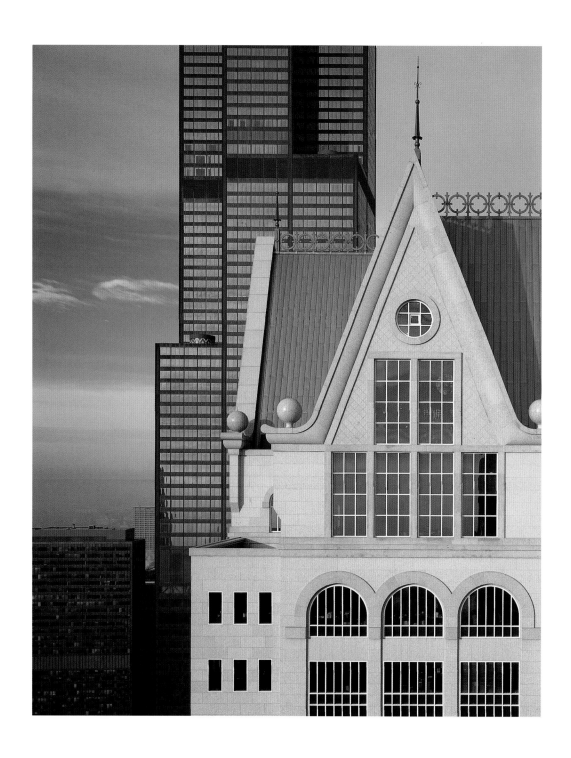

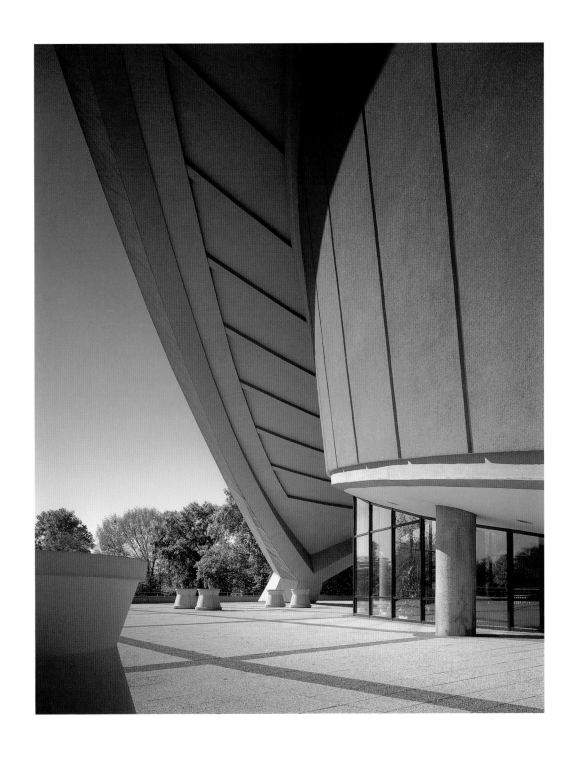

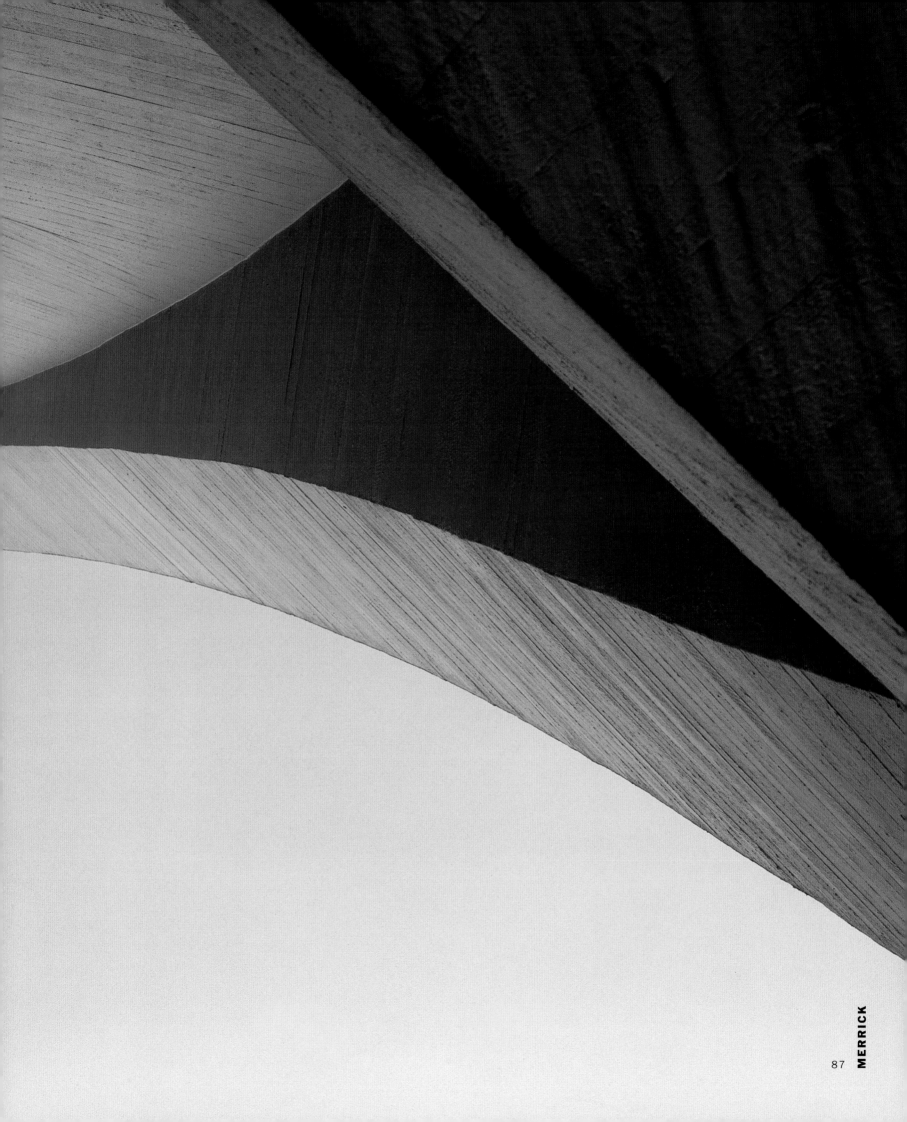

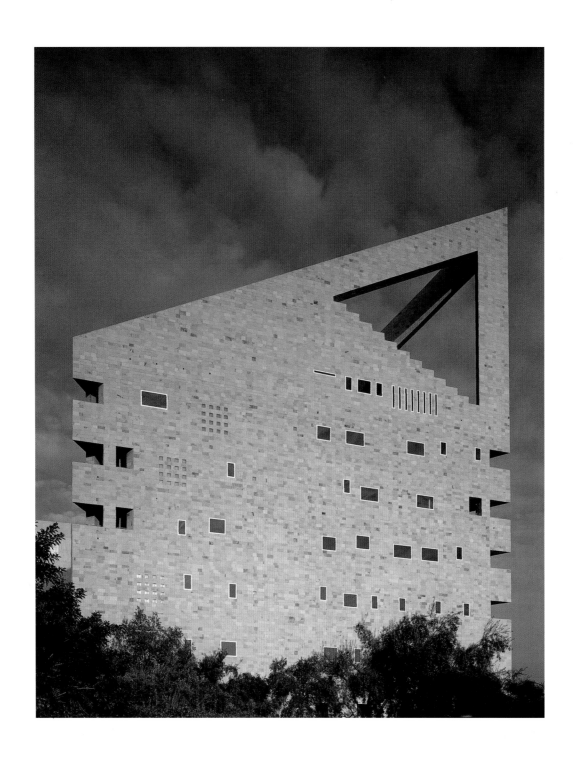

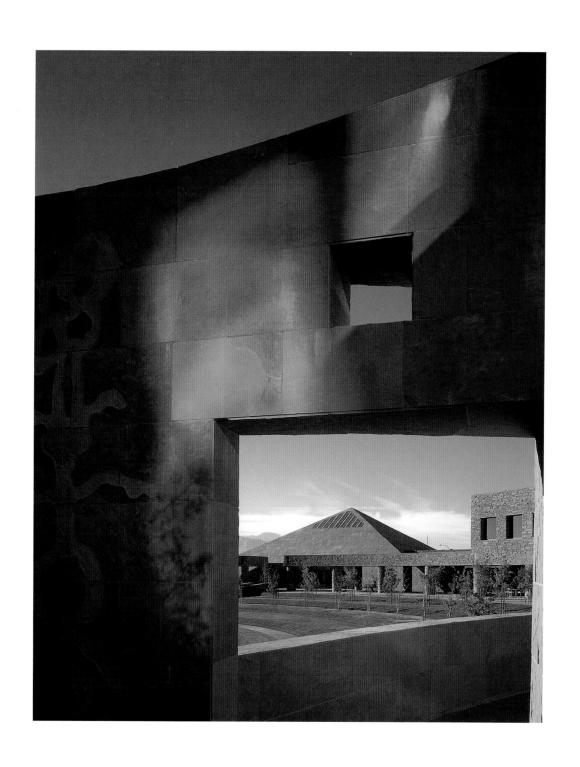

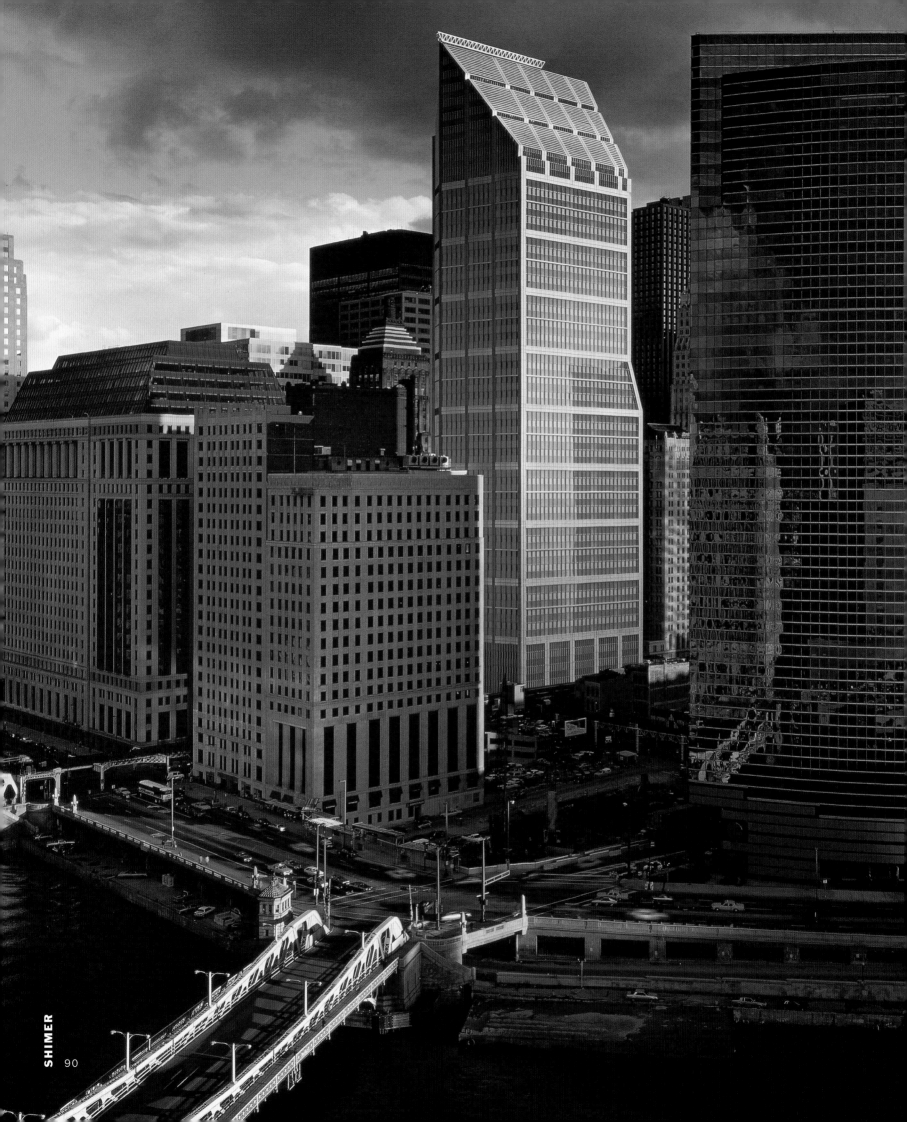

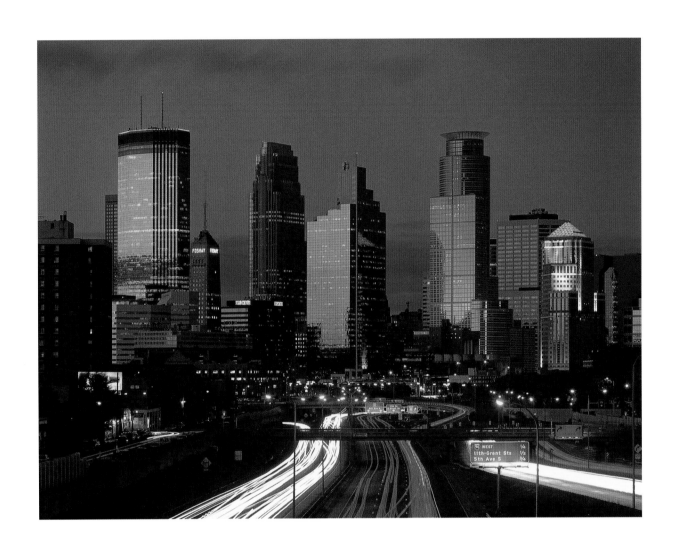

HARR

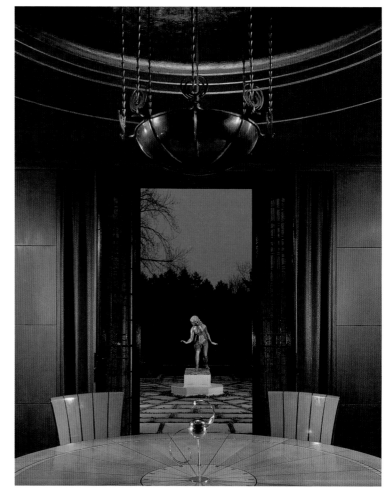

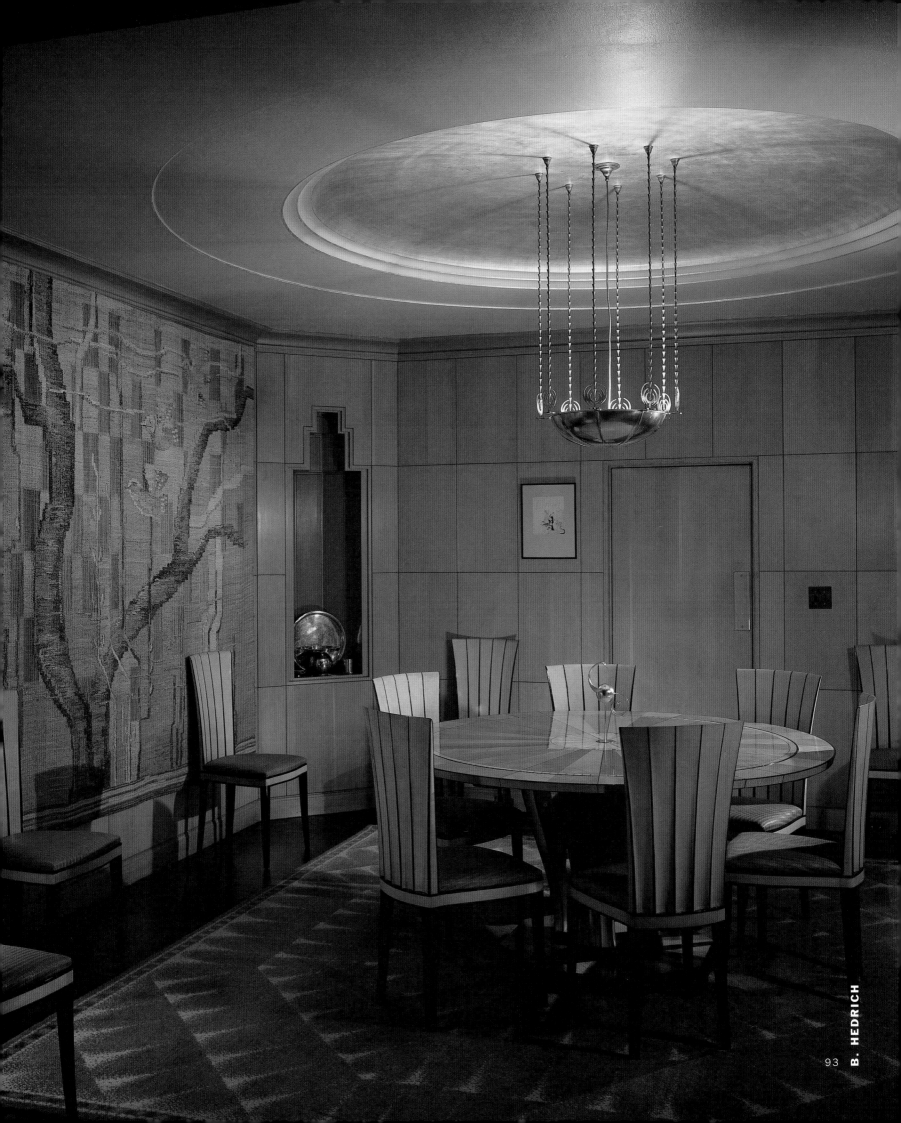

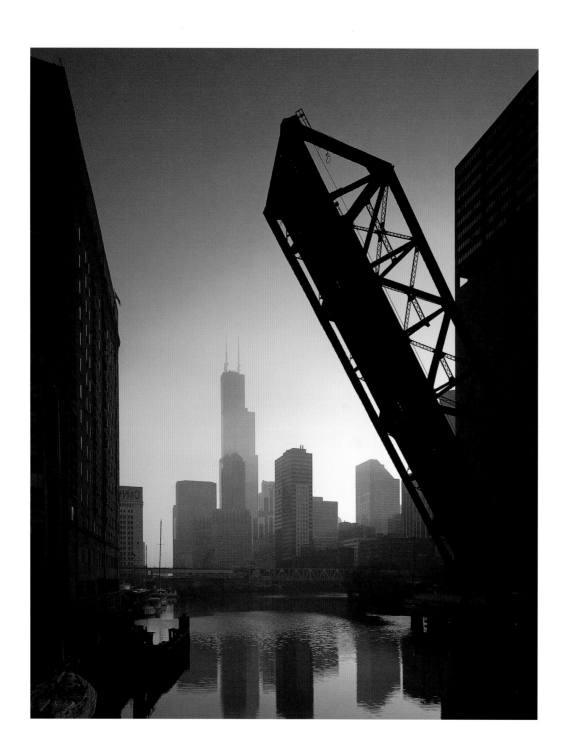

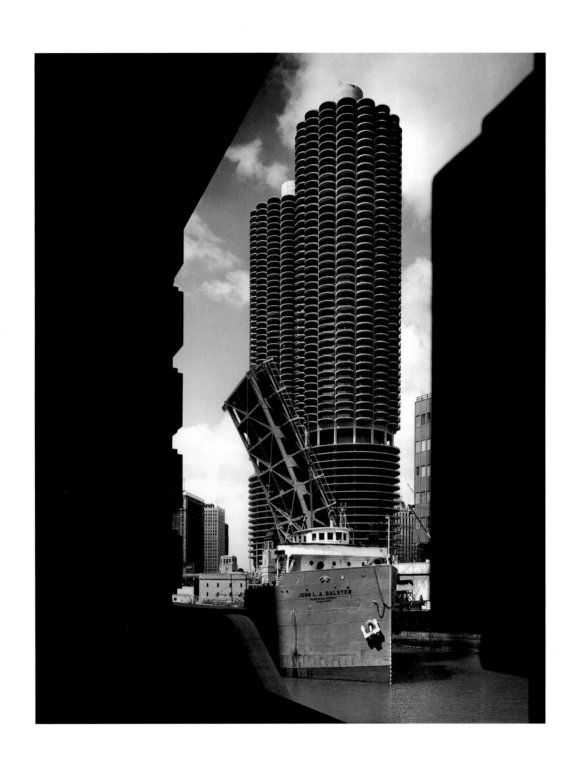

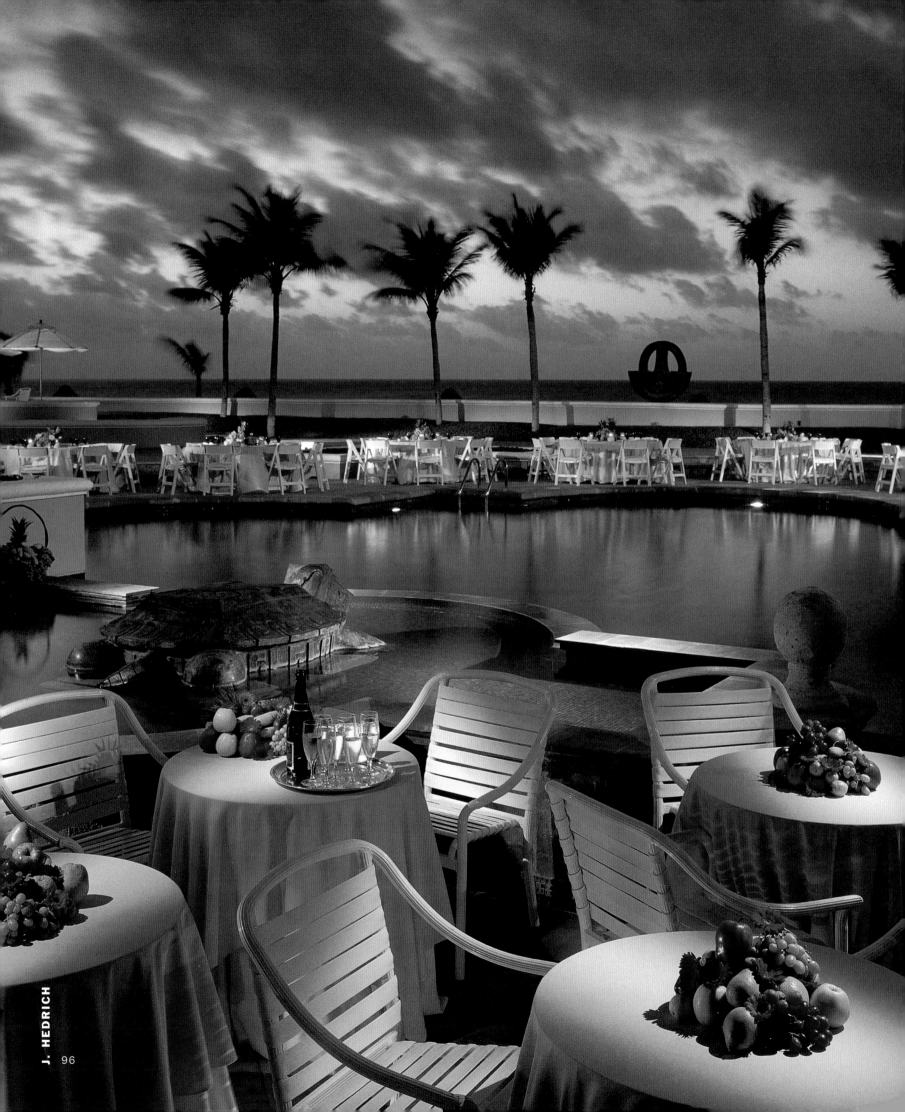

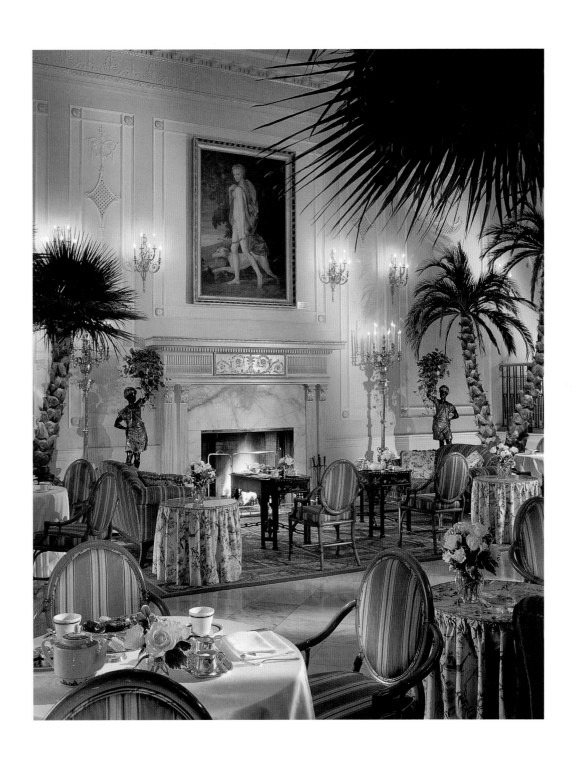

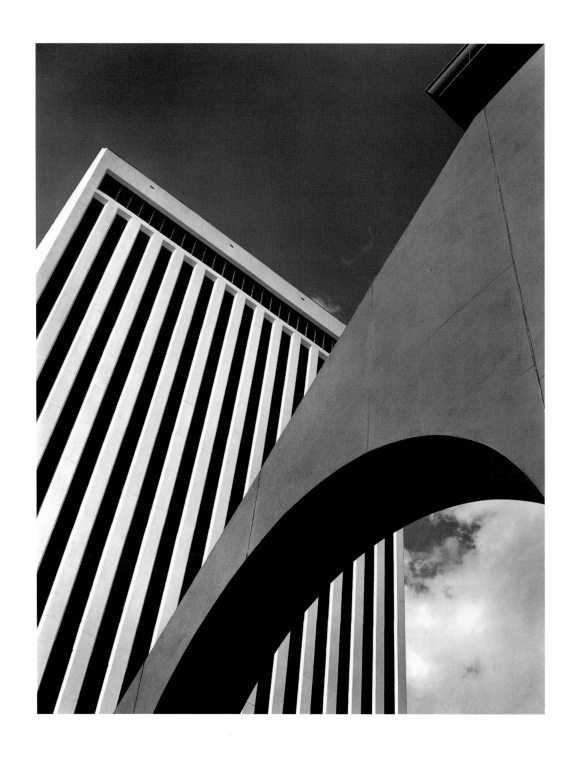

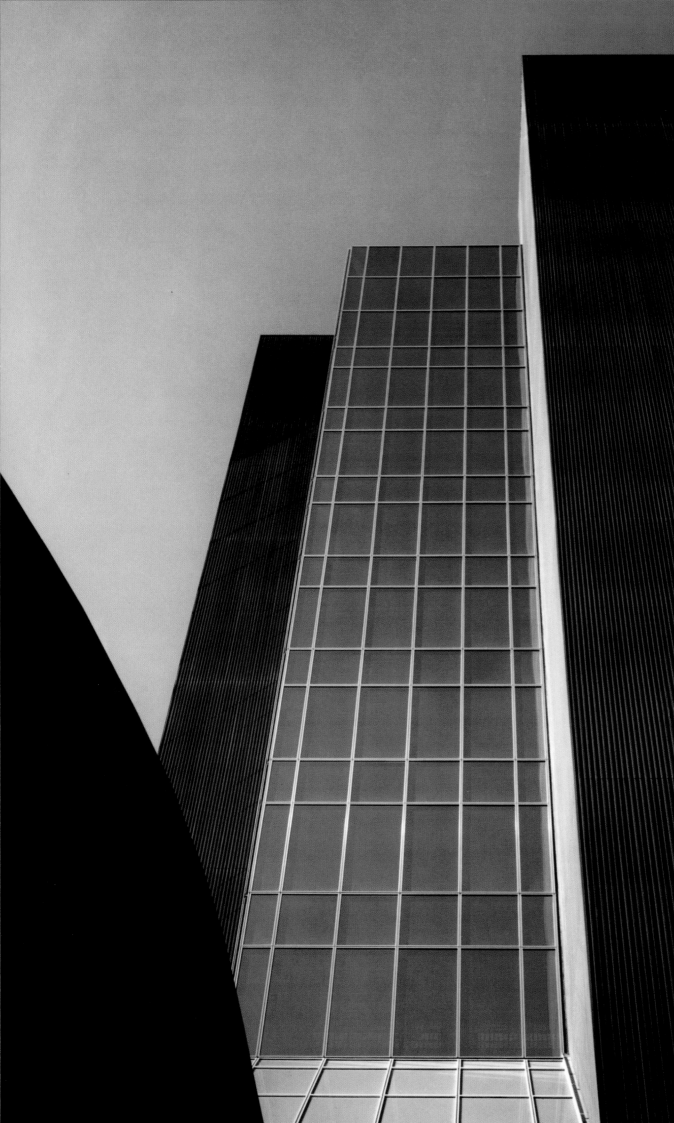

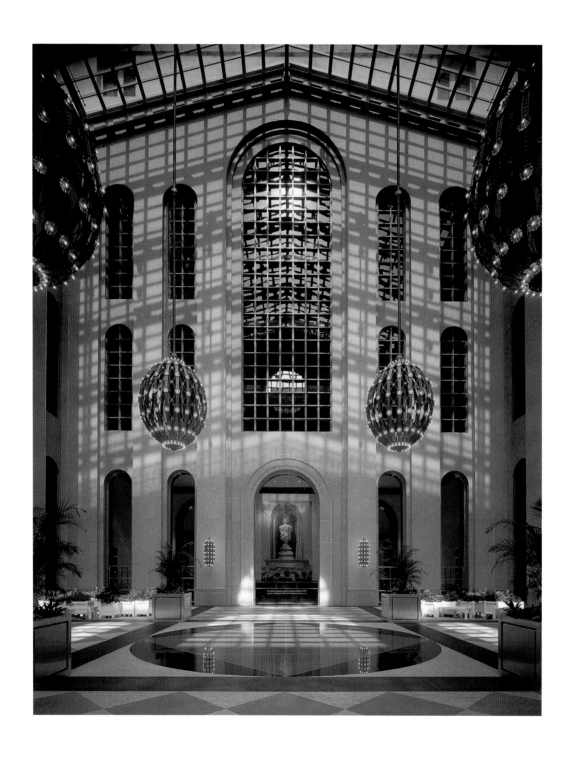

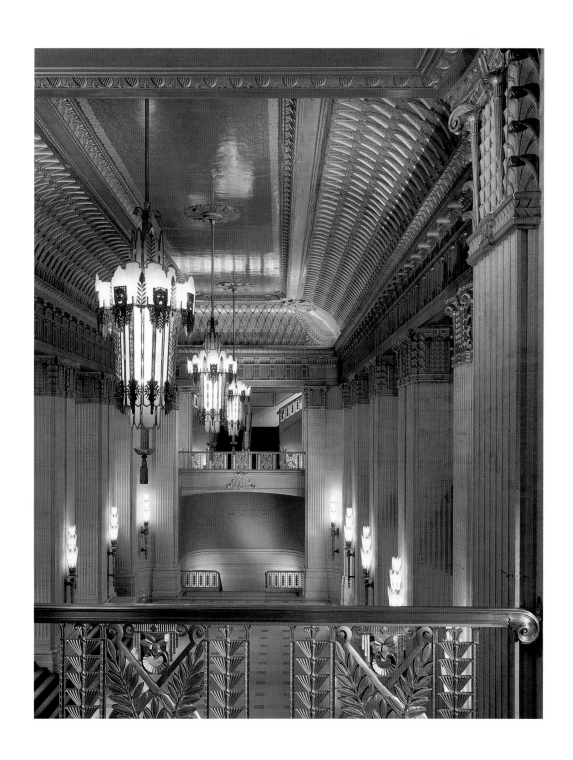

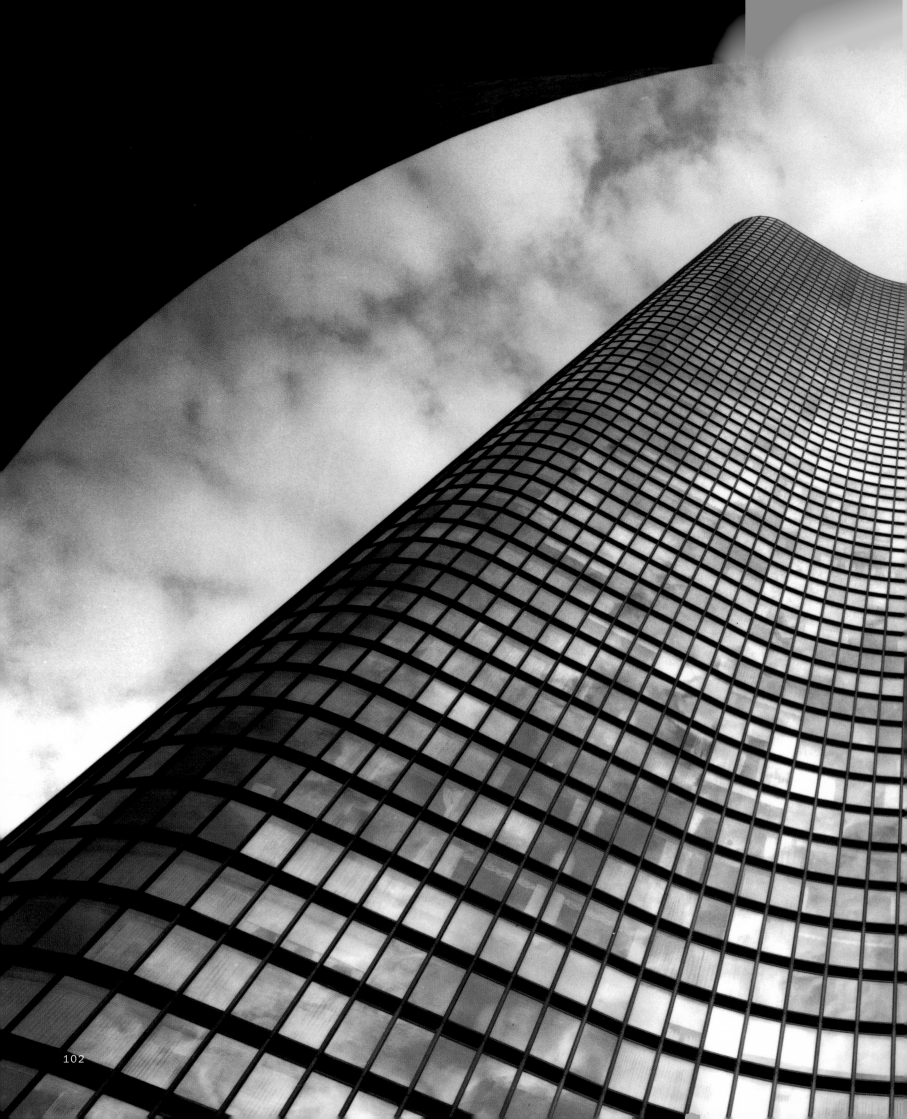

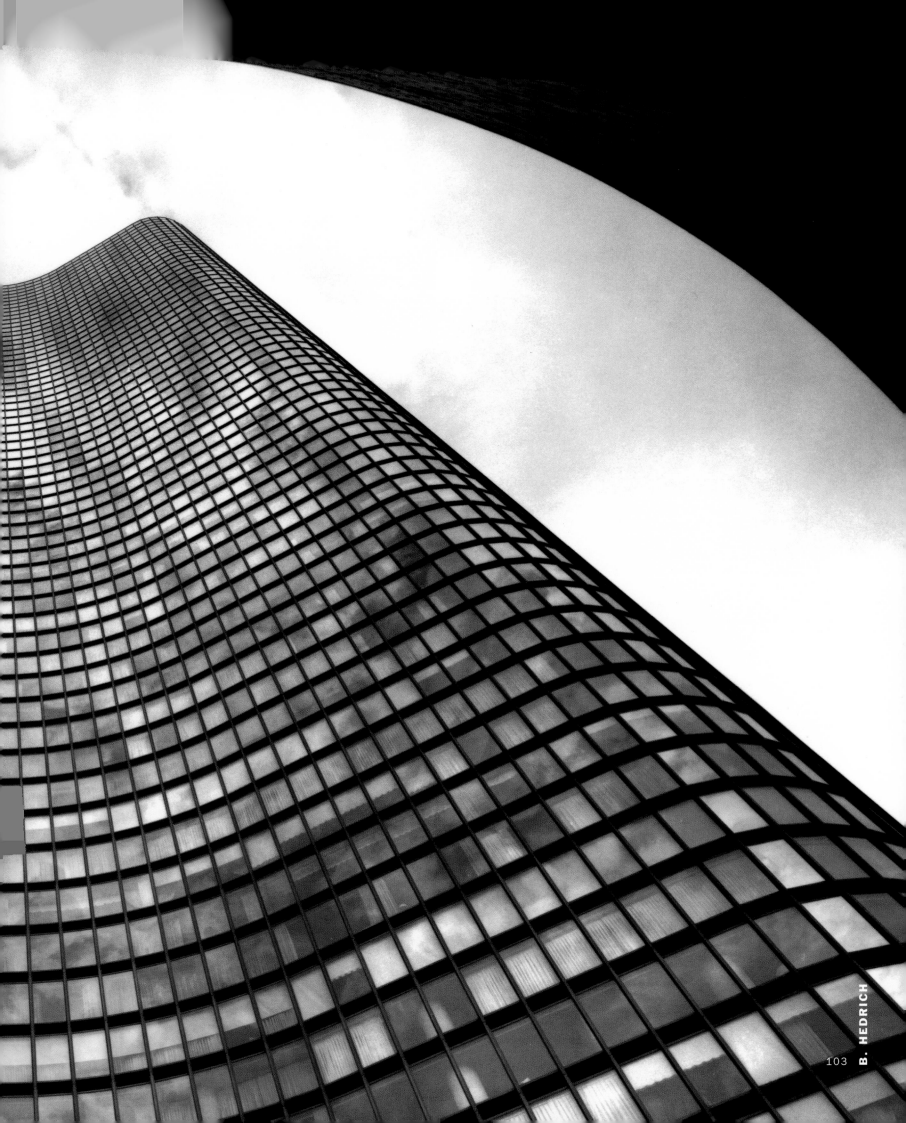

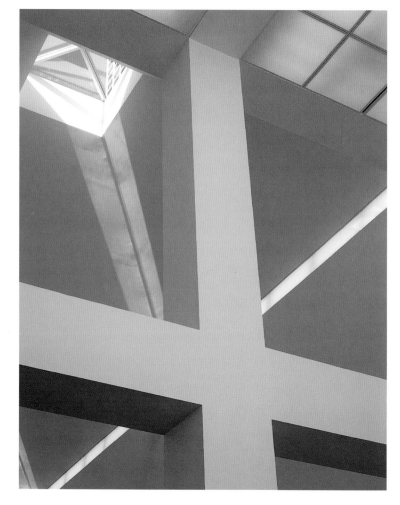

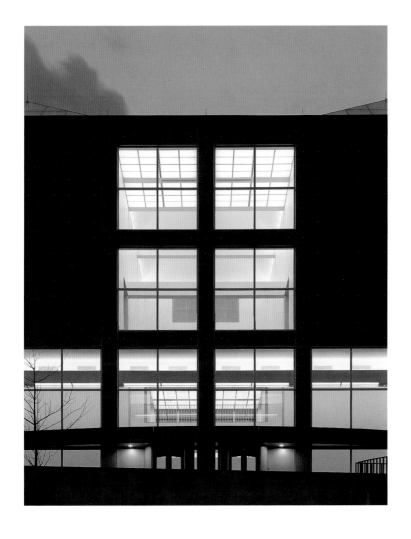

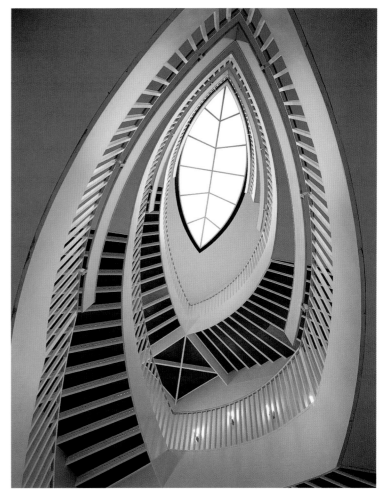

105

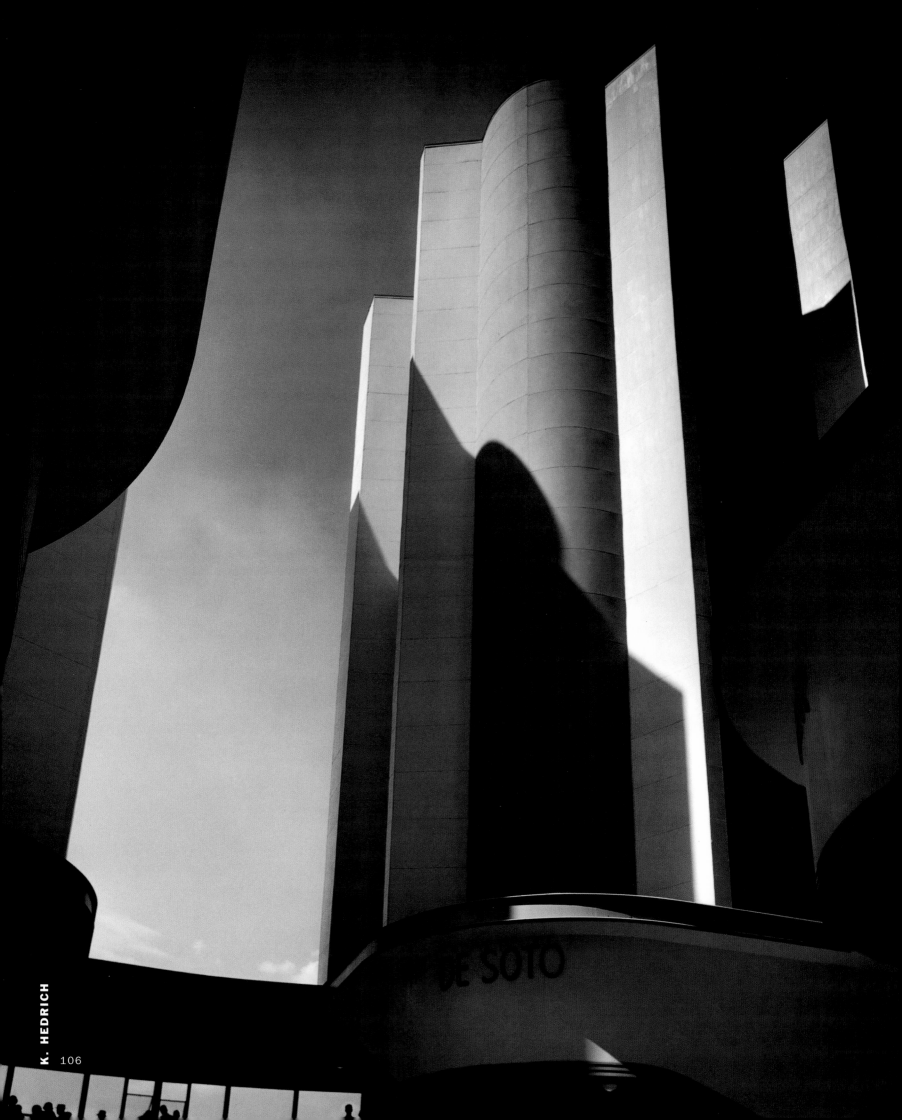

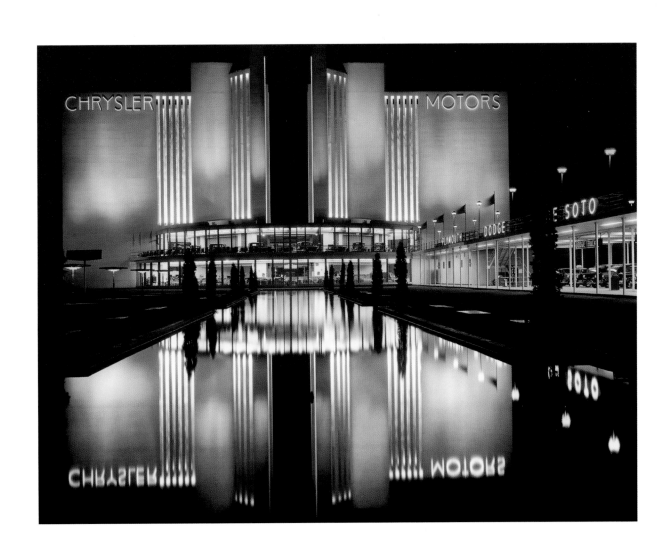

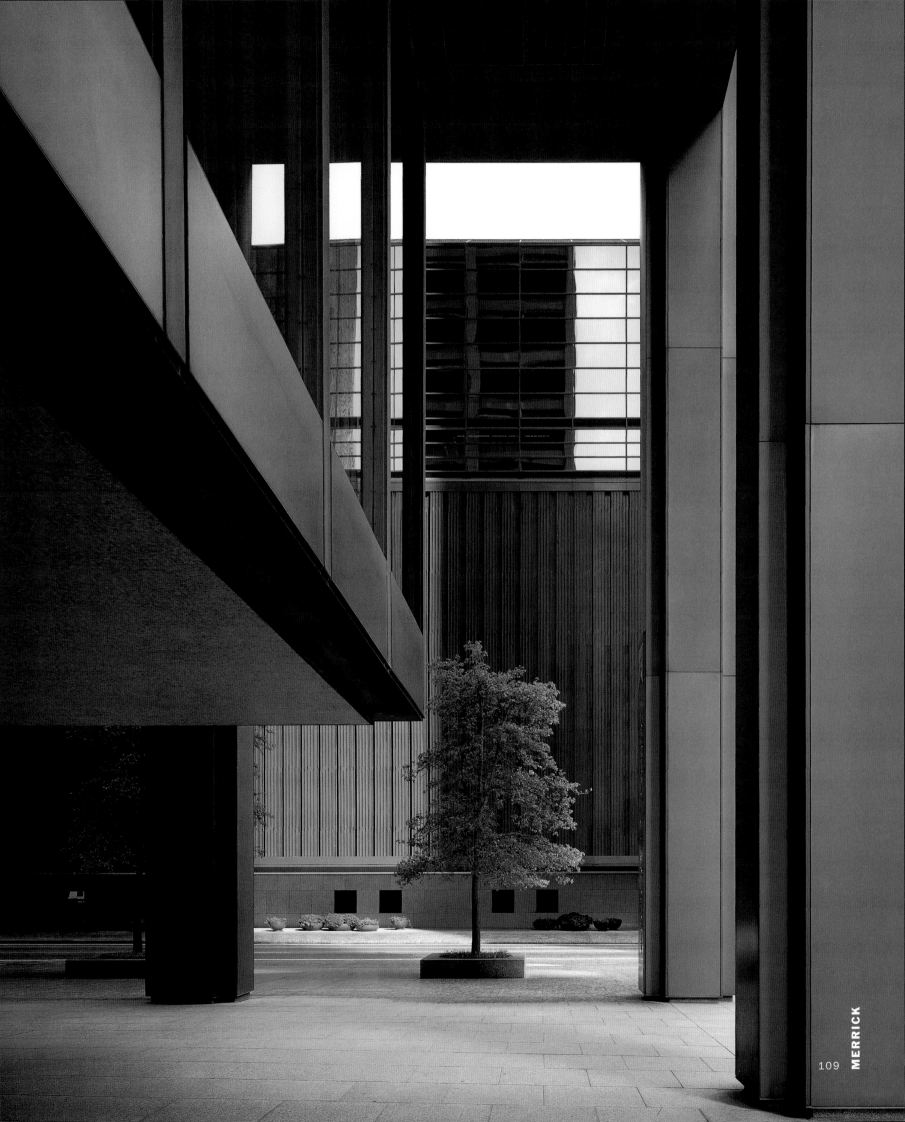

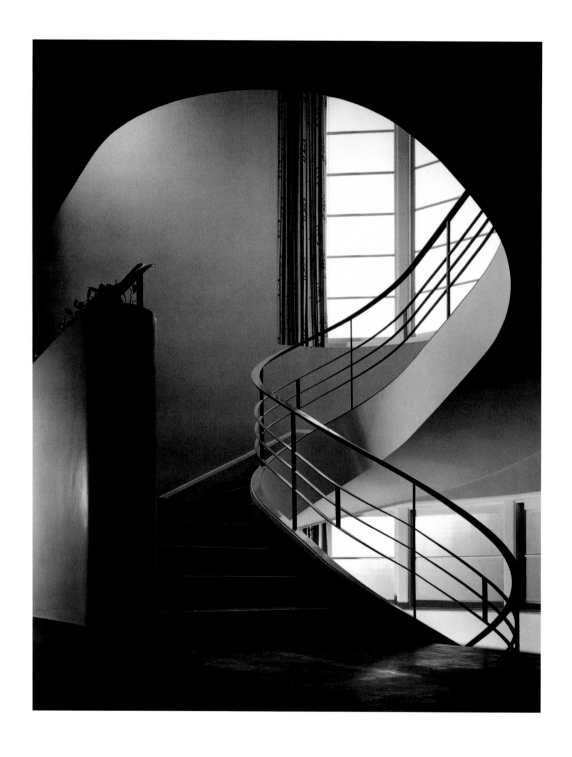

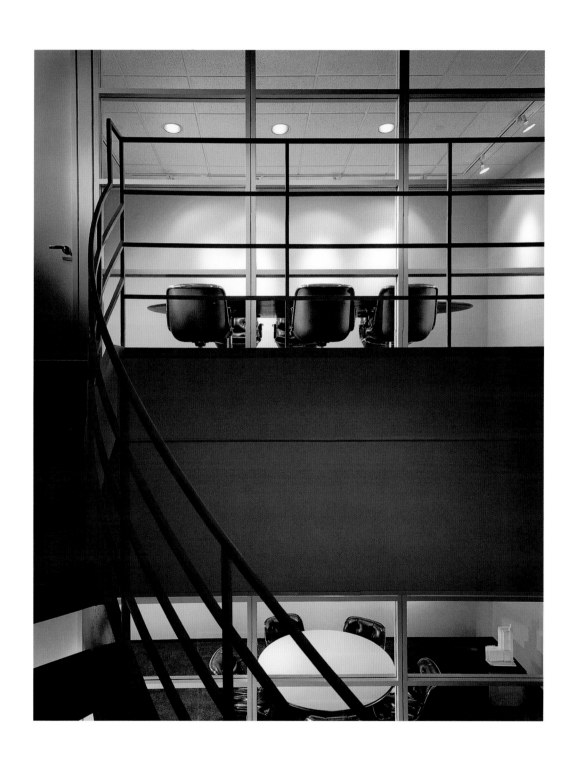

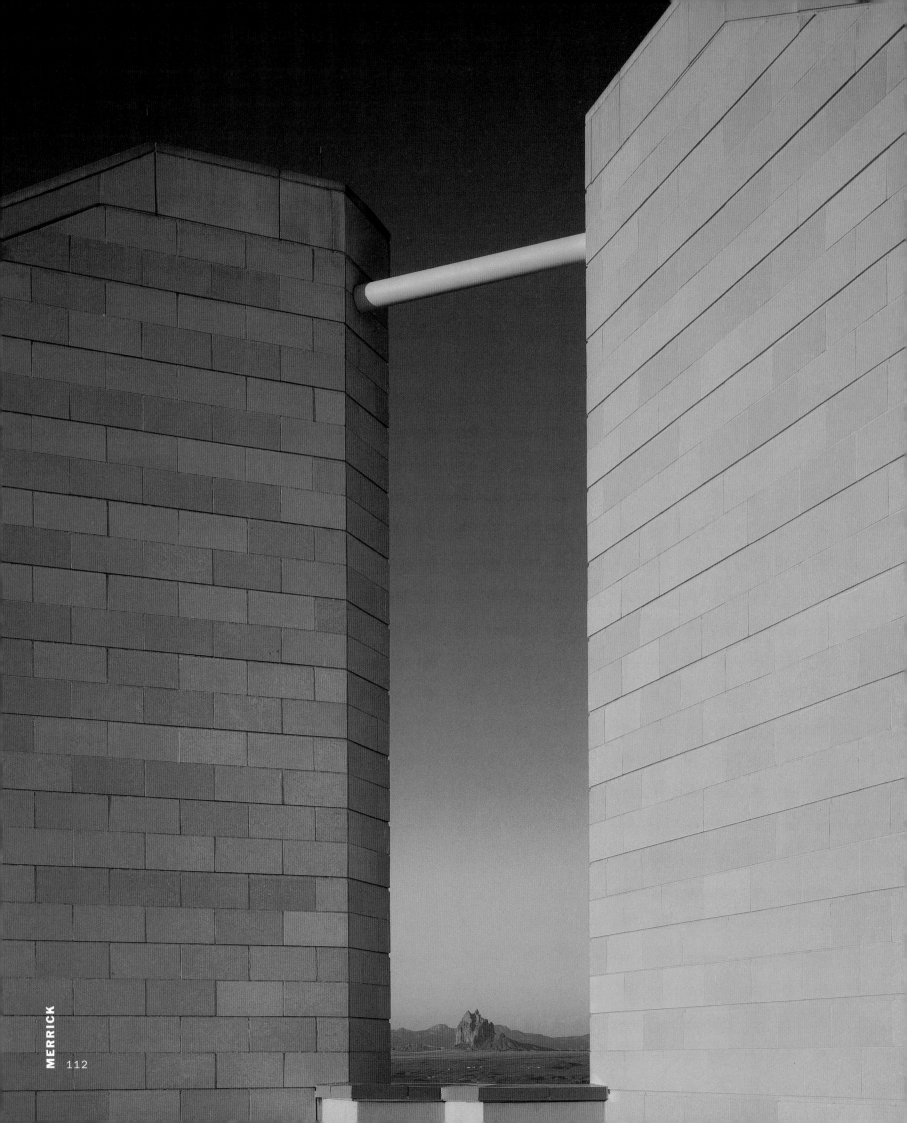

112 **NICK MERRICK**
1994
Northern Navajo
Medical Center
Shiprock, New Mexico
Architect: Anderson
DeBartolo Pan

Shiprock Monument is a volcanic monolith rising over 700 feet above the desert floor. It is also an important spiritual and healing site, which figures prominently in the origin story of the Navajo people. The hospital, located fifteen miles away, was designed to give each patient room a view of Shiprock and overall to have a metaphorical resemblance to the monument. This photograph, made at sunrise, is a view through the "cones" atop Shiprock back to the monument itself.

117 **BILL HEDRICH**
1938
North Pole Ice Cream Parlor
River Forest, Illinois
Architect: Bertrand Goldberg

118 **STEVE HALL**
1997
Little Village Academy
Chicago, Illinois
Architect: Ross-Barney &
Jankowski Architects

Carol Ross-Barney's bold geometric forms and vibrant colors serve as a beacon in hard urban environments. Elementary school children and teachers alike are energized and uplifted. Her design exemplifies the power of architecture to transform one's experience of place.

119 **G. TODD ROBERTS**
1999
Lear Corporation
Dearborn, Michigan
Architect: Neumann Smith
& Associates

120–121 **STEVE HALL**

1986

Coal Power Plant 1939

Near Kalamazoo, Michigan

These images were made during my days working with my mentor, Nick Merrick. These photographs were the first serious body of work I made with a view camera—one of the studio's old eight-by-ten-inch Deardorff's with Tri-X film. Since I was not formally trained in photography, I was studying Nick's work, Ken and Bill Hedrich's, Ezra Stoller's, Edward Weston's, and Eugene Atget's. These images were made during a couple of days working in the intense and silent atmosphere of the abandoned building.

122 **BILL HEDRICH**

1967

Auditorium Theater

Chicago, Illinois

Architect: Adler & Sullivan, 1887

Renovation Architect: Harry Weese Associates

123 **NICK MERRICK**

1981

Orchestra Hall

Chicago, Illinois

Architect: Daniel Burnham, 1905

Renovation Architect: Skidmore, Owings & Merrill

124–125 **BILL HEDRICH**

1939

Skyline, Palmolive Building

Chicago, Illinois

Architect: Holabird & Root

It began to rain when we were setting up on North Avenue beach for this night shot of the Palmolive Building. Then the lightning began, and I made this exposure by just removing the cap from the lens.

126 **BOB SHIMER**

1985

Negley Paint Company

Headquarters

Schertz, Texas

Architect: Chumney/Urrutia

127 **BOB SHIMER**

1994

Southwestern Bell

Mobil Retail Outlet

Oklahoma City, Oklahoma

Architect: Rand Elliott

128 **BOB HARR**

1975

5551 South University

Chicago, Illinois

Architects: Keck & Keck

129 **KEN HEDRICH**

1930

Diana Court,

Michigan Square Building

Chicago, Illinois

Architect: Holabird & Root

Sculptor: Carl Milles

130–131 **NICK MERRICK**

1983

The Painted Apartment

Chicago, Illinois

Architect: Krueck and Olson

Ron Krueck told me that his client, a major art collector, had come to him asking to live within a piece of art—instead of beside it. For Ron, the photography was to be an extended exploration upon a theme. That attitude allowed me to use his three-dimensional, live-in piece of art as a starting point for the creation of unique, two-dimensional photographs.

132 **KEN HEDRICH**
1932
Hodge Residence Stairway
Highland Park, Illinois

133 **JON MILLER**
1997
Sioux City Arts Center
Sioux City, Iowa
Architect: Skidmore,
Owings & Merrill
Design Architect: Joseph
Gonzales

The challenge was to find the simplicity and order that existed within a complex design scheme. The solution was to emphasize and distort the simple shapes and let the more complex ones fall away from the lens.

134 **JIM HEDRICH**
1998
Bass Performance Hall
Fort Worth, Texas
Architect: David M. Schwarz
Architectural Services

135 **JUSTIN MACONOCHIE**
1999
Continental Airlines
Commuter Jet Concourse
Cleveland, Ohio
Architect: The Smith Group
Designer: Richard Powell

The trick to shooting in a public space is to capture people in an orderly fashion within a structured composition. Although this shot appears tranquil, most of the time we were being trampled by the hustle and bustle of America on the move.

136 **BOB SHIMER**
1992
Private Residence
Connecticut
Architect: Rand Elliott

I love the intense blue that results from using tungsten film outside at dusk. The night was in fact cloudy, but the strong blue masked that fact.

137 **CHRIS BARRETT**
1998
Fixler Residence
Palm Beach, Florida
Architects: Powell/Kleinschmidt

138 **JIM HEDRICH**
1990
Marriott Hotel, Solana
Dallas, Texas
Architect: Legorreta Arquitectos

139 **JIM HEDRICH**
1988
IBM, Solana
Dallas, Texas
Architect: Legorreta Arquitectos

140–141 **JIM HEDRICH**
1988
Solana
Dallas, Texas
Architect: Legorreta Arquitectos

142 **SCOTT MCDONALD**
1987
Midway Airport
Airplane Hanger
Chicago, Illinois
Architect: Paul Shaver

143 **BOB SHIMER**
1995
Skyline
Chicago, Illinois

144 **BOB HARR**
1994
Indiana Government Center
Indianapolis, Indiana
Architect: HNTB

145 **JON MILLER**
1999
Nikken Corporation
Headquarters
Irvine, California
Architect: Gensler
and Associates
Design Architect: Jeffrey Hall

146 **BOB SHIMER**
1990
Practice Center for
the Ballet Oklahoma
Oklahoma City, Oklahoma
Architect: Rand Elliott

*We were trying desperately to get
the old car moved from in front of
the building, because the sunset
was tremendous…and fading.
So we shot anyway. In reality,
the car represents well the priva-
tions of the neighborhood, as well
as the hardships that dancers
endure to pursue their art.*

147 **BOB SHIMER**
1984
CTA Terminal, O'Hare Airport
Chicago, Illinois
Architect: Helmut Jahn

148 **CRAIG DUGAN**
1999
Krunzinski Building
Oak Brook, Illinois
Architect: Kwasek Architects

149 **NICK MERRICK**
1989
Herman Miller Western
Regional Facility
Rocklin, California
Architect: Frank Gehry

*I was immediately struck that
Gehry had set up this complex
as a sort of acropolis, with the
copper pergola in the role of the
Parthenon. The formal clarity
of the relationships between the
various "temples" of the complex
had a visceral effect upon me.*

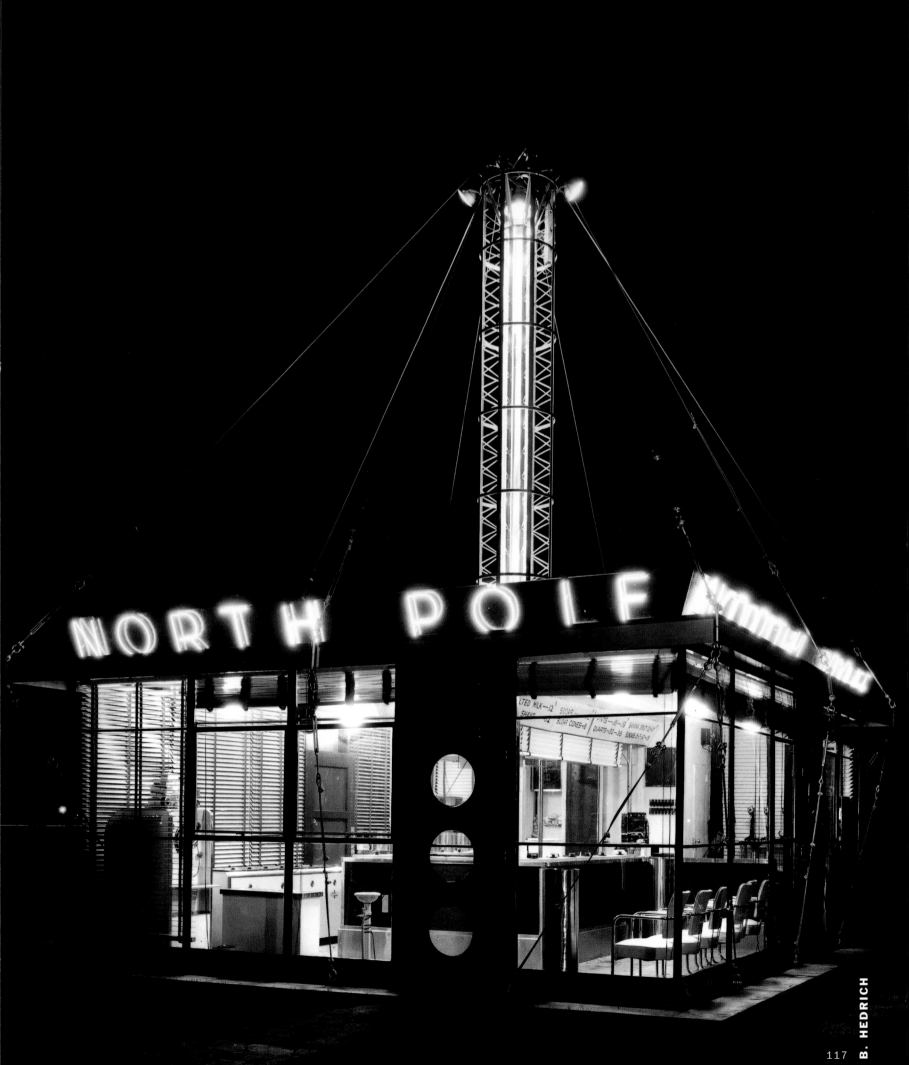

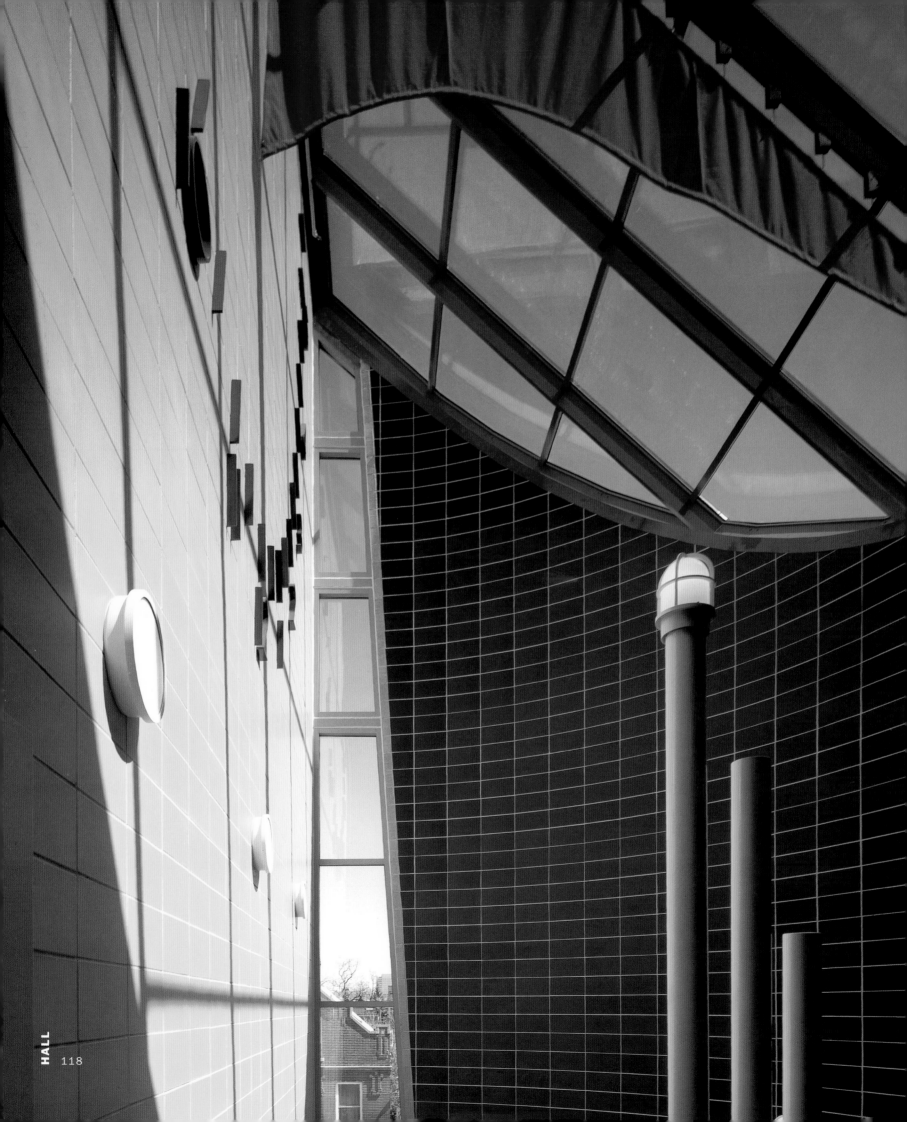

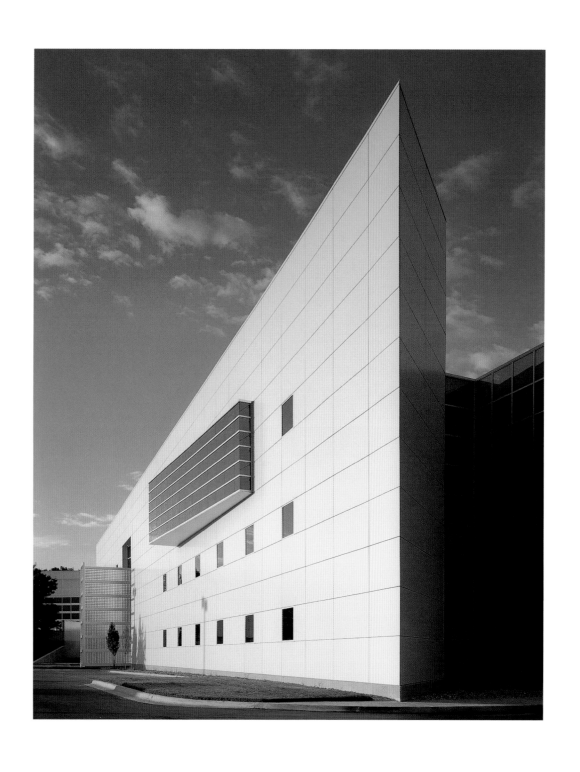

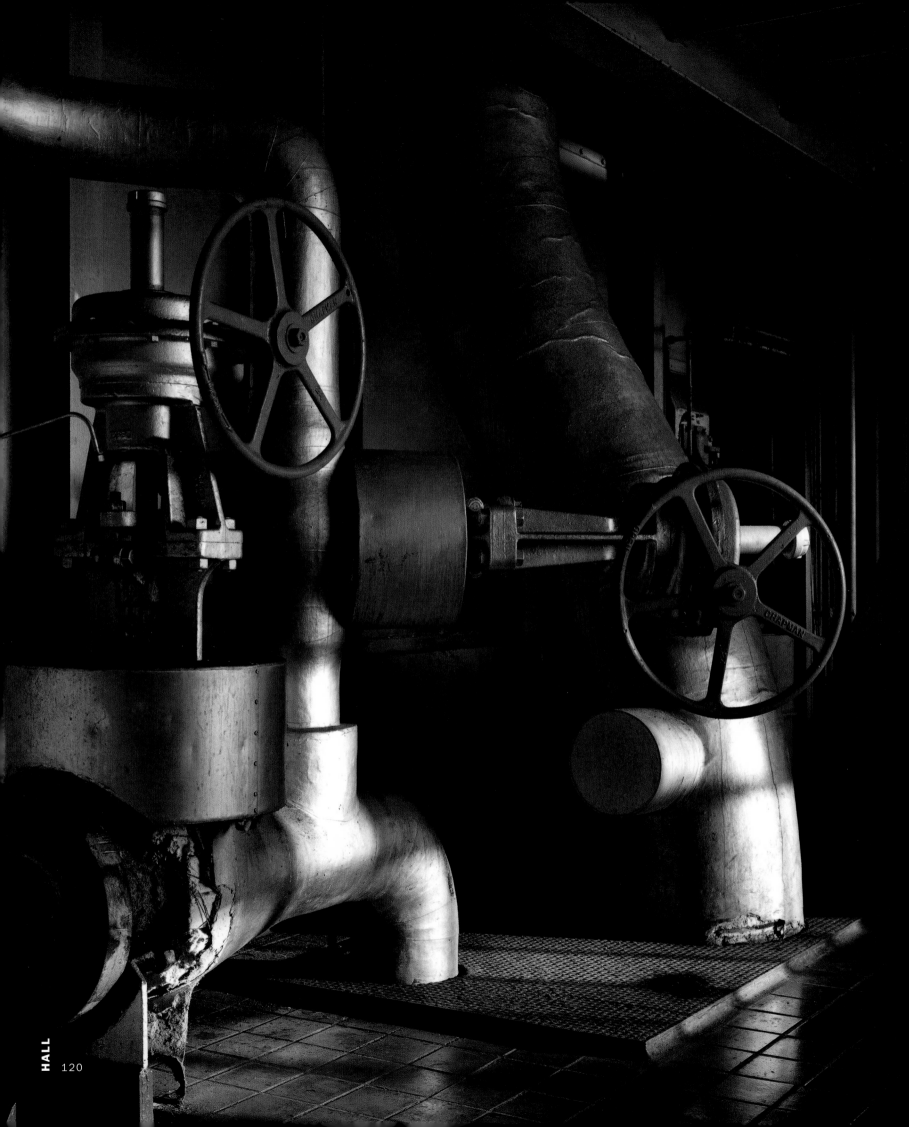

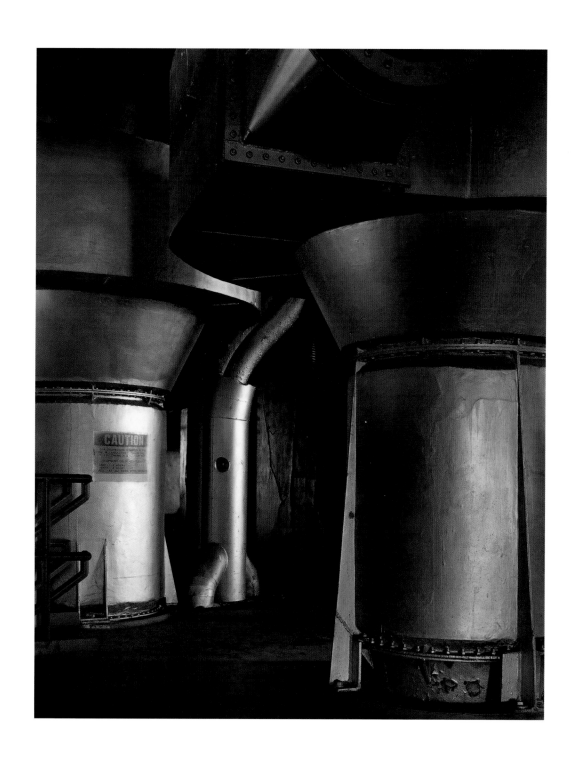

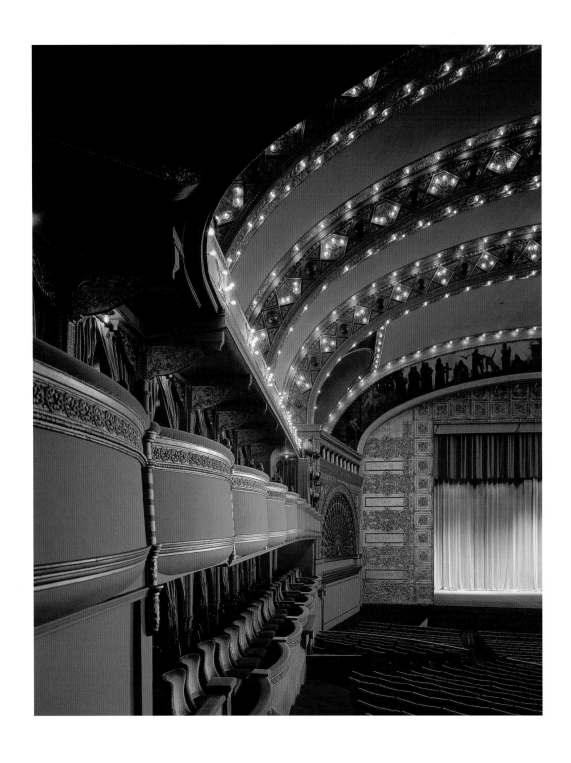

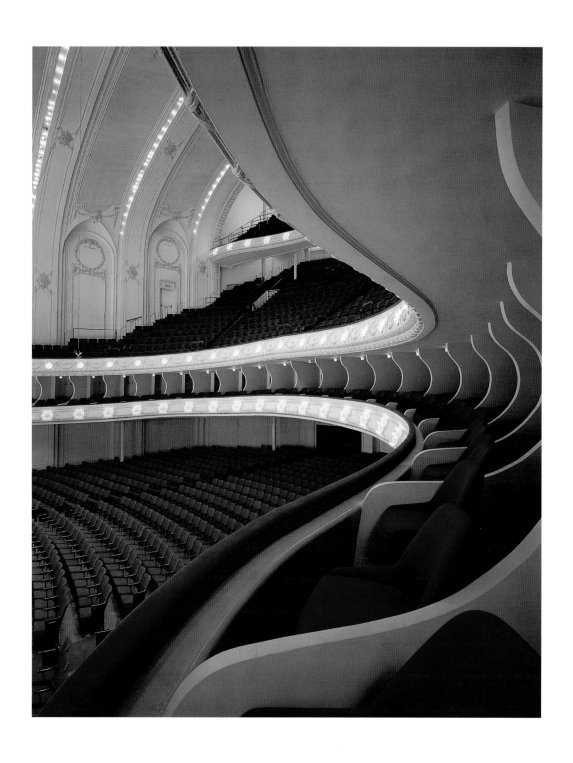

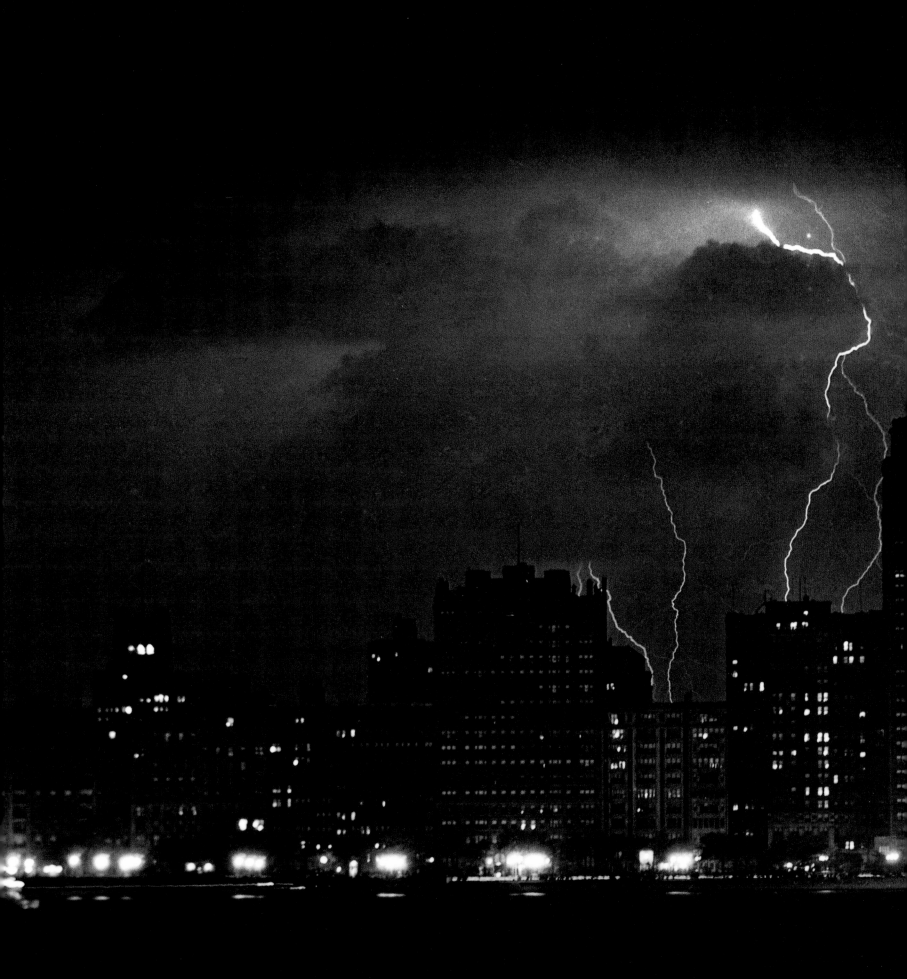

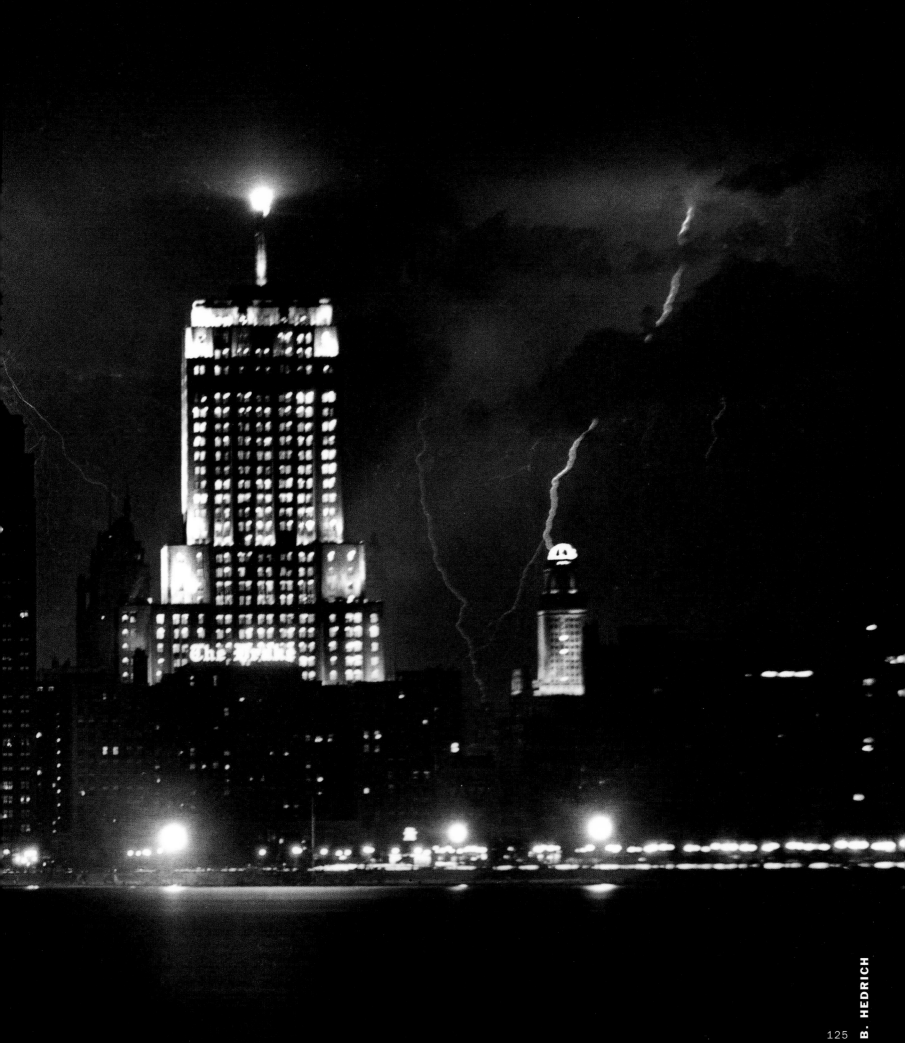

B. HEDRICH

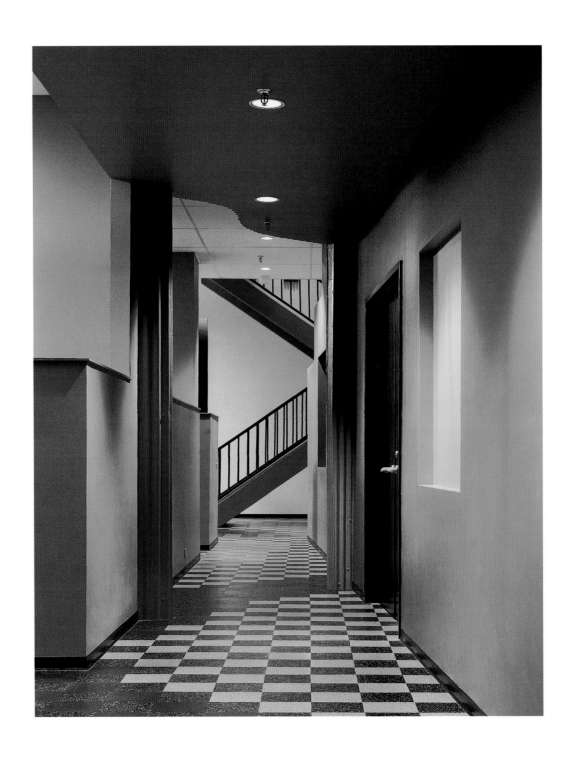

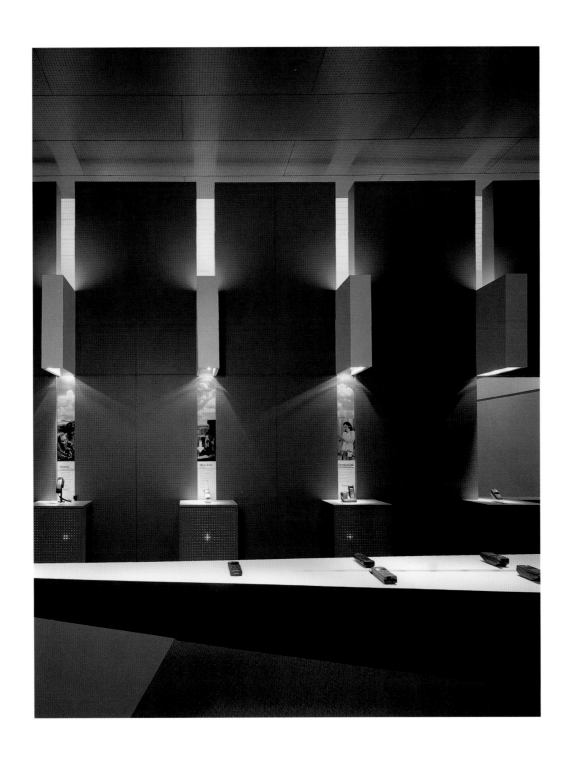

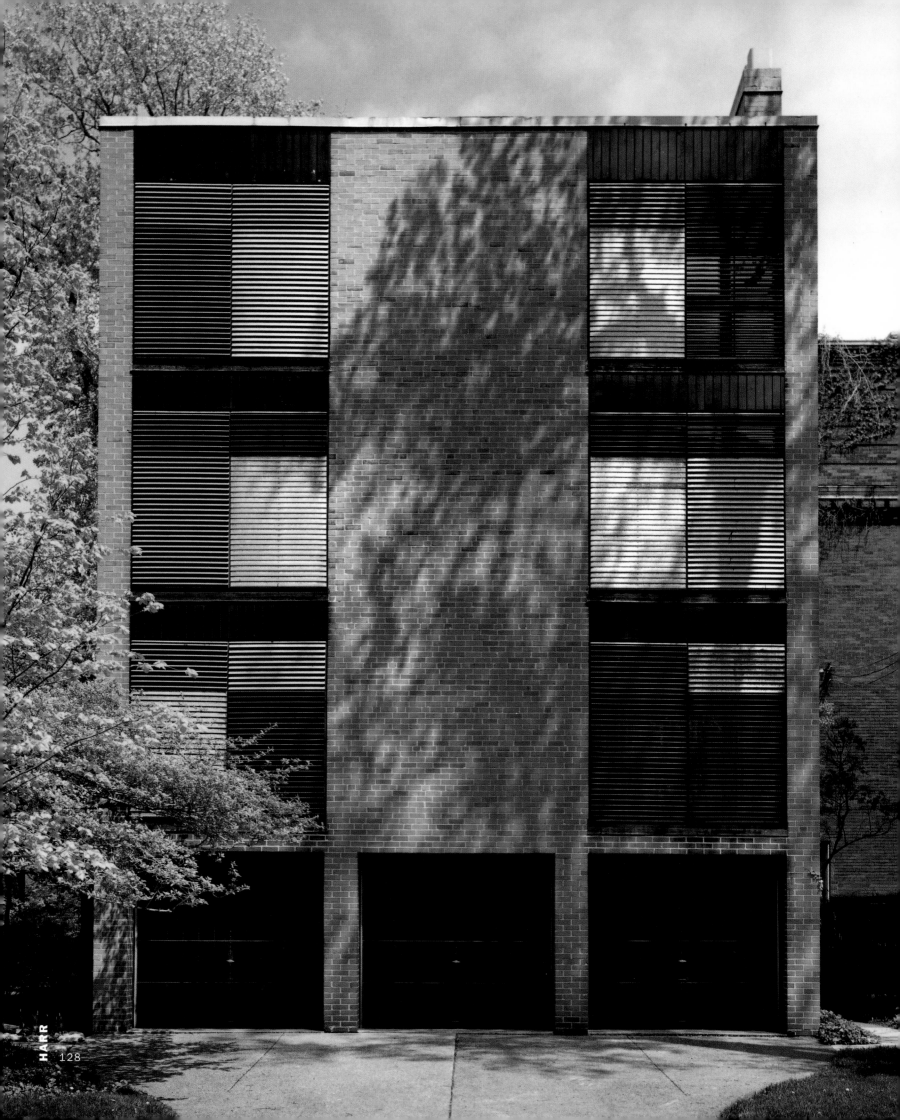

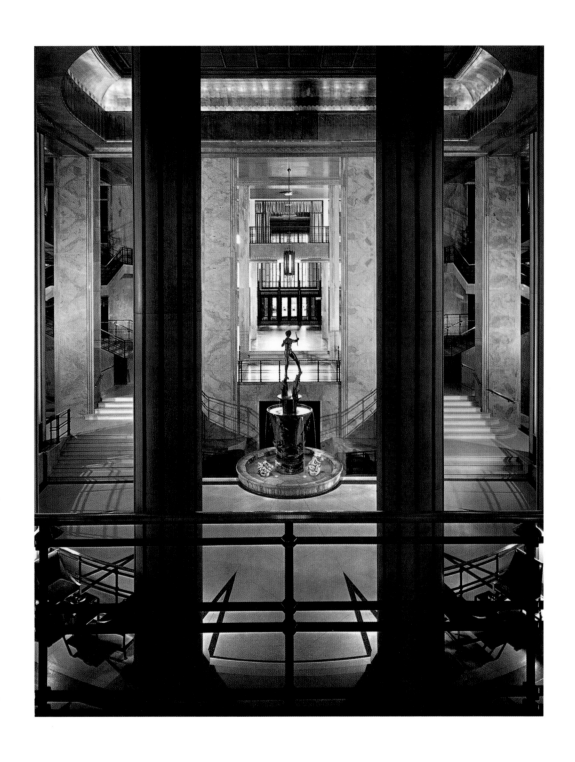

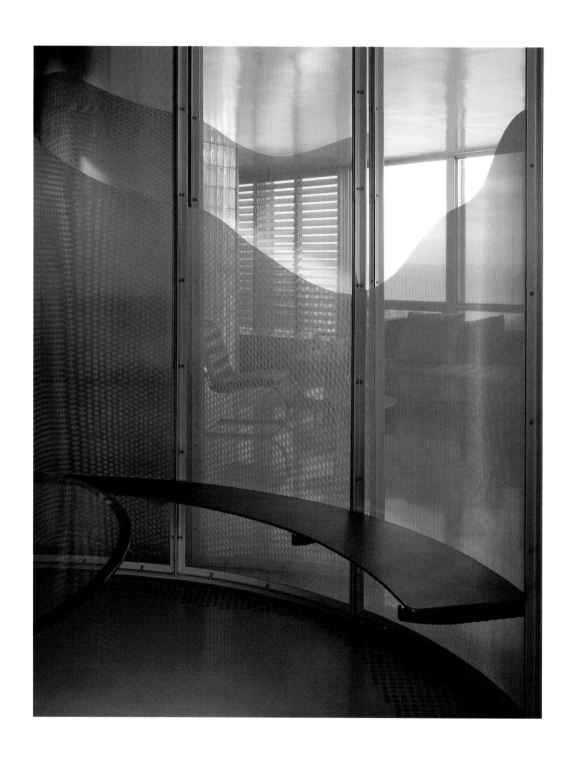

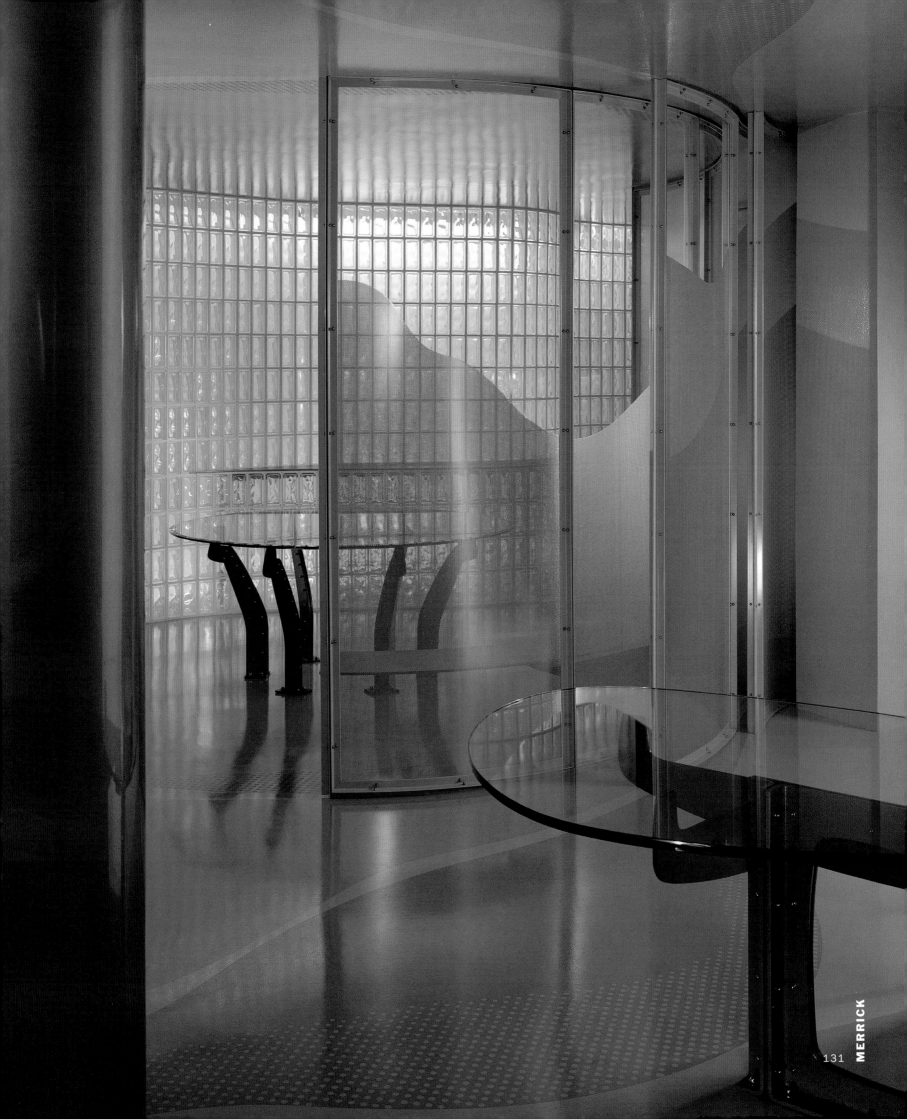

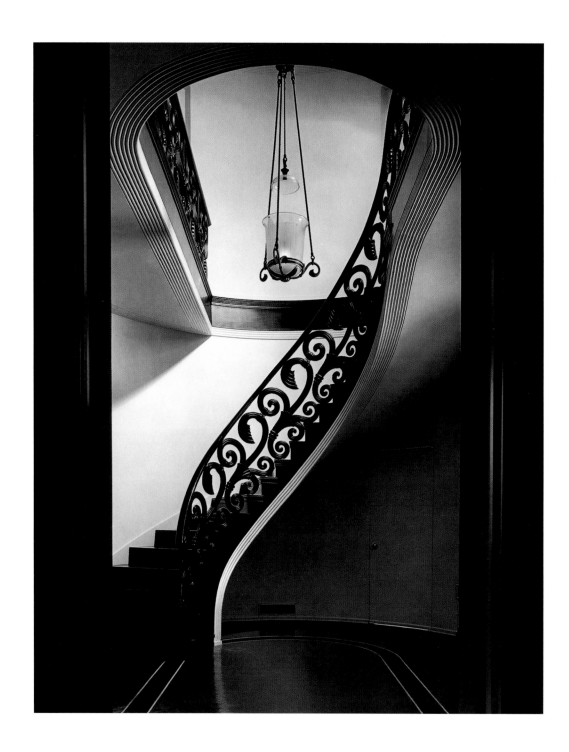

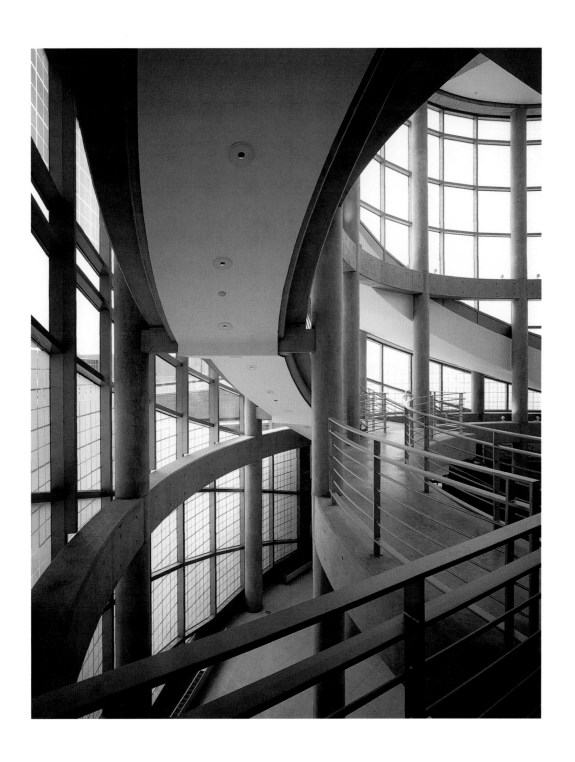

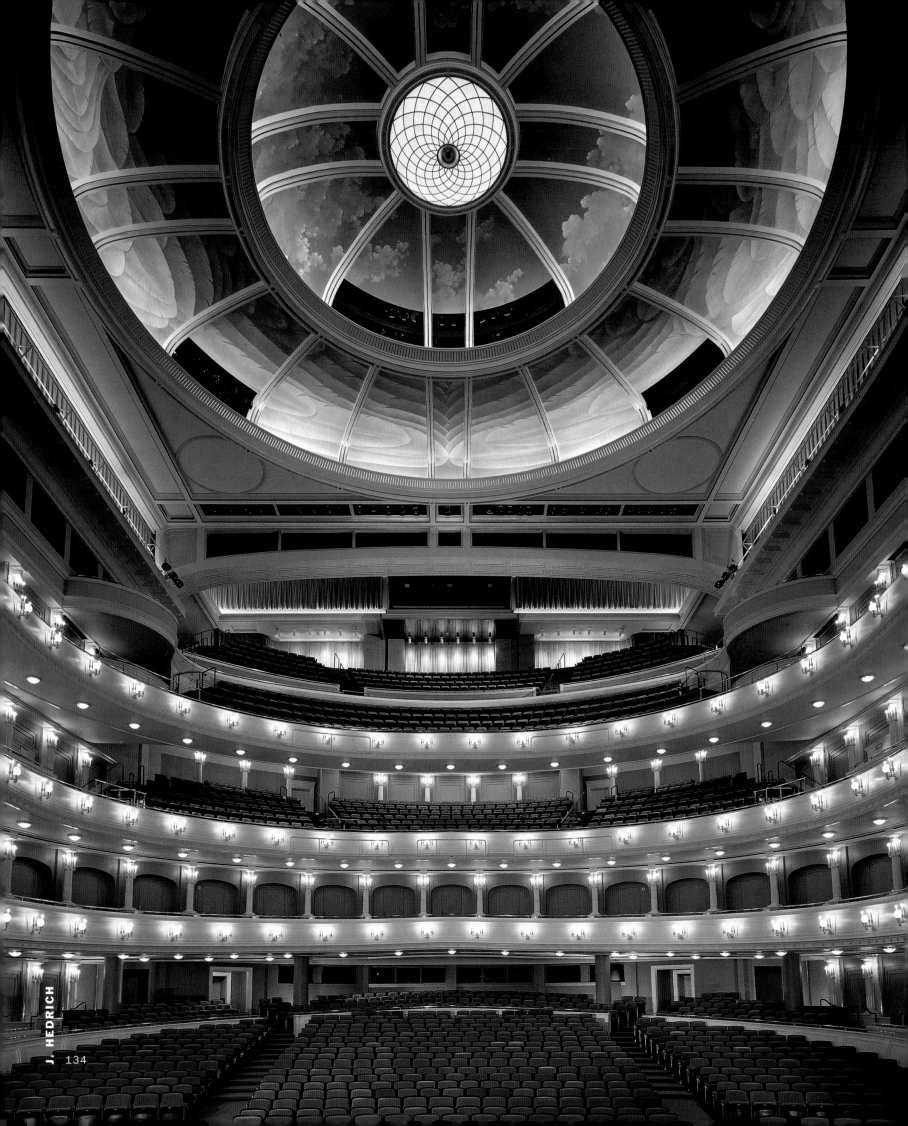

134

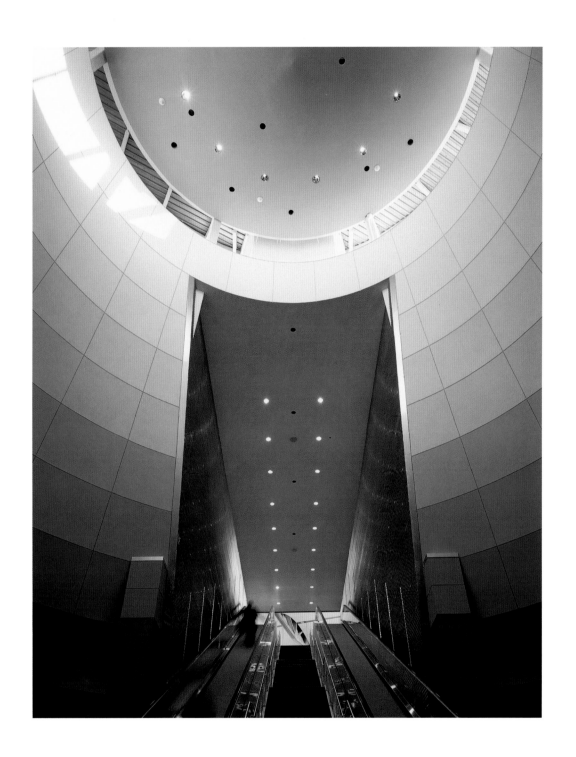

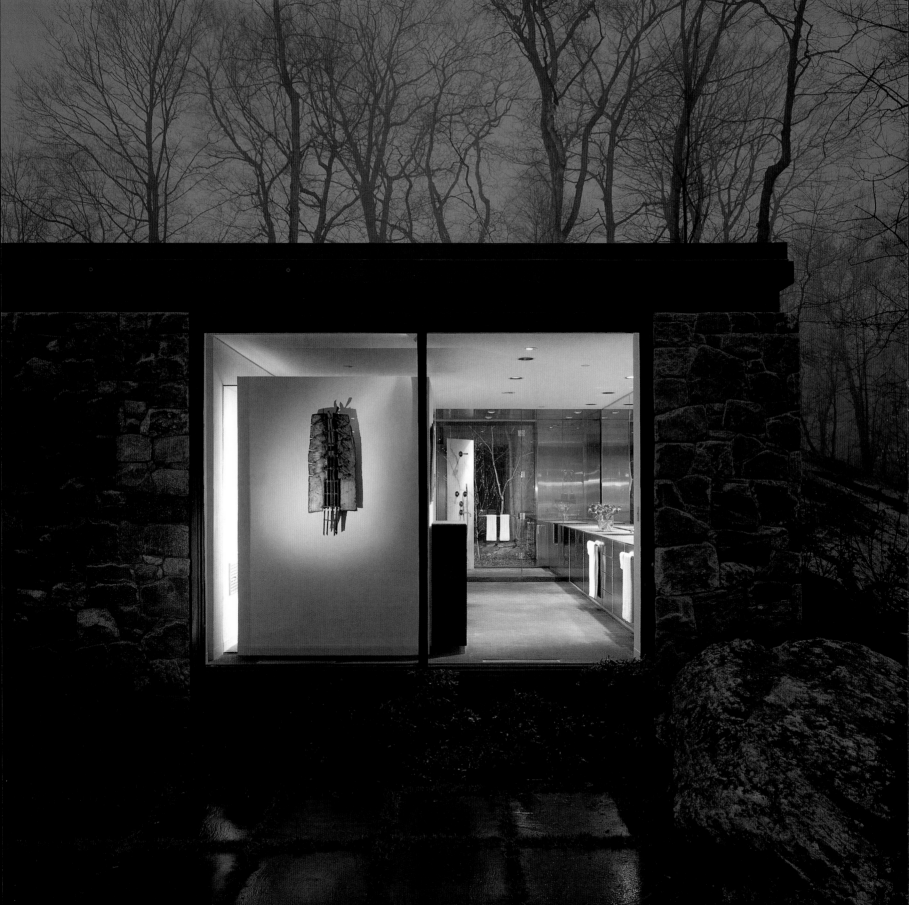

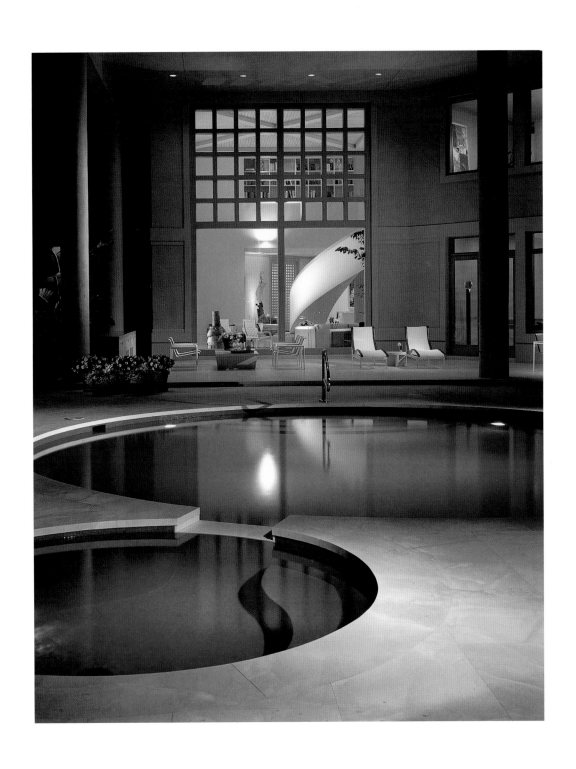

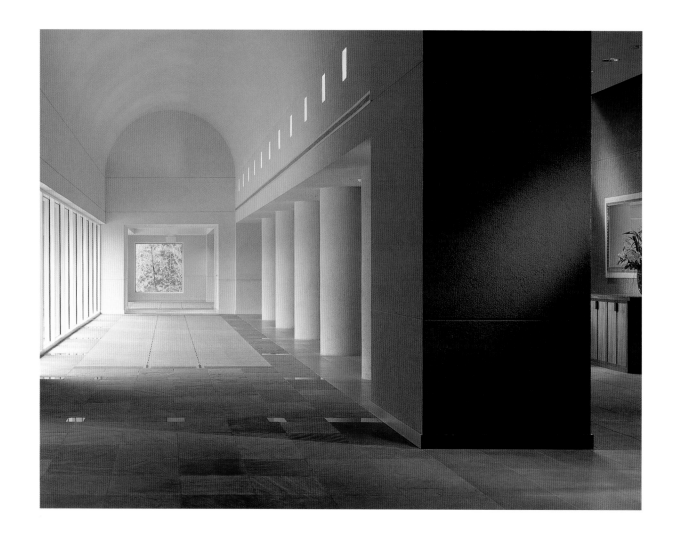

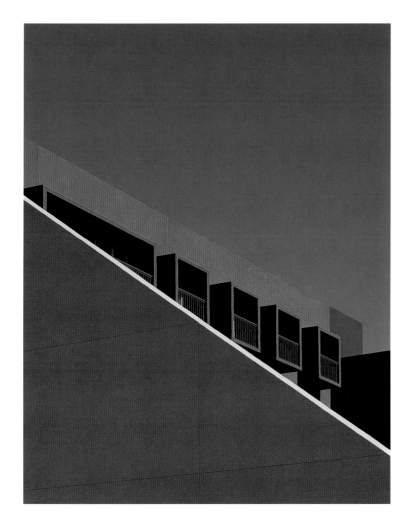
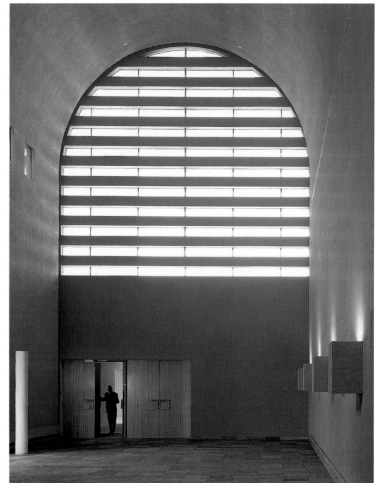

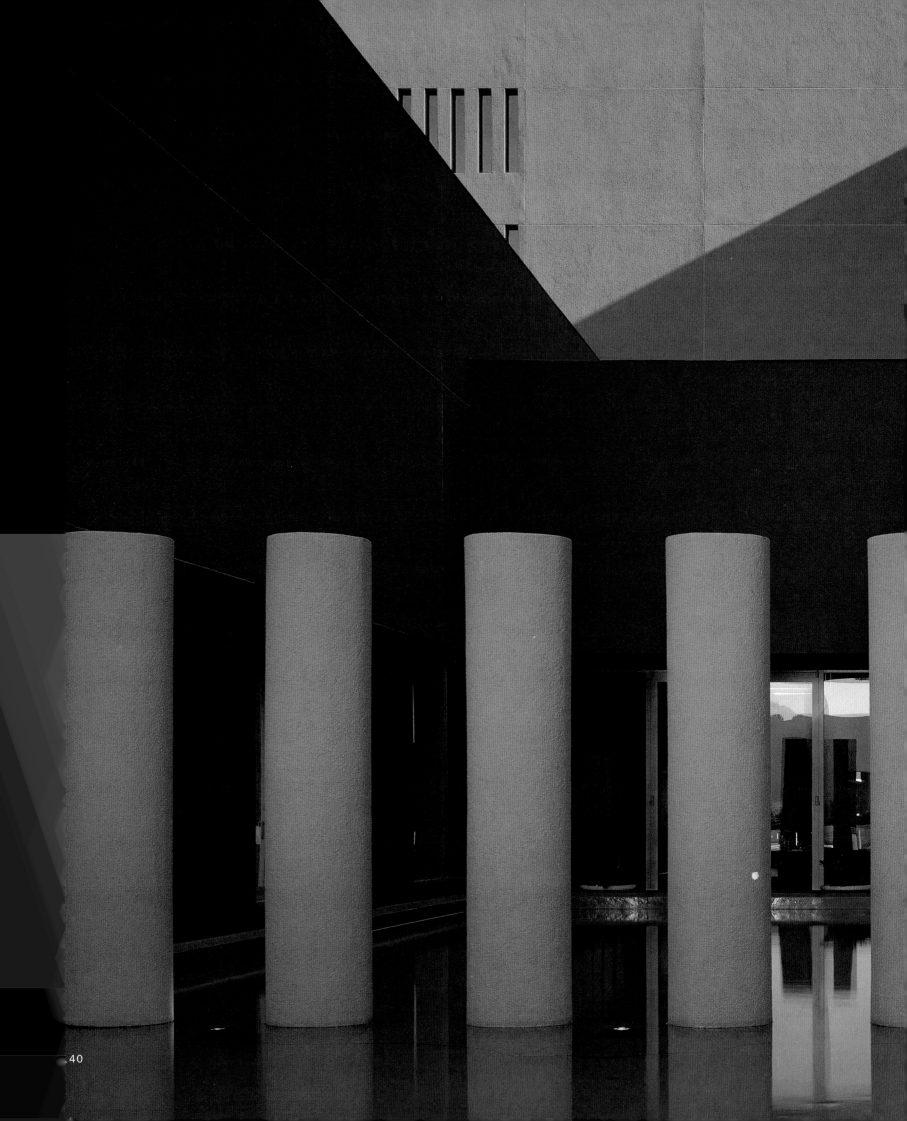

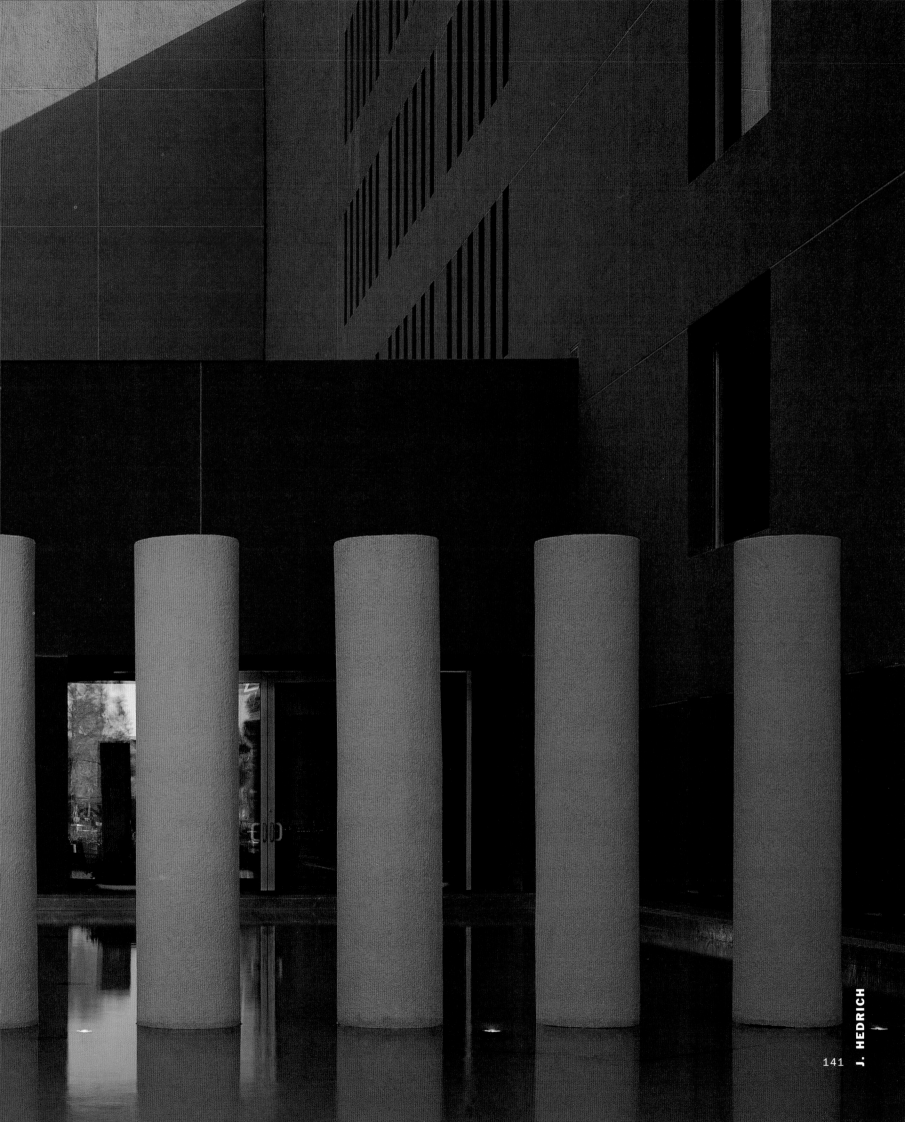

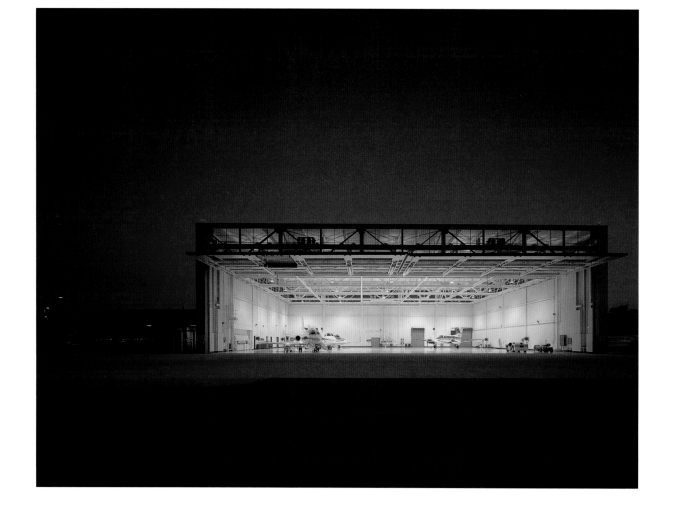

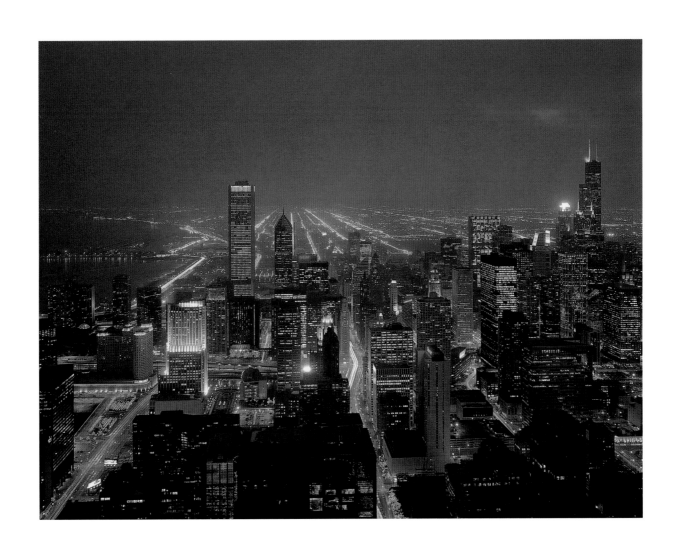

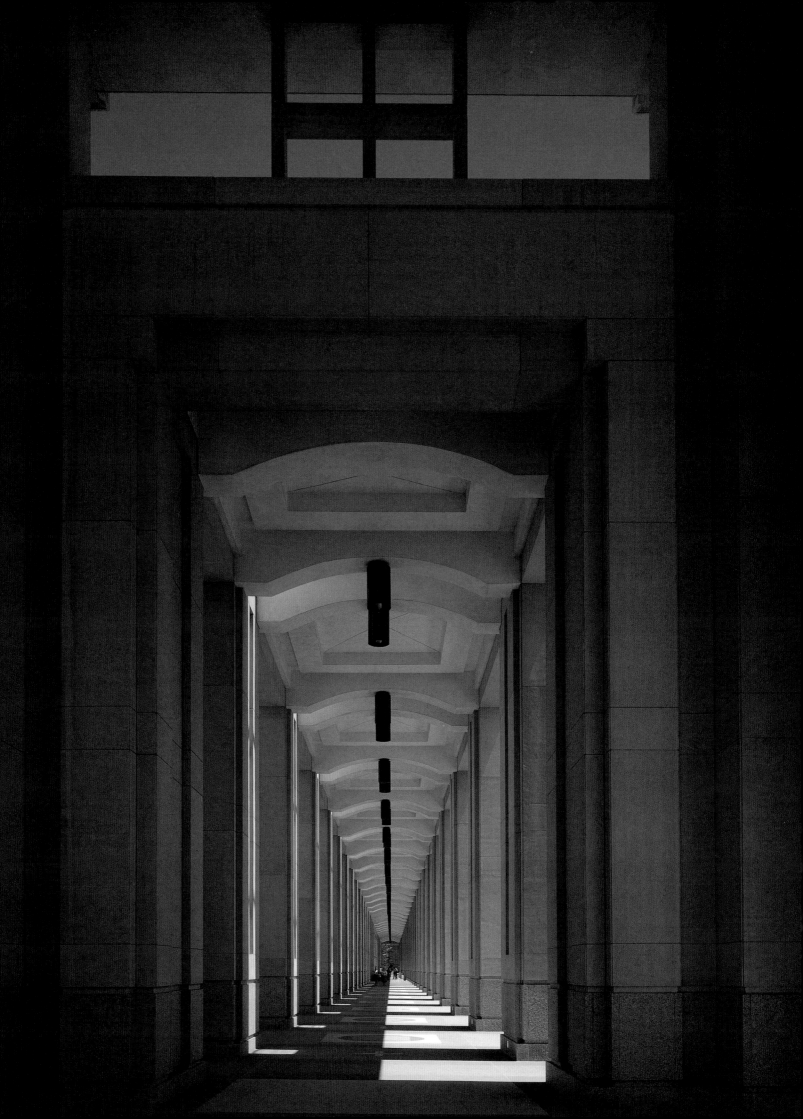

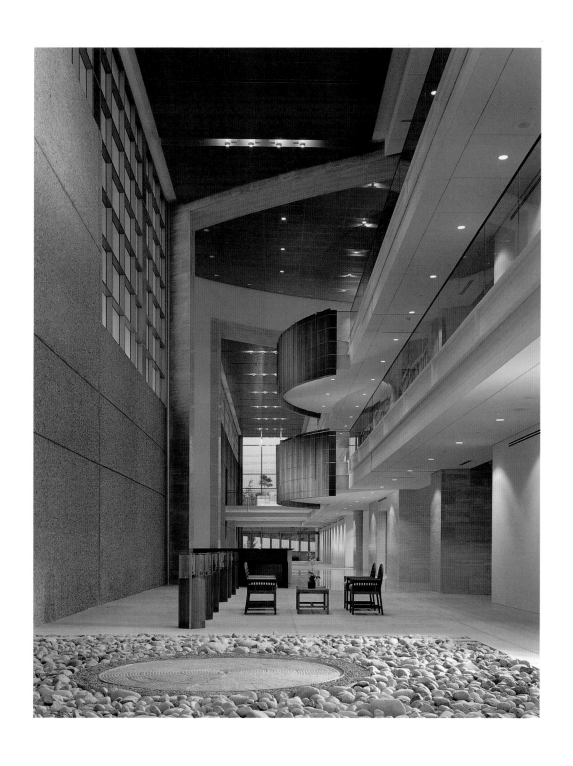

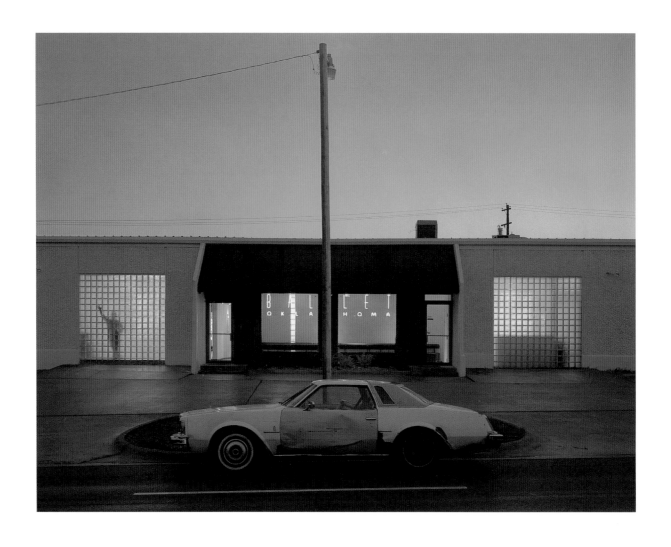

O'Hare

cta 2776

SHIMER

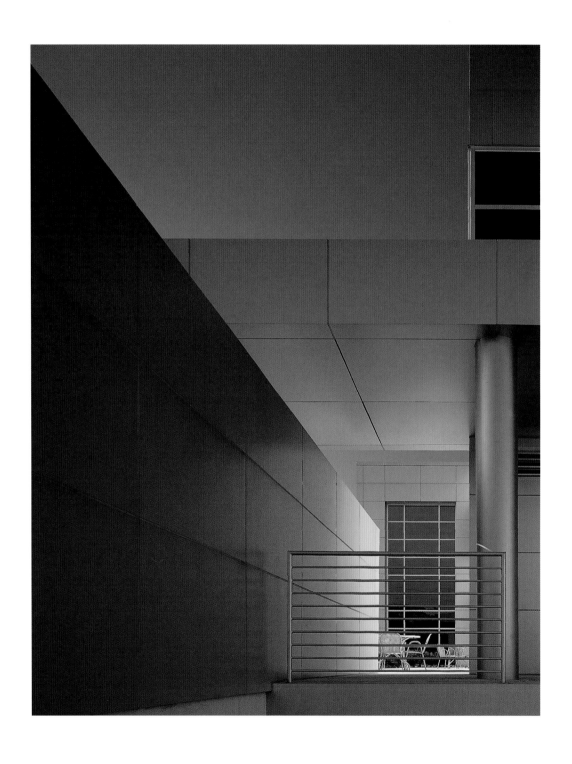

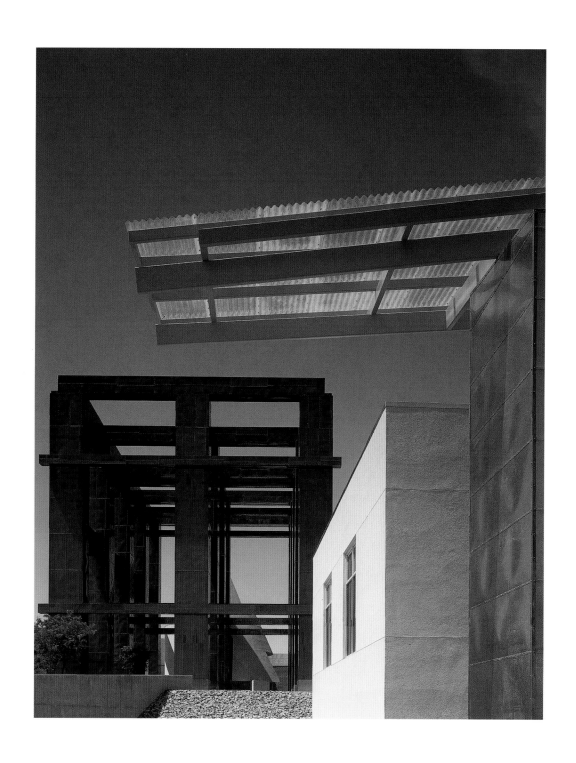

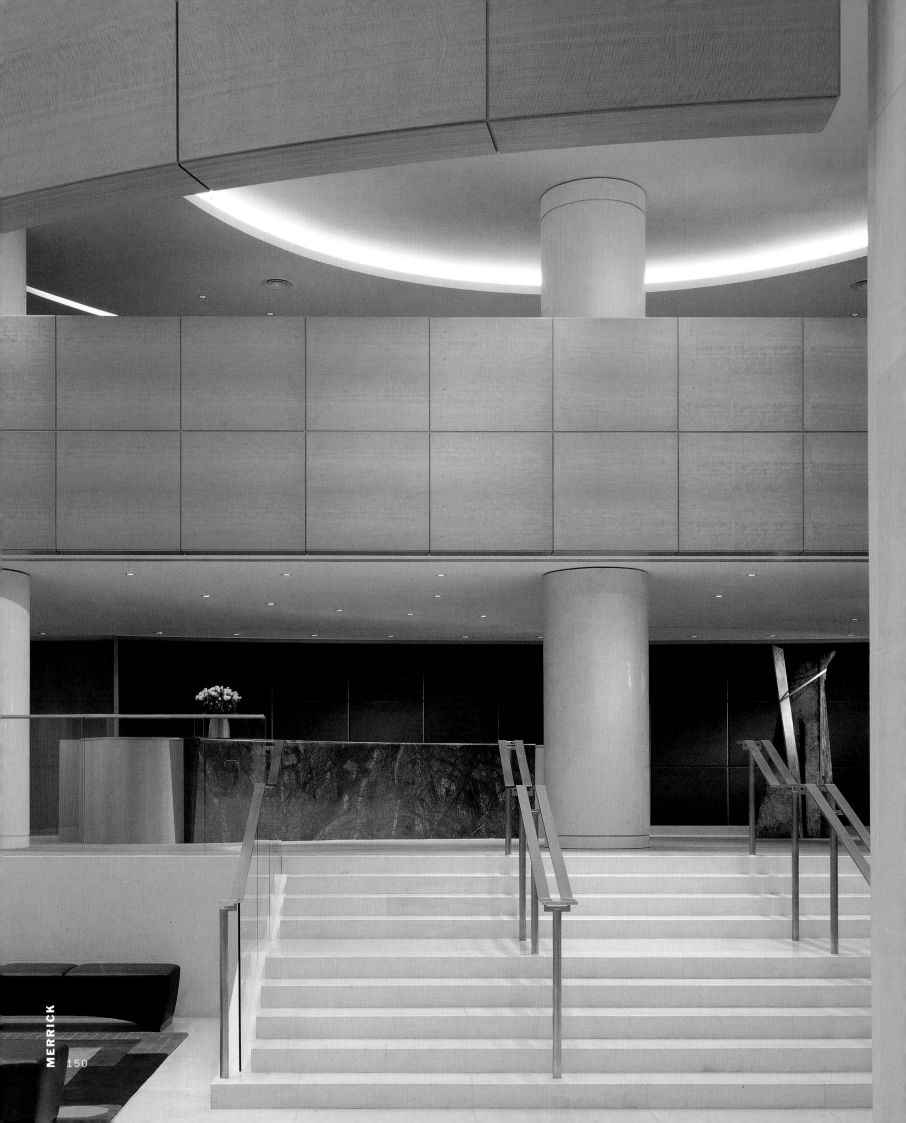

150 **NICK MERRICK**

1998

Linklaters & Paines Law Offices

London, United Kingdom

Architect: Gensler and

Associates

Designers: Antony Harbour

and Donald Brinkman

The spatial clarity and crispness
of detail that characterizes much
of Gensler's work was always at
its best in the hands of Tony and
Don. This was one of Don's last
projects before his untimely death
late that same year. Here Tony
and Don brought elegant
American Modernist interior
design to an old English law
practice.

155 **BILL HEDRICH**

1935

Office of James F. Eppenstein

Chicago, Illinois

Architect: James F. Eppenstein

156 **BOB HARR**

1965

30 North LaSalle Street

(Old Chicago Stock Exchange)

Chicago, Illinois

Architect: Adler & Sullivan,

1894

157 **KEN HEDRICH**

1936

Fisher Apartments

Chicago, Illinois

Architect: Andrew ReBori

158 **NICK MERRICK**

1993

Screen Actors Guild

Los Angeles, California

Architect: Keating Mann

Jernigan Rottet

Designer: Lauren Rottet

159 **JIM HEDRICH**

1972

Sears Tower

Chicago, Illinois

Architect: Skidmore,

Owings & Merrill

Design Architect: Bruce Graham

The Aluminum Company of
America wanted the new Sears
Tower on the cover of their 1972
Annual Report. The building
had been topped off, but the upper
stories were far from complete.
After much scouting, I located
the perfect vantage point atop
the Board of Trade Building.
It enabled me to contrast the
lighted bottom half of the build-
ing against the darkened city
streets and the dark upper stories
against the late afternoon sky.

160–161 **STEVE HALL**
1997
Des Moines Art Center
Des Moines, Iowa
Architects: Eliel Saarinen,
I. M. Pei, Richard Meier
Sculptor: Albert Giacometti,
1947

*The Des Moines Art Center was
a once-in-a-lifetime career
opportunity. The assignment was
to make about fifty black-and-
white images for the monograph,
An Uncommon Vision, celebrat-
ing the Center's Fiftieth
Anniversary. The Center is a
little-known treasure: three
buildings designed by Eliel
Saarinen, 1948; I. M. Pei,
1968; and Richard Meier, 1985.
After several hours of scouting
with the graphic designer, I
came across this view to the
Meier Building; the stairs a
leading line to the building atop
the hill. These first images set
the tone for a week of photo-
graphic exploration.*

162–163 **KEN HEDRICH**
1943
Cranbrook Academy
Bloomfield Hills, Michigan
Architect: Eliel Saarinen
Sculptor: Carl Milles

164 **NICK MERRICK**
1993
Sears Tower Lobby Renovation
Chicago, Illinois
Architect: Skidmore,
Owings & Merrill, 1974
Renovation Architect:
DeStefano and Partners

165 **BILL ENGDAHL**
1964
North Shore
Congregation Israel
Glencoe, Illinois
Architect: Minoru Yamasaki

166 **JON MILLER**
1992
United States Gypsum and
AT&T Buildings
Chicago, Illinois
Architect: Skidmore,
Owings & Merrill
Design Architect: Adrian Smith

167 **JON MILLER**
1991
181 W. Madison Building
Chicago, Illinois
Architect: Cesar Pelli

*This graceful soaring tower made
of granite is topped off with
brushed stainless steel finials.
They catch light and sparkle only
in the summer with the high
angle of the sun, and then only
for twenty minutes.*

168 **BILL HEDRICH**
1942
Taliesin West
Scottsdale, Arizona
Architect: Frank Lloyd Wright

169 **BILL HEDRICH**
1937
Taliesin
Spring Green, Wisconsin
Architect: Frank Lloyd Wright

*The oriental statue in this pic-
ture Wright named "The Ancient
Spirit of Modern Times" was a
favorite piece of his art collec-
tion. One morning, my assistant
gave the statue's backside a loving
pat and asked, "How's everything,
Egg Foo Yong?" Wright became
very irritated and stomped out of
the room, muttering under his
breath about the quality of that
day's youth.*

170 **BOB HARR**
1989
Home Savings
Los Angeles, California
Architect: PHH Environments

*Right place—right time. When
sunlight dominates, timing is
important.*

171 **JIM HEDRICH**
1977
The Stoa of Atticus
Athens, Greece

172–173 **SCOTT MCDONALD**
1999
Club Industrial de Monterrey
Monterrey, Mexico
Architect: RTKL Associates

174 **BOB HARR**
1982
Crystal Cathedral
Garden Grove, California
Architect: Phillip Johnson

175 **BILL HEDRICH**
1966
St. Francis De Sales Church
Muskegan, Michigan
Architect: Marcel Breuer,
Herbert Beckhard

176–177 **JON MILLER**
1995
Frank Lloyd Wright
Home & Studio
Oak Park, Illinois
Architect: Frank Lloyd Wright

Photo: K. Hedrich

Bill Hedrich was Frank Lloyd Wright's favorite photographer. I was lucky enough to be Bill's apprentice: for four years we worked together. We both loved to tell stories, but to listen firsthand to Bill's accounts of Wright and Mies was a wonderful and rich part of my photographic schooling. It was with that spirit that I approached shooting Wright's own home and studio. I tried to use a moodier style of ighting to emulate the way Bill would have lit. The seed of Wright's ideas and early concepts were all there in his laboratory of a house. He was adding on and changing it constantly. The evolution of his thought process was all there: the whimsy of the tree he built around in the passage from the home to the studio; the explosion of scale one experiences entering the studio; the magical space of the children's playroom. It is the most joyous and playful room that Wright created for his young family.

178–179 **KEN HEDRICH**
1939
U.S. Gypsum Plant
Genoa, Ohio

180 **NICK MERRICK**
1994
Trip Travel Agency
Los Angeles, California
Architect: AREA
Designers: Walt Thomas
and Henry Goldston

181 **JIM HEDRICH**
1989
Johnston Residence
Franklin, Michigan

182 **BILL HEDRICH**
1971
Geraghty Residence
Des Moines, Iowa
Architect: Jack Bloodgood

183 **BILL HEDRICH**
1952
Private Residence
Midland, Michigan
Architect: Alden B. Dow

184 **JON MILLER**
1997
Michigan Avenue Apartment
Chicago, Illinois
Architect: Vallerio DeWalt Train

185 **BOB SHIMER**
1995
Oklahoma City Chamber of
Commerce Headquarters
Oklahoma City, Oklahoma
Architect: Rand Elliott

186–187 **NICK MERRICK**
1994
Herman Miller
Eames Furniture
Galisteo, New Mexico

*Herman Miller was considering
reintroducing a line of their
classic furniture to the consumer
market. As an initial marketing
strategy, I proposed classic furni-
ture in timeless settings—and
made these test photographs on
my property in New Mexico.*

188 **BILL ENGDAHL**
1966
Christian Science Student
Center, University of Illinois
Urbana, Illinois
Architect: Paul Rudolph

191 **JON MILLER**
1987
Texas Commerce Bank Lobby
Dallas, Texas
Architect: Skidmore,
Owings & Merrill
Interior Designer: Debra
Lehman-Smith

192 **KEN HEDRICH**
1943
Cranbrook Academy
Bloomfield Hills, Michigan
Architect: Eliel Saarinen
Sculptor: Carl Milles

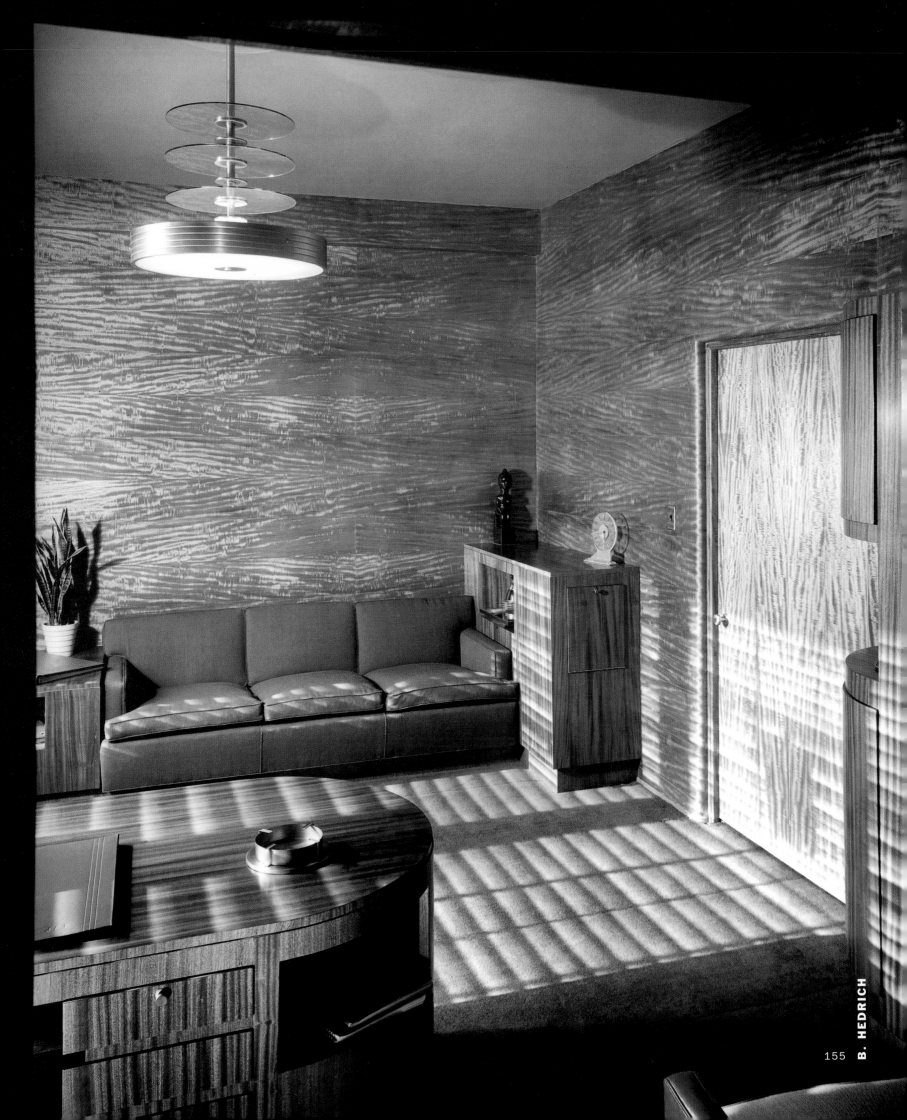

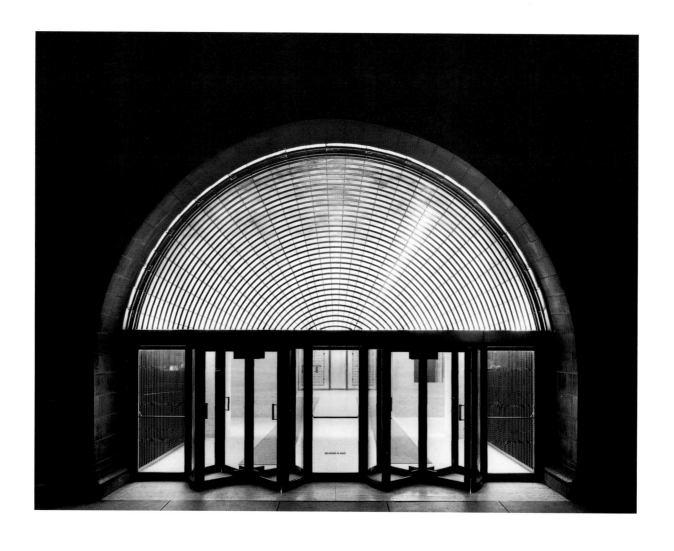

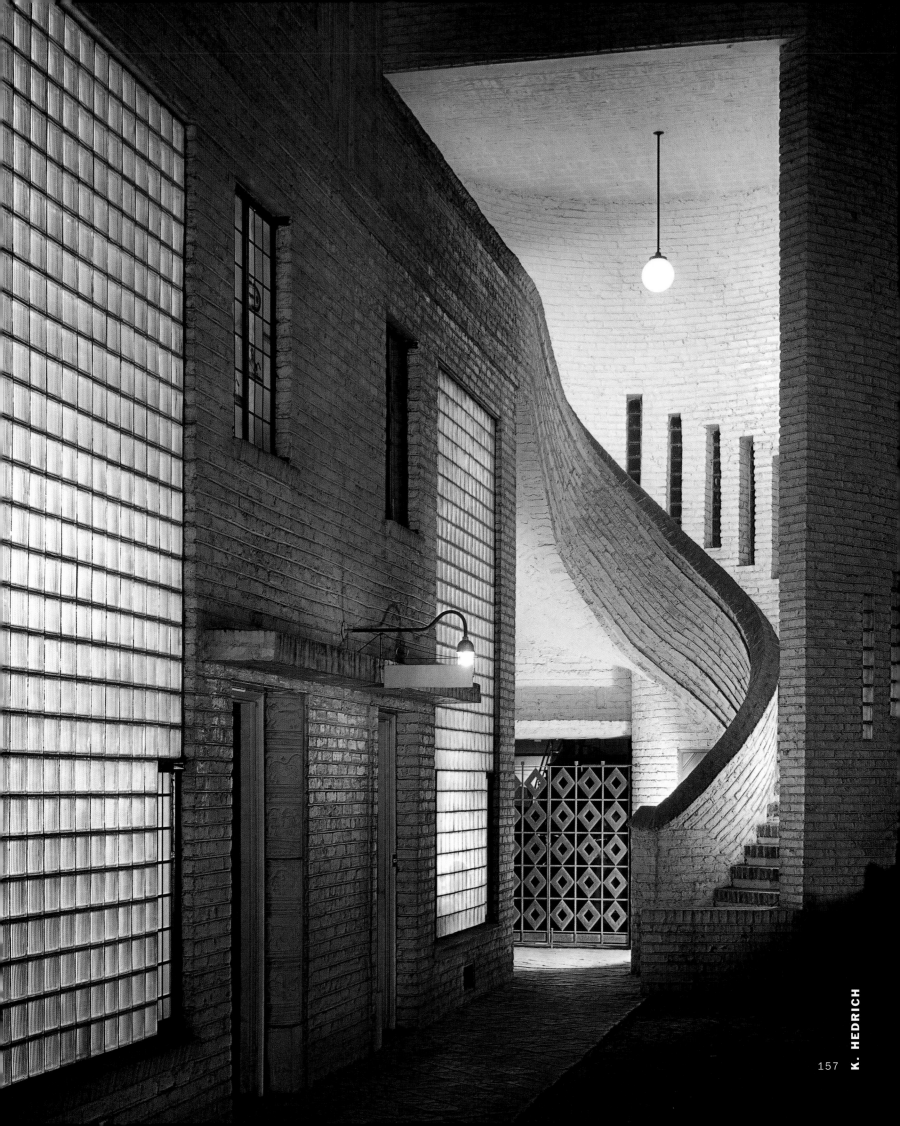

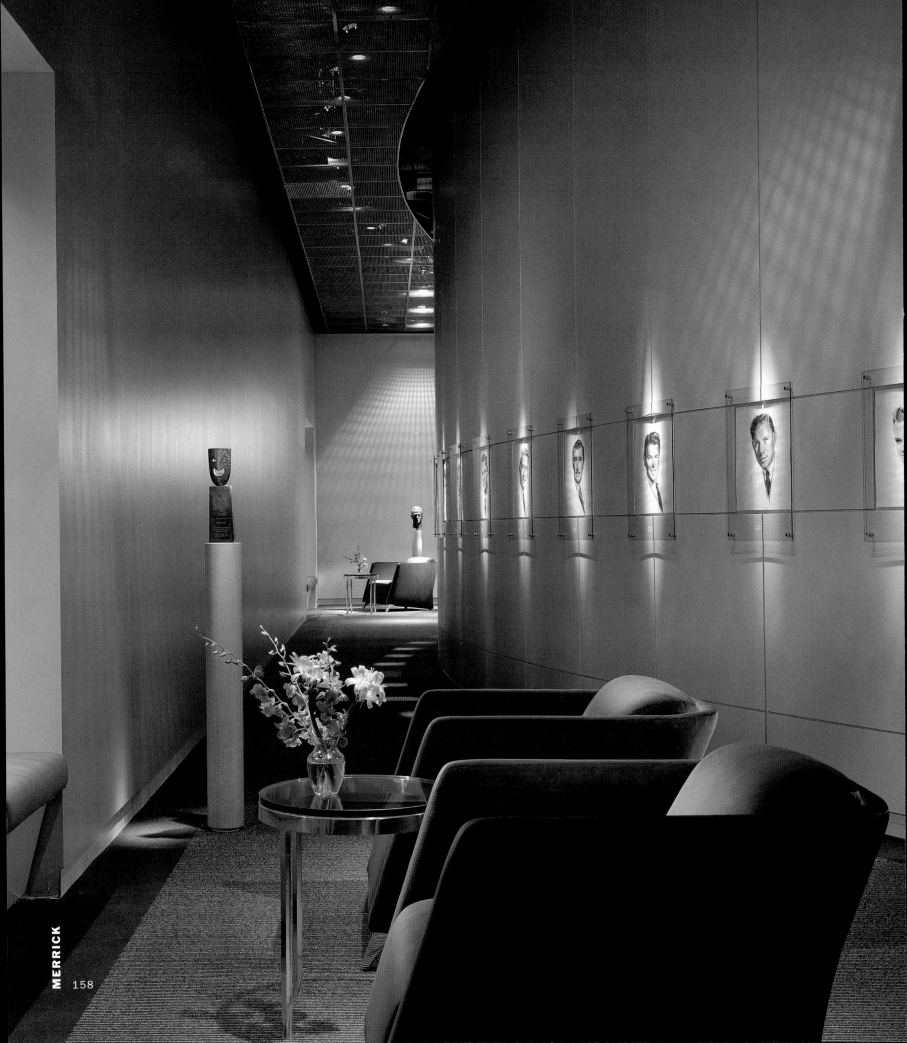

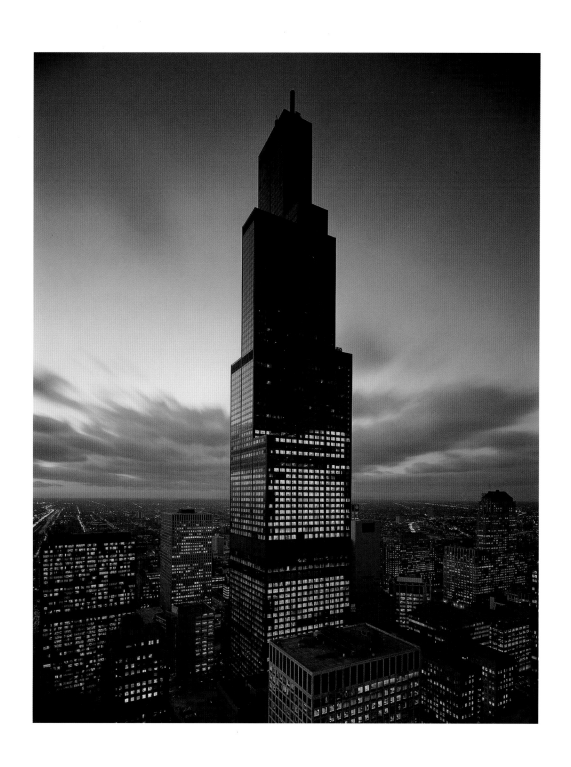

J. HEDRICH

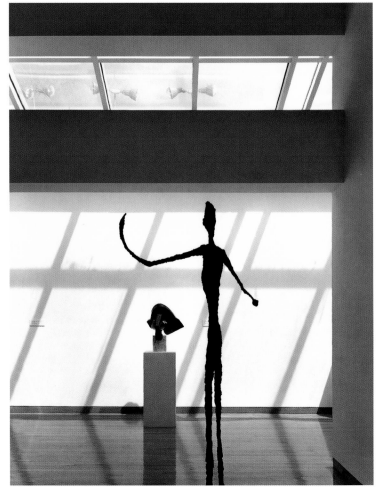

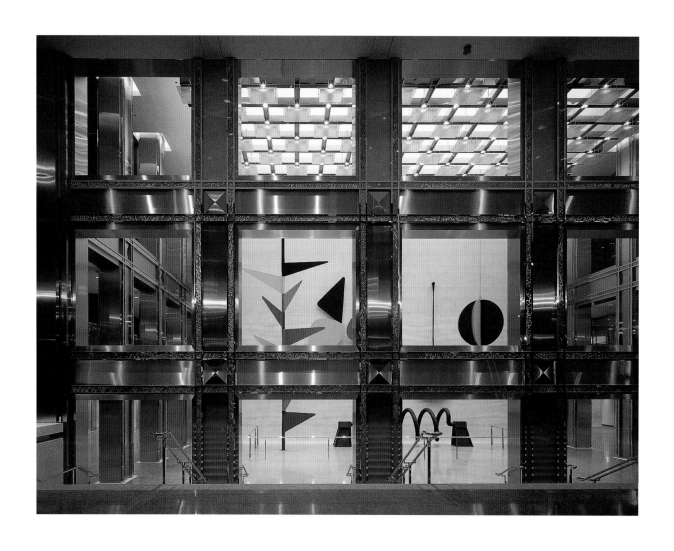

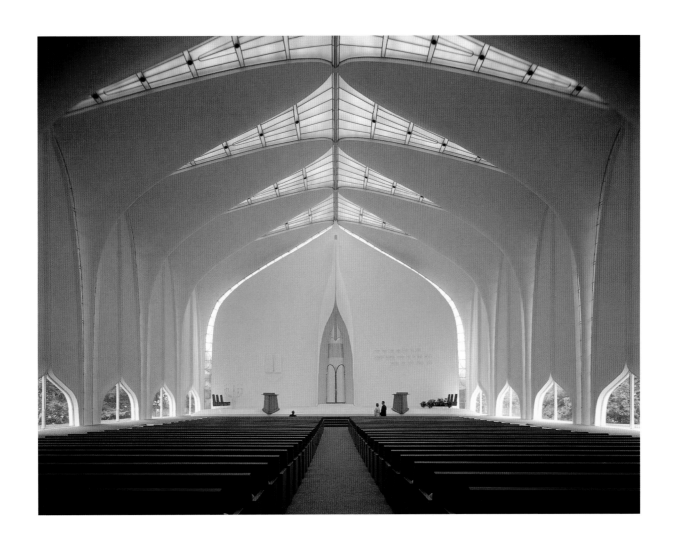

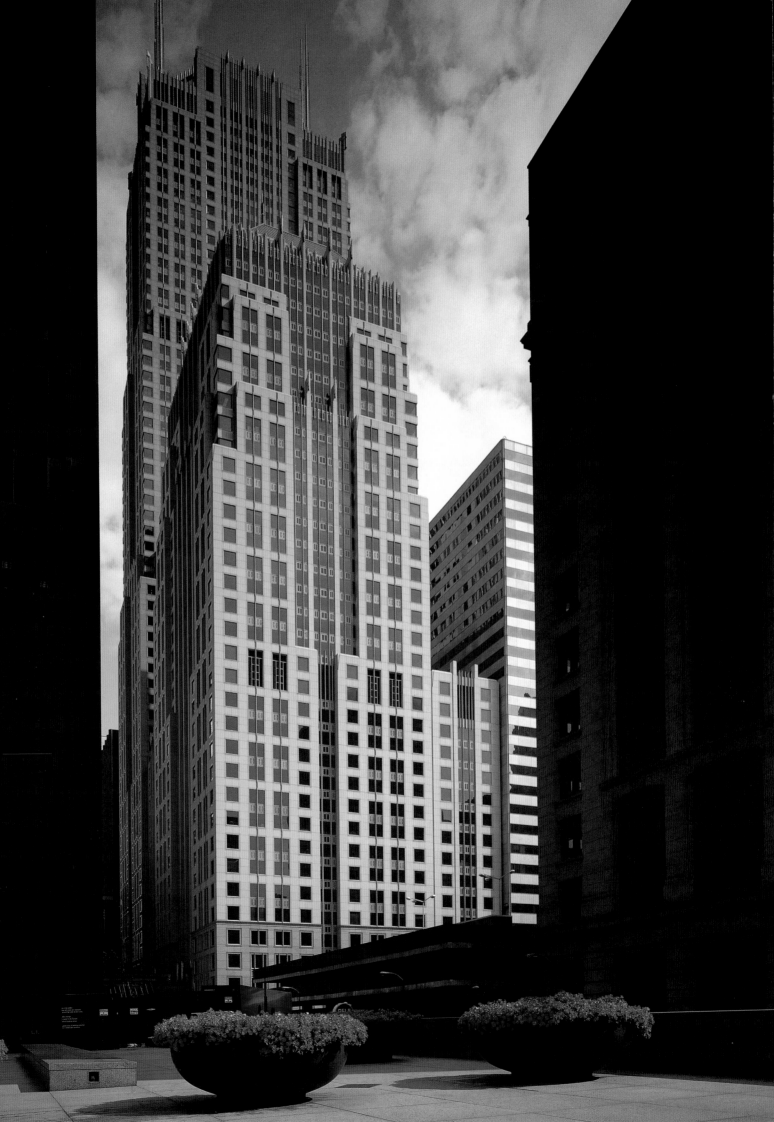

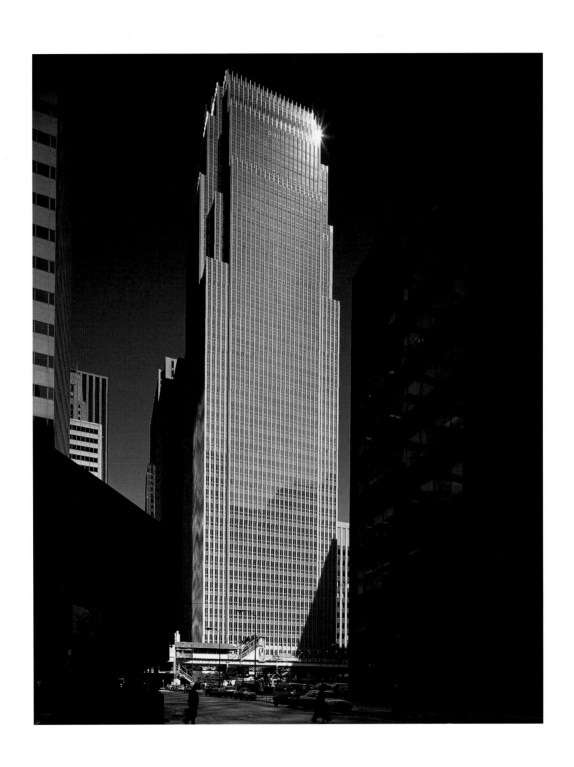

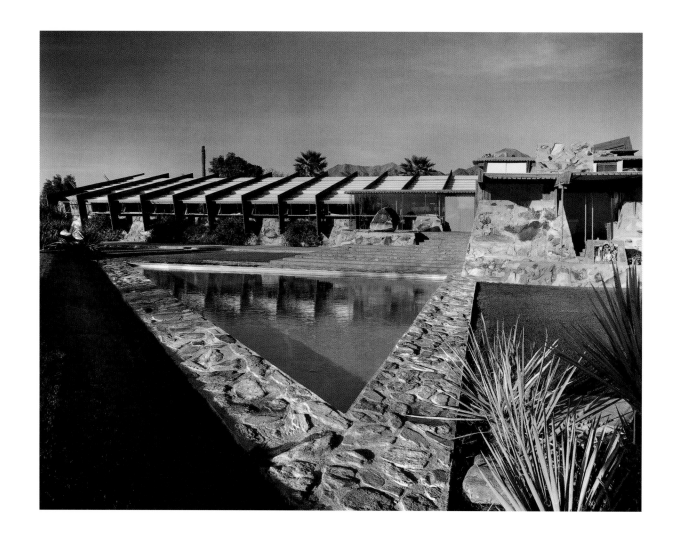

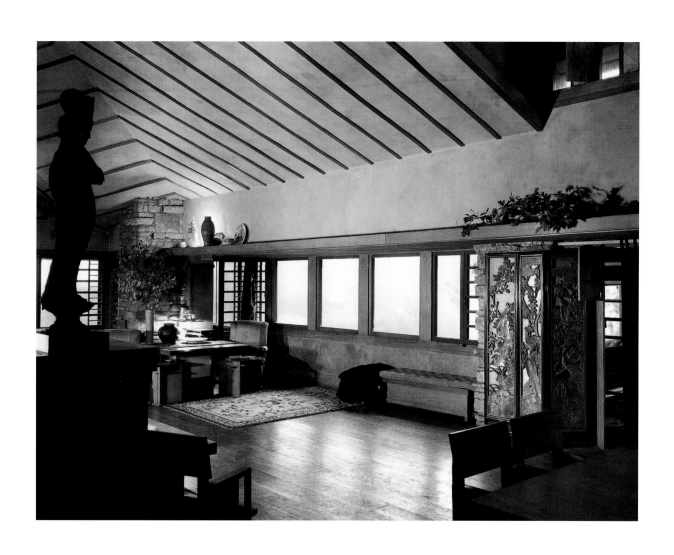

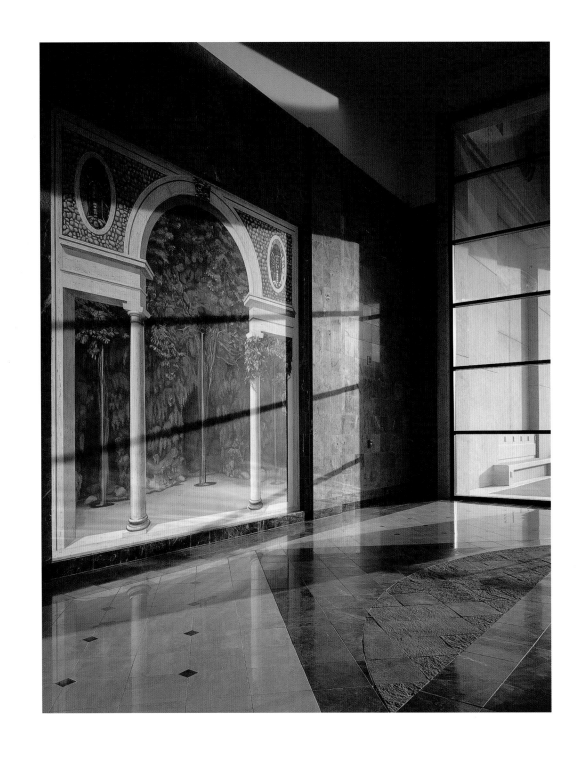

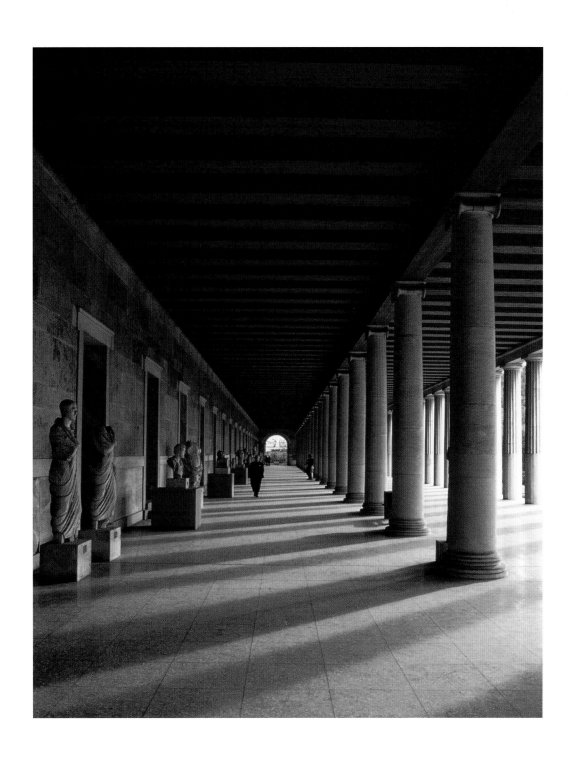

172

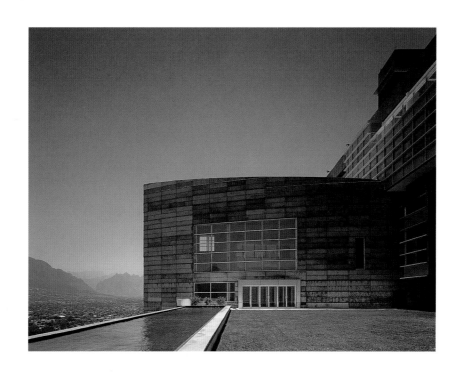

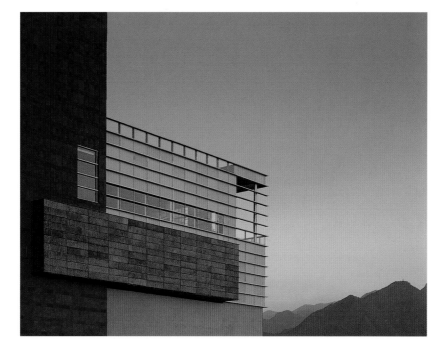

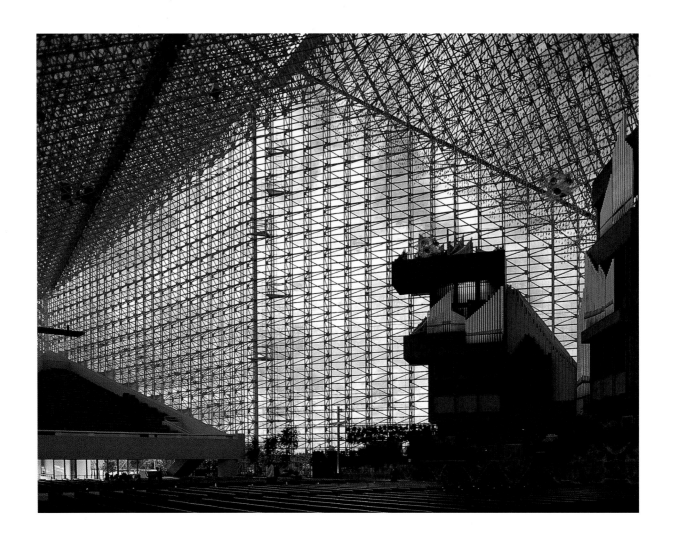

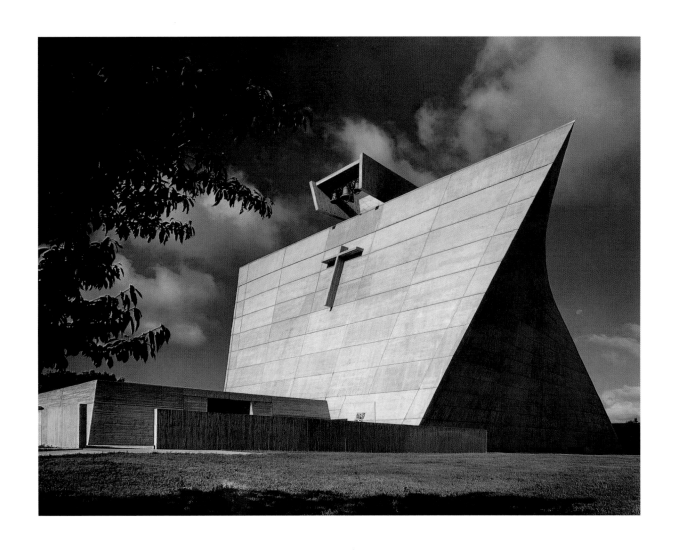

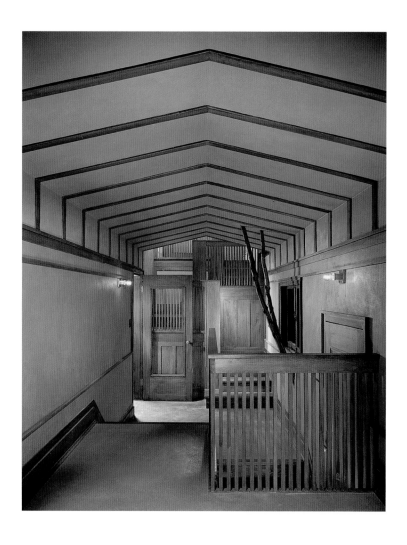

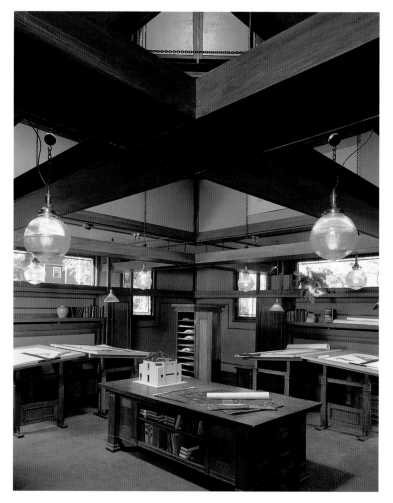

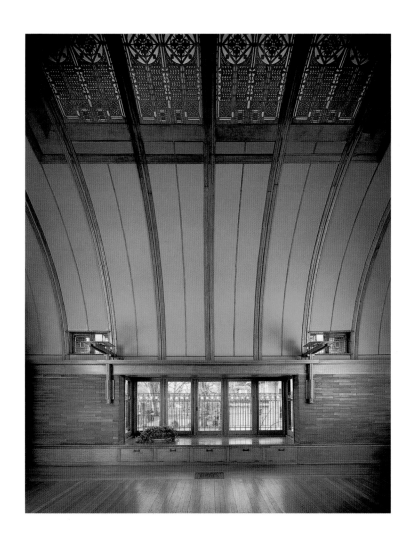

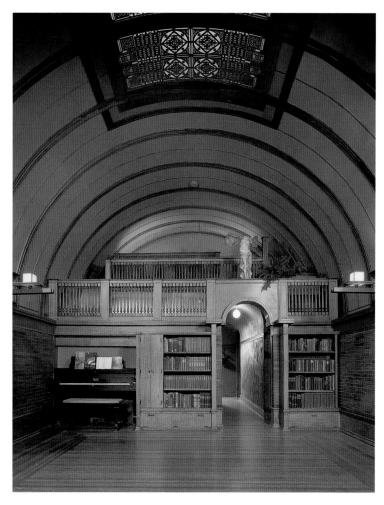

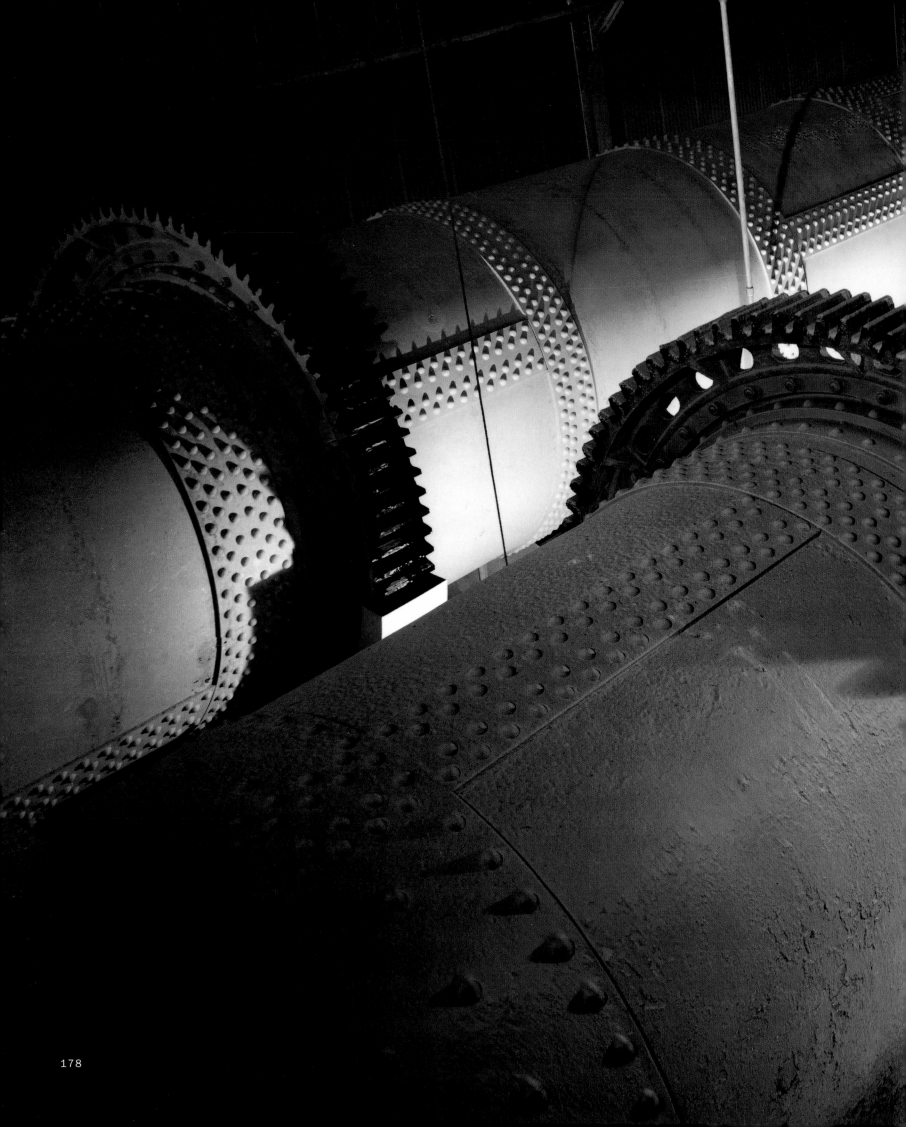

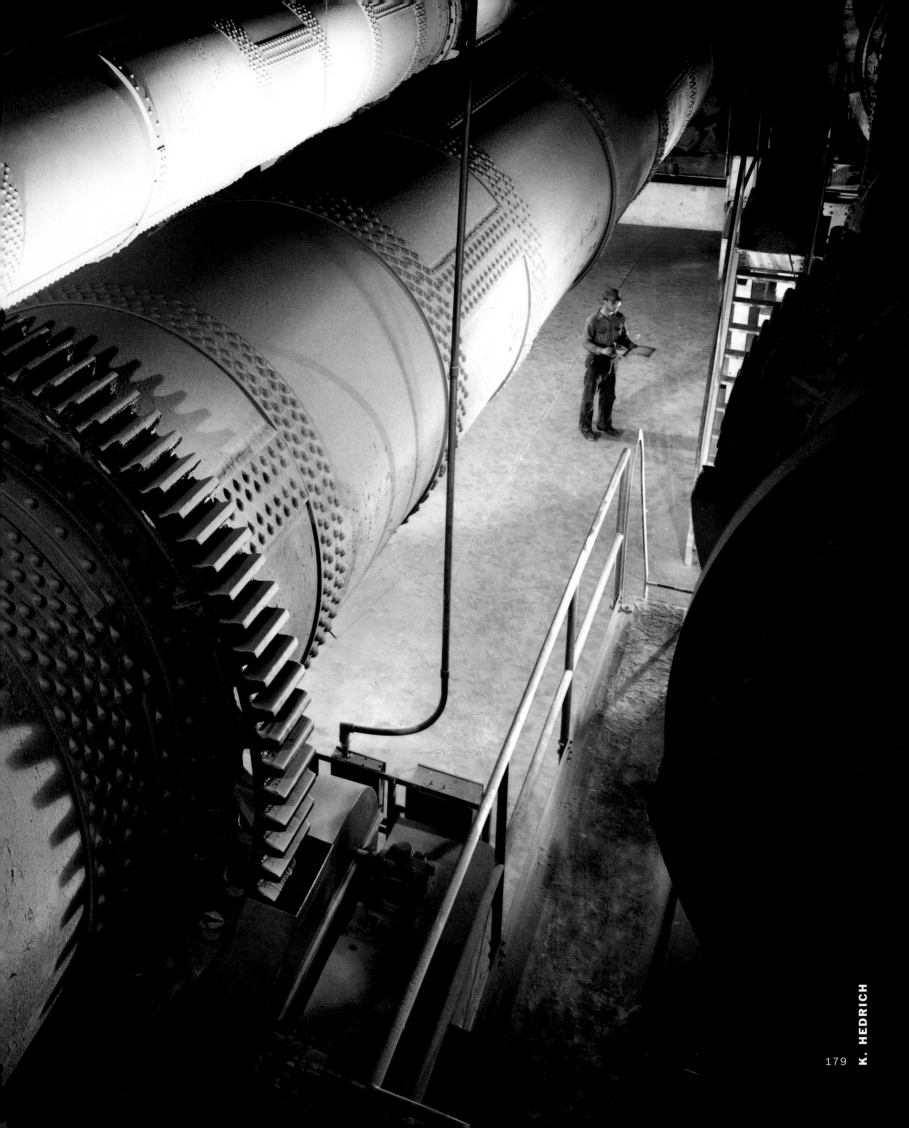

K. HEDRICH

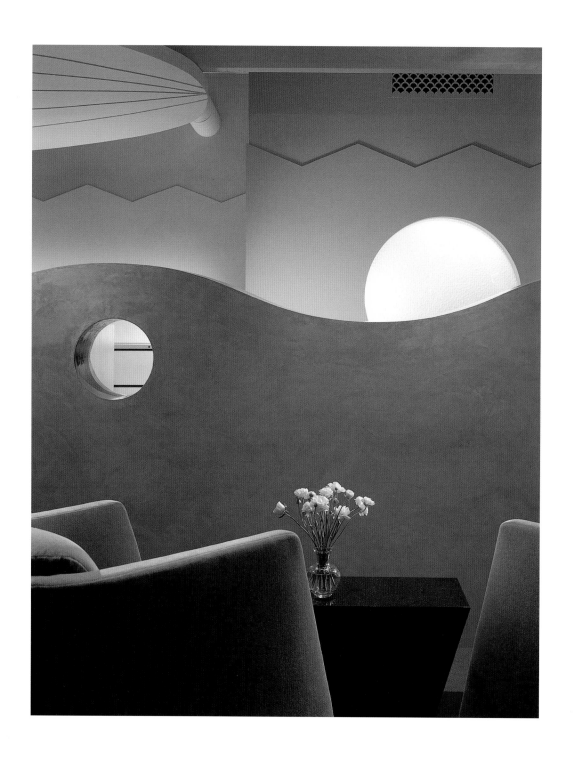

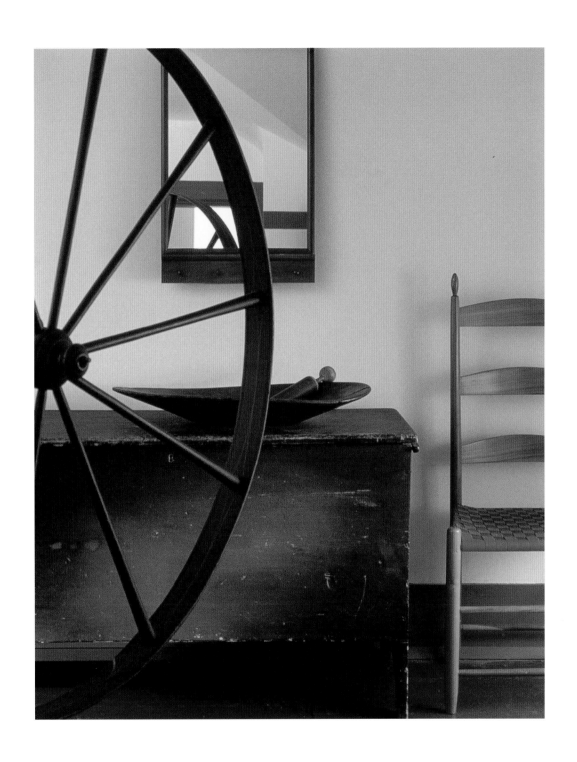

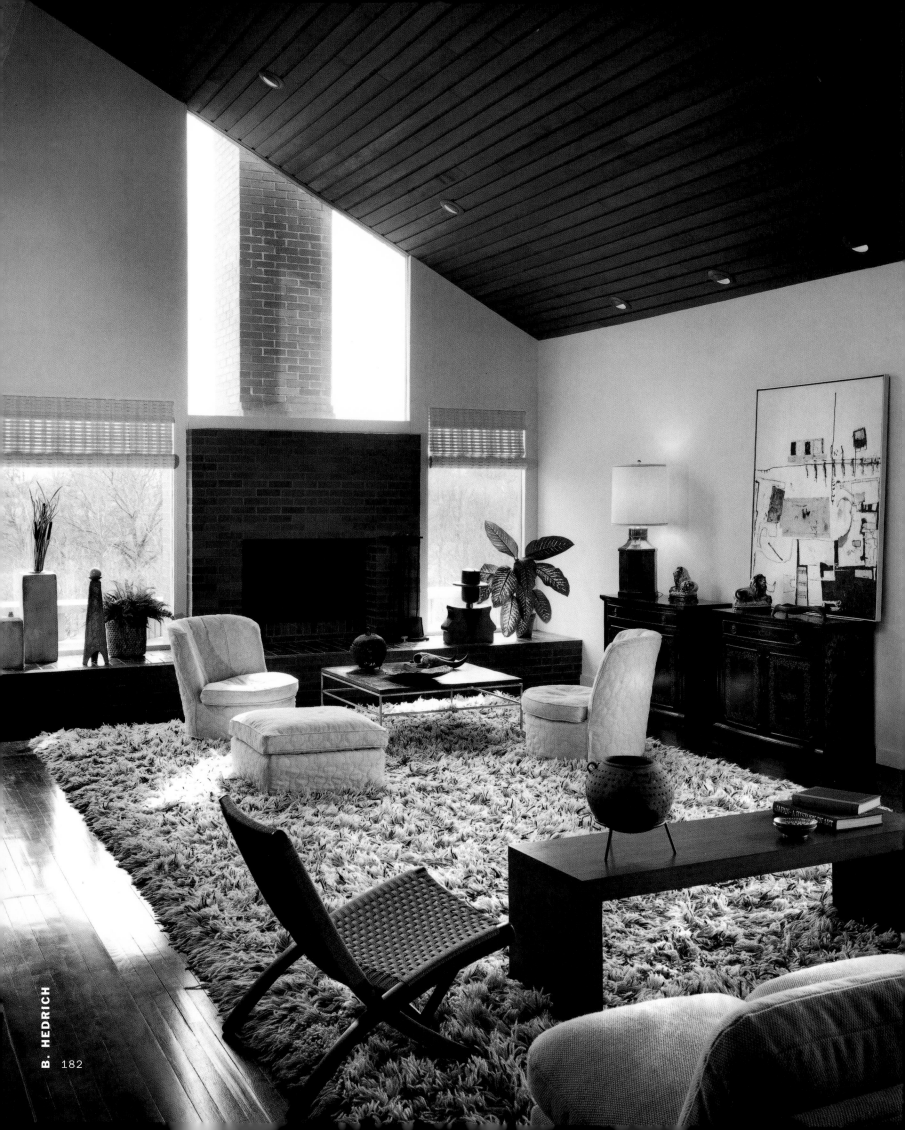

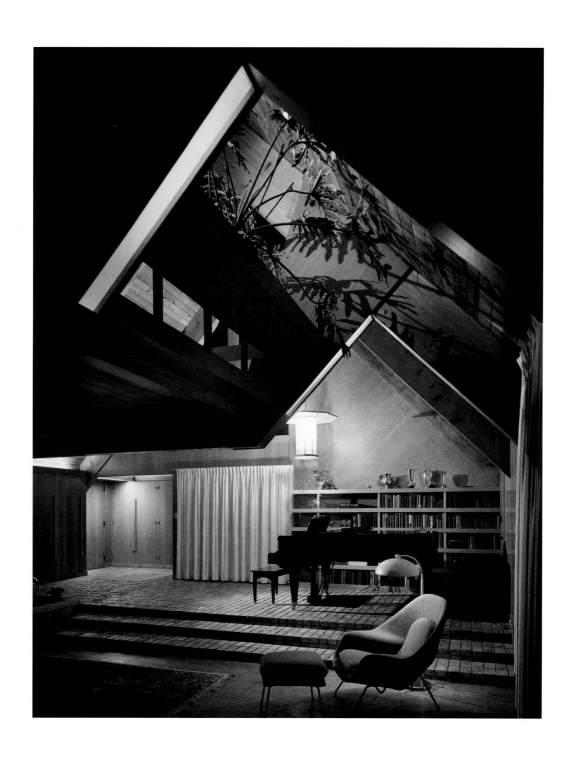

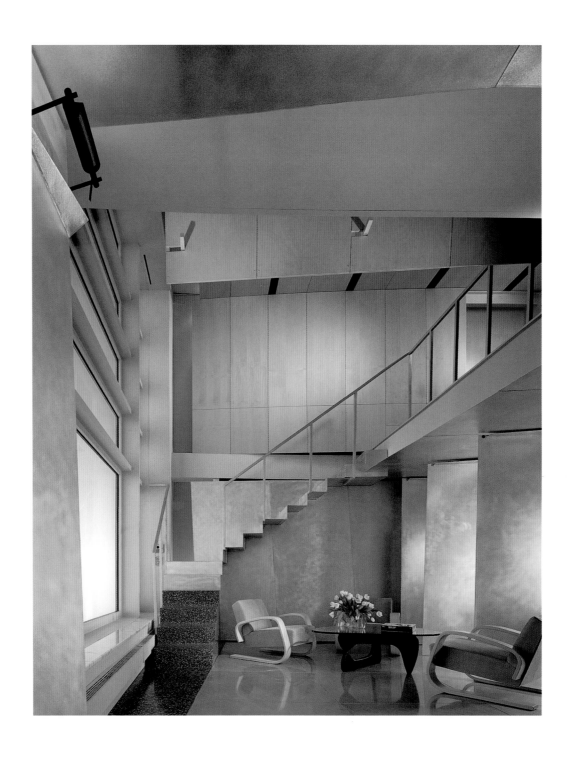

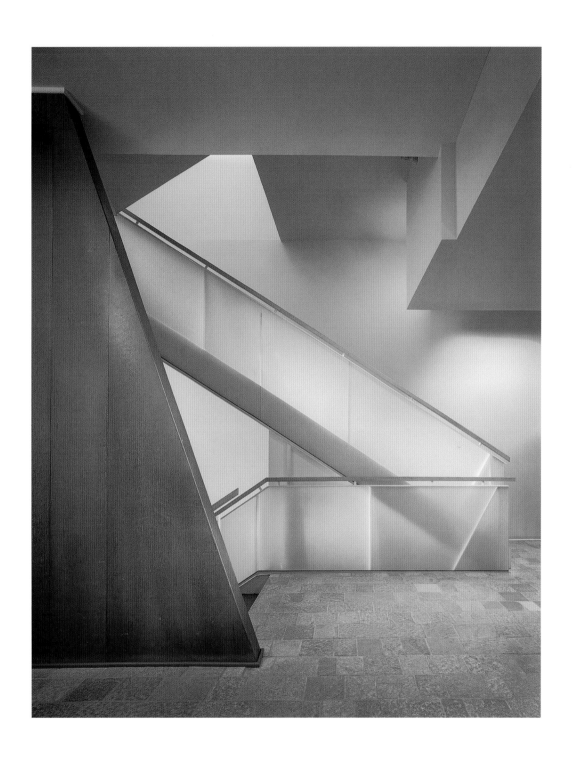

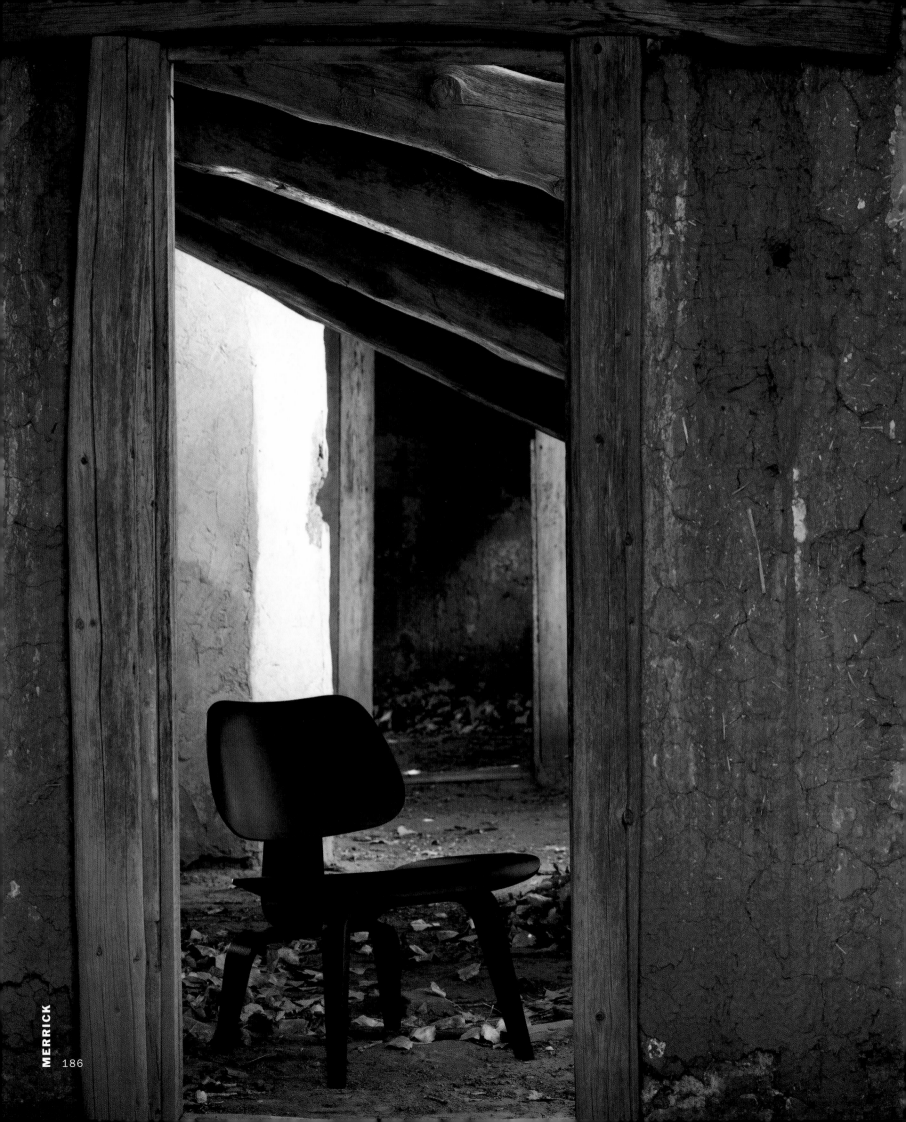

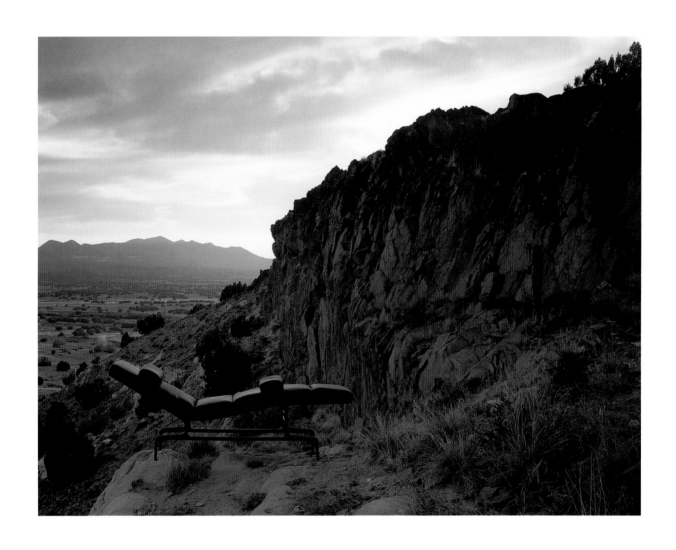

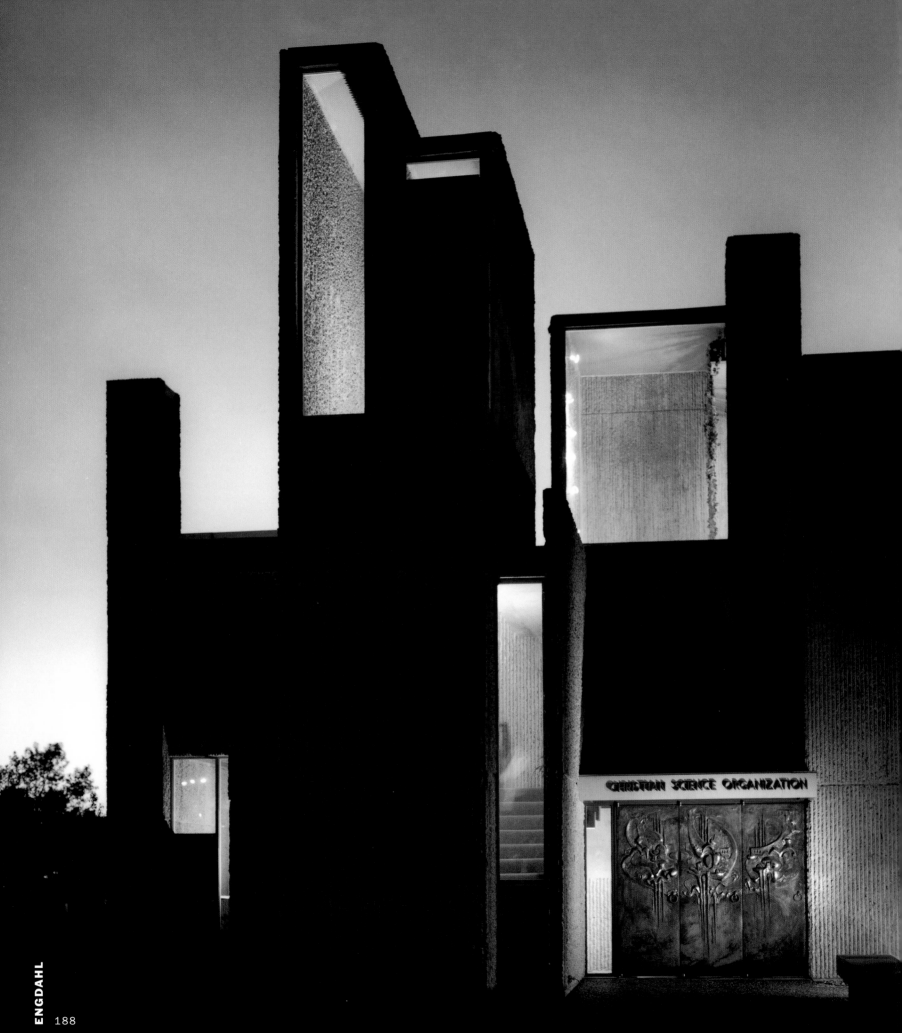

INDEX

(page numbers in italic indicate photographs)

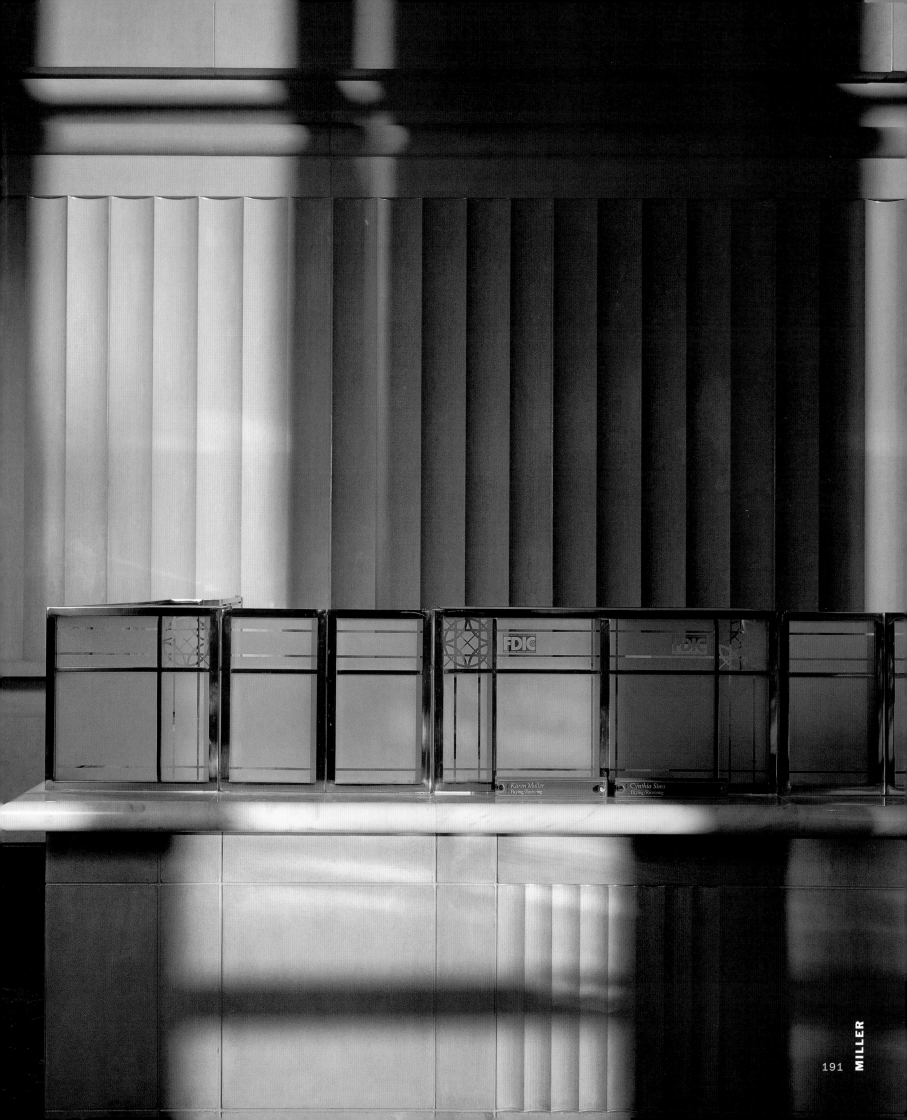

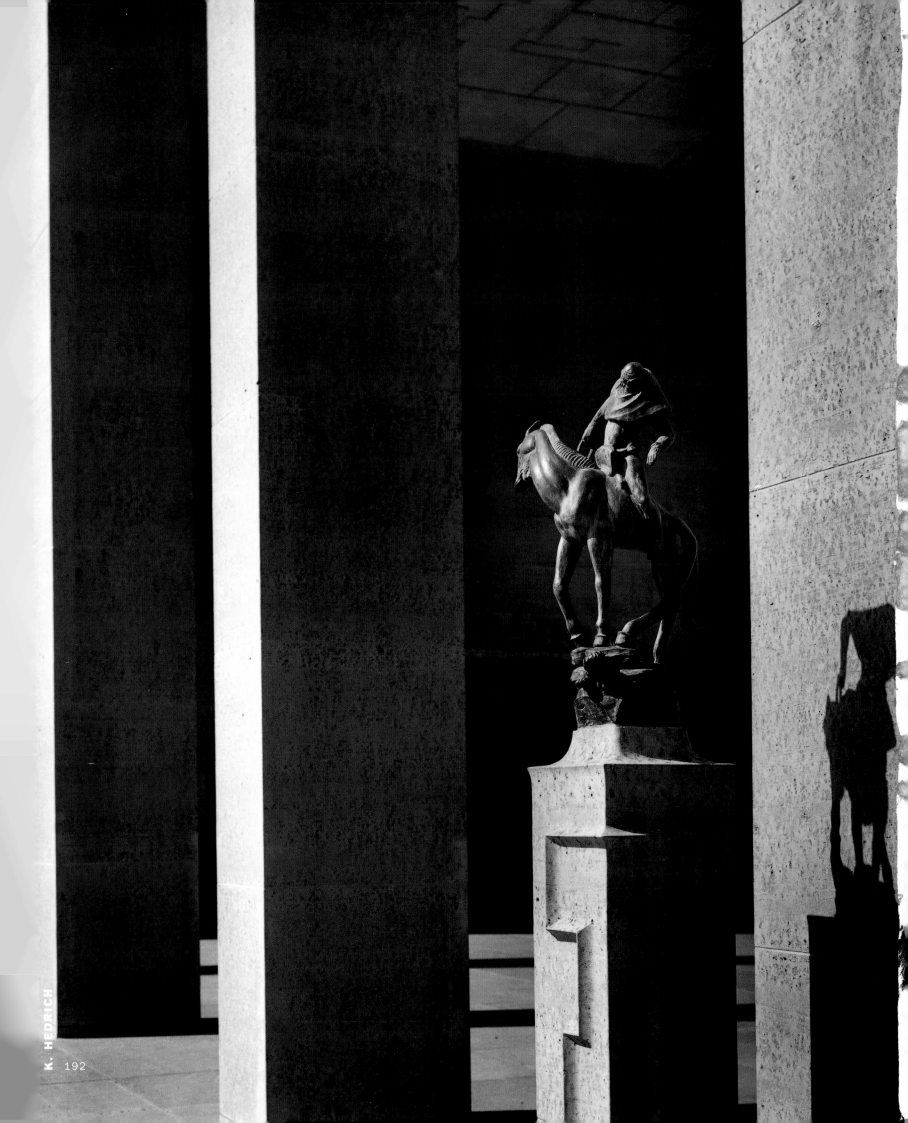

192

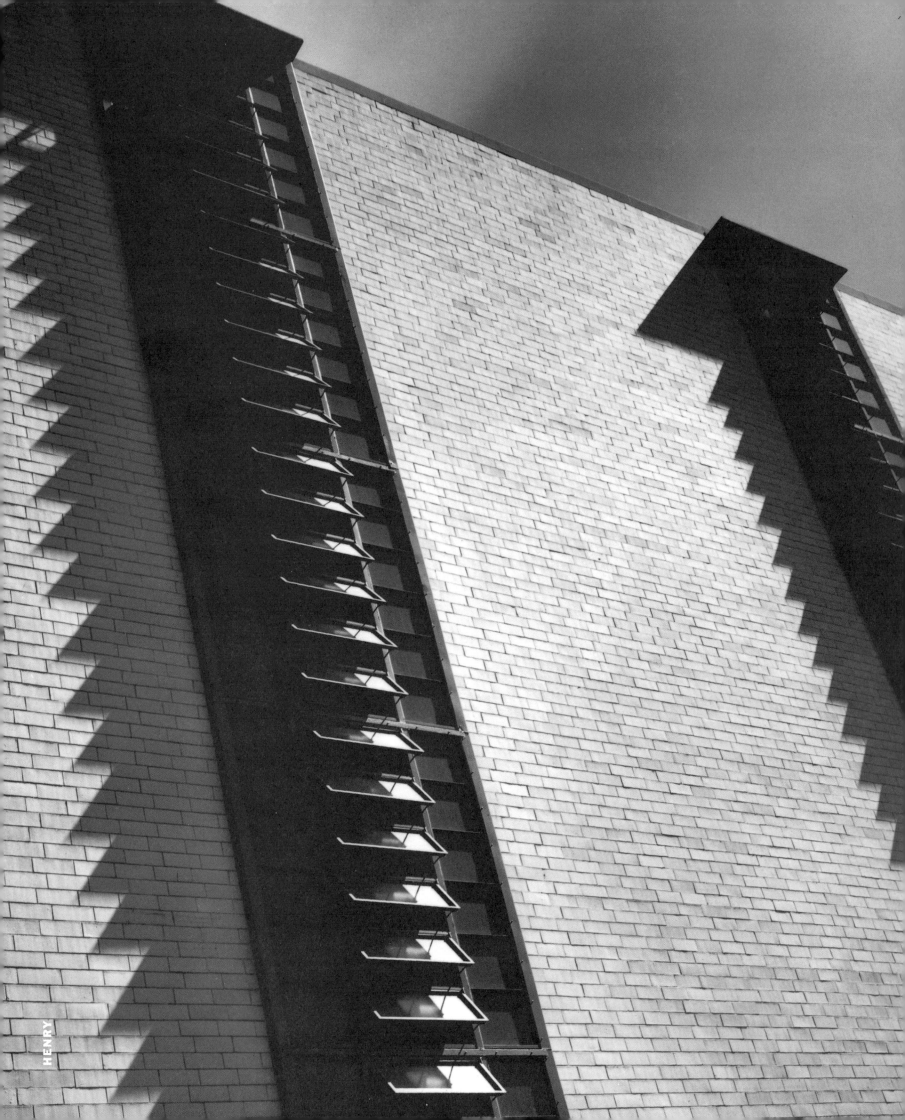